For the Fallen

For the Fallen

A century of remembrance since the Great War

Words by Peter Francis
Photographs by Michael St Maur Sheil

CWGC
Commonwealth War Graves Commission

Produced for the CWGC by AA Publishing
© Commonwealth War Graves Commission 2014

Editors: Louise Stanley and Donna Wood
Art Director: James Tims
Designer: Tracey Freestone
Image retouching and internal repro: Ian Little
Cartography provided by the Mapping Services Department of AA Publishing
Mountain High Maps ® Copyright © 1993 Digital Wisdom, Inc.

The Commonwealth War Graves Commission is responsible for marking and
maintaining the graves of those members of the Commonwealth forces who
died during the two world wars, for building and maintaining memorials to the
dead whose graves are unknown and for providing records and registers of these
1.7 million burials and commemorations found in most countries throughout
the world. In this special centenary publication only First World War graves are
featured. Casualty figures have been rounded up in the text and historical spellings
of placenames are used. The Commonwealth War Graves Commission does not
include accents on cemetery names.

The location of individual burials and commemorations can be found using the
Commission's website at www.cwgc.org

Published by AA Publishing (a trading name of AA Media Limited,
whose registered office is Fanum House, Basing View, Basingstoke RG21 4EA;
registered number 06112600).

A04990

ISBN: 978-0-7495-7647-9

A CIP catalogue record for this book is available from the British Library.

The contents of this book are believed correct at the time of printing. Nevertheless,
the publishers cannot be held responsible for any errors or omissions or for changes
in the details given in this book or for the consequences of any reliance on the
information provided by the same. This does not affect your statutory rights.

Printed and bound in Spain by Estella

theAA.com/shop

Contents

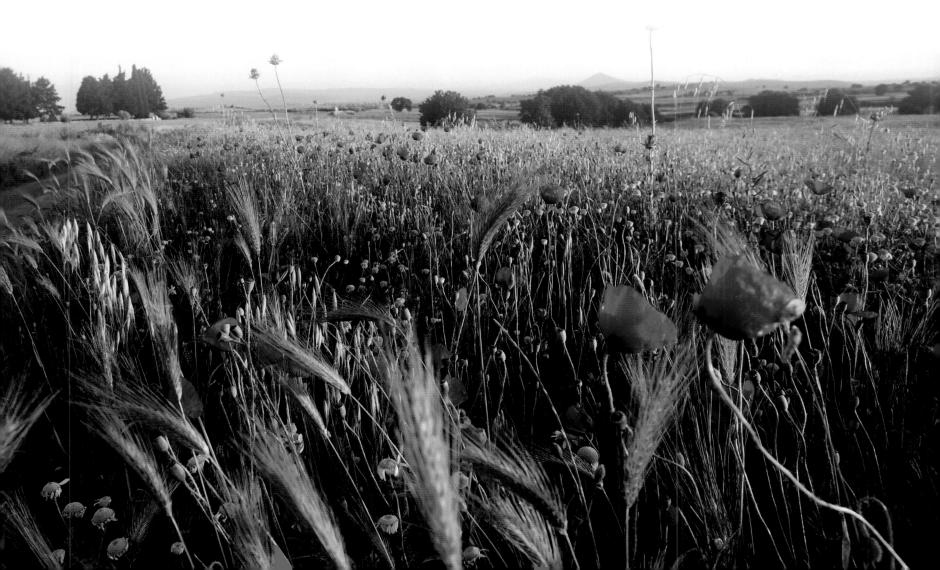

In the erection of memorials on the graves there should be no distinction between officers and men

General Sir Nevil Macready, 1918

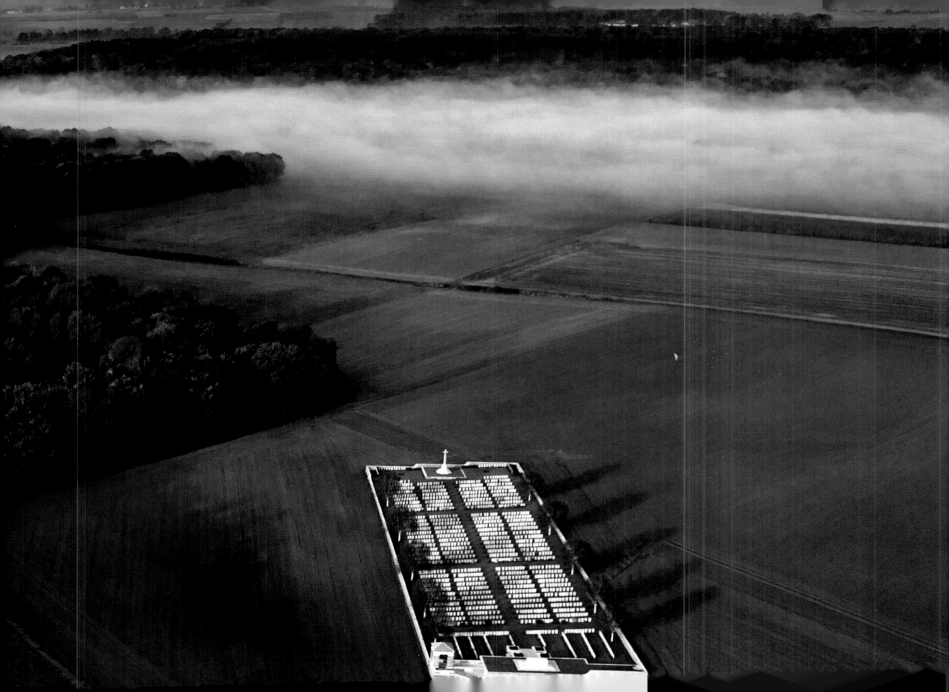

Foreword

For more than 40 years it has been my privilege, as President of the Commonwealth War Graves Commission, to witness first-hand the work of this remarkable organisation at the very heart of First World War remembrance.

To the readers of this book, or modern visitors to a Commonwealth war cemetery or memorial, the existence of these places may at first seem inevitable. In a way, a century on from the events that led to their creation, we have grown accustomed to them. But in 1914, it was by no means certain that any such fabric of remembrance would exist.

In so many ways, the First World War was different to previous wars – in its sheer scale, in the technology employed, and in the number of casualties it caused. What is perhaps not appreciated is that it also changed the face of remembrance. That is largely thanks to the vision and tireless efforts of one man – the founder of the Imperial (now Commonwealth) War Graves Commission, Fabian Ware.

He was determined that those who died would not be forgotten. The organisation he inspired achieved a commemorative task never before seen in its scale, complexity and ambition. The principles it established regarding equality of treatment and permanence of commemoration were far-sighted and have left us with poignant physical reminders of the war.

To see the headstones of the fallen, perfectly in line, with military precision – as if these young men and women were still on parade – has a haunting effect on those who come to see them. So too the memorials to those with no known grave never fail to move – great structures inscribed with the names of those the first industrialised war denied their own grave. Over 1.1 million names of the fallen; to be found on headstones or memorials tended by the Commission with care and simple dignity.

The aim here is to give an insight into the scope and sheer variety of Commonwealth war cemeteries worldwide, but this volume also serves to mark the dedication of the Commission and its staff in caring for these places and the important role they continue to play in our remembrance. The stunning photographs in this book capture the way in which the Commission has fulfilled its unique function around the world for a hundred years.

Despite the uniformity of commemoration adopted by the Commission after the Great War – to ensure that those who had died would be treated with true equality no matter their rank, race, or creed and no matter where they fell – no two cemeteries are alike. Like the men and women they commemorate, each has its own character and story to tell and it is this we have attempted to portray.

I have been fortunate to have visited cemeteries around the globe and to have met with many of the Commission's dedicated staff. I am always deeply impressed by the skill and commitment of everyone involved.

Those visits also brought home to me the enormous sacrifice made by the Commonwealth nations and the truly international nature of the Commission's role. It is deeply moving to visit the last resting-place of those from Australia, Canada, India, New Zealand, and South Africa as well as the United Kingdom. Each visit also makes one aware of the price paid by servicemen and women from many other nations.

A century on, the Commission's work remains a magnificent act of unity by the post-war Commonwealth, determining that those who had served their country would never be forgotten. From the desert of Trekkopje in Namibia, to the lush undergrowth of Buff Bay in Jamaica; from an isolated grave on St Finnan's Isle in Loch Shiel, Scotland, to the 72,000 names on the Thiepval Memorial in France, the Commission helps make that so.

The work of remembering goes on.

His Royal Highness The Duke of Kent
KG, GCMG, GCVO, ADC
President, Commonwealth War Graves Commission

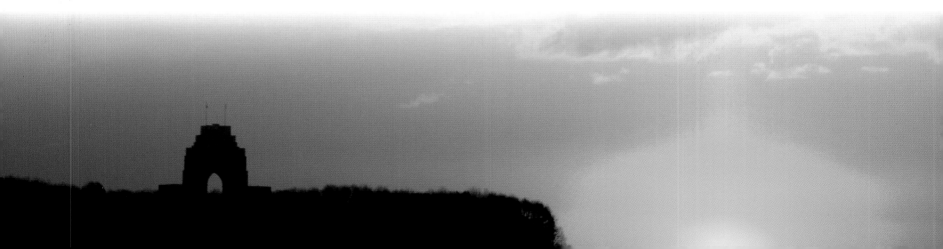

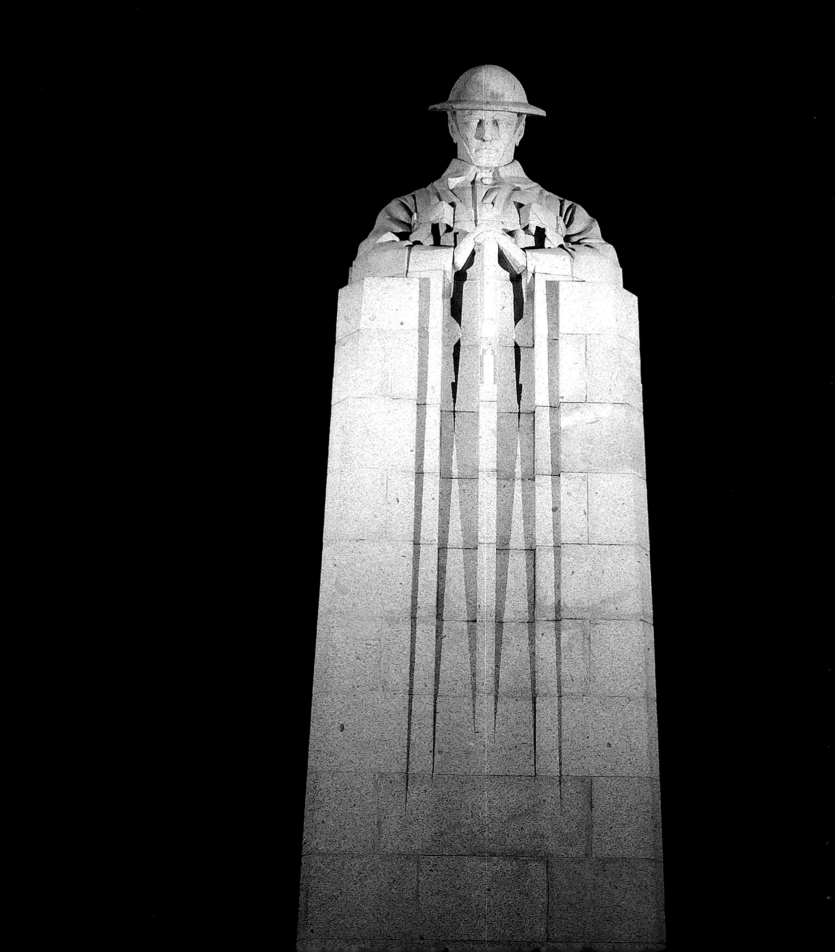

My subject is War, and the pity of War.
The Poetry is in the pity

Wilfred Owen, July 1918

Introduction: A century of care

Every November, a small red flower, the universal symbol of remembrance, brings a splash of colour to towns and cities across the Commonwealth. As the poppies appear on street corners and coat lapels, few would question the importance of remembering those who had died at war, or as a result of conflict. And yet, as His Royal Highness has already alluded to in the foreword to this volume, it is difficult for those of us who have grown up with this powerful symbol, immortalised in the poem 'In Flanders Fields' by John McCrae, to appreciate how revolutionary a concept remembrance of the war dead was in 1914.

Before the First World War, soldiers who died while serving in the army of the British Empire could not expect a lasting or fitting memorial. On occasion, regiments or comrades would mark a grave or attempt to give it some permanence, and perhaps even establish a regime for maintenance, but it was often the fate of the soldier to be forgotten – his individuality lost in mass graves that largely went unmarked and unnoticed. The First World War was to change that. Partly because the nature of war, and the army itself, changed, but also because for the first time a remarkable organisation was created to ensure the dead would never be forgotten.

A century on, and the war which affected more people, in more countries, than any previous conflict still has a strange power to fascinate us. The long shadow it cast did much to shape the world in which we now live. For good or bad it touched the lives of virtually every family in the United Kingdom and the wider Commonwealth. Historians still debate its causes, children still study its poetry, and even the songs and language of the war have entered our popular culture.

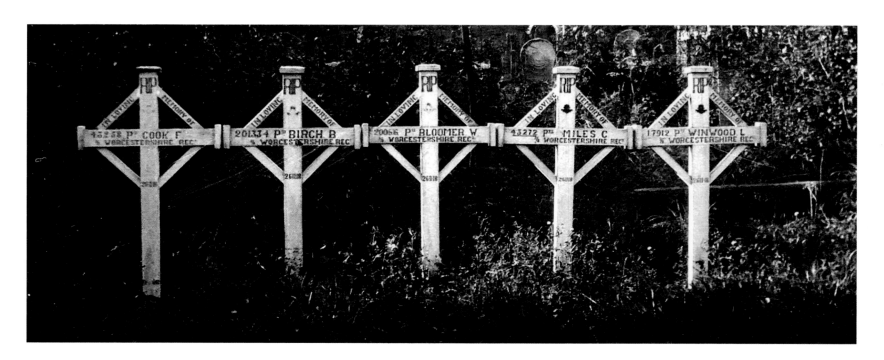

Early grave markers at Cramont in 1922

But it is in the cemeteries and memorials maintained by the Commonwealth War Graves Commission, the stunning images of which fill this volume, that we have perhaps its most powerful legacy. The war cemeteries are physical reminders of the conflict and its human cost – perhaps even monuments to human frailty or nobility. What is certain is that they have a lesson for each of us to this day.

It is not our intention to give a detailed history of the Commission in this book nor our ongoing work. However, it is important to understand from where the organisation came, the ideals it embodied, some of the challenges it faced, and how this is reflected in the images that can be seen in these pages.

The Imperial (later Commonwealth) War Graves Commission was established by Royal Charter during the heat of the global conflict of the early 20th century. Its creation was largely due to the vision, stubbornness and determination of one man – Fabian Arthur Goulstone Ware (1869–1949).

When war was declared in August 1914, Ware, like many others, felt duty bound to serve. Up to this point he'd had a varied career – from Director of Education in the Transvaal to Editor of the *Morning Post* – but was considered too old for active service. Undeterred, Ware travelled to France in September of 1914 under the authority of the British Red Cross, with a motley crew of volunteers – each driving an assortment of private vehicles, hastily converted to serve as ambulances. A fluent French speaker, Ware was initially posted to a section of the Front manned by the French army and although he was immediately struck by the scale and savagery of the war – particularly its impact on French civilians – there was little, as yet, to mark out Ware or his unit as unique. They were well-led

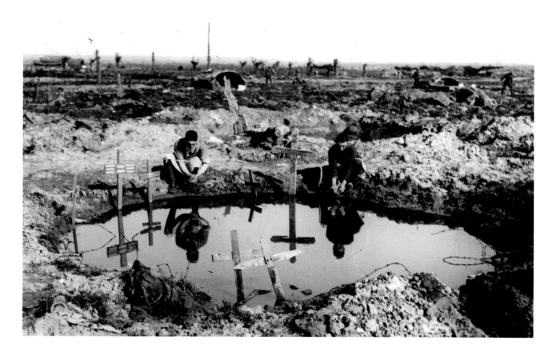

Makeshift crosses in a water-filled crater, before the Commission began its work

Sir Fabian Ware

and organised, but the vital work they did in recovering, treating and transporting the sick and wounded was replicated up and down the line by other units identical to their own.

It would also be true to say, at least initially, that Ware's interest in the graves of those who died served a practical consideration rather than a sentimental one. At its starkest and simplest, keeping records of the dead made the job of his unit – in knowing who was dead or missing – more straightforward. But Ware's view was about to change.

While stationed at Bethune in France, his unit was inspected by Lieutenant-Colonel Stewart – a Red Cross Medical Assessor. As the two men walked and talked among the hastily erected wooden crosses that formed a makeshift soldier's cemetery, so the idea of establishing an official organisation to mark and care for the graves was first raised. Both men were aware of the growing public dissatisfaction with the treatment of the dead. It was the lack of any obvious system, the flimsy nature of the grave markers, and the already fading inscriptions that irked Ware and Stewart. With Stewart's support, Ware was about to embark upon what was to become – at 45 years of age – his life's defining work.

With typical thoroughness, Ware organised his unit to mark and care for all the graves they could find. He drew up detailed instructions for the task and, attuned to public feeling at home, established an enquiries service to answer the thousands of letters his unit was receiving each week for information about the missing and the dead – even supplying photographs of graves where possible. By 1915, the unit's work was believed to be so important to the public at home, and to the morale of troops at the front, that they were relieved of their Red Cross duties and became part of the British Army – the Graves Registration Commission, with Fabian Ware at its helm.

Even at this early stage Ware was already planning for the future permanence of these cemeteries and with great foresight,

he established close links with the French and Belgian authorities – securing rights for his unit and land for cemeteries. In 1917, with the support of the Prince of Wales, Ware submitted a memorandum to the Imperial War Conference suggesting the need for an independent organisation to carry on the work of marking and caring for the graves of the fallen once the war was over. It was unanimously approved and by Royal Charter on 21 May 1917, the Imperial (renamed Commonwealth in 1960) War Graves Commission was born.

Although charged with a clear purpose, this new Imperial organisation had neither clear plans nor any point of reference for its work. Nothing on this scale had ever been attempted before and it was still by no means certain when the war would be over. Everything you see in this volume – the headstones, the memorials, the walls, the gardens, the very 'fabric' of remembrance – had yet to be worked out. Of two things Ware was certain; that the dead should be treated equally and that this work should be permanent.

Ware had already secured, with the help of the French and British, an order banning the repatriation of remains of the fallen. A few wealthy families had brought their son's bodies home, but Ware felt that allowing the dead to remain where they had fallen, side by side, was central to what he was trying to achieve – a reflection of common sacrifice, irrespective of social or military rank, race or creed. The first meeting of the newly formed Commission endorsed that view, although there remained a battle to convince the public. This far-sighted principle has resulted in war graves in almost every corner of the globe – the images in this volume detailing the sheer range of sites, countries and climates in which the Commission works.

Ware's attention now turned to what form the cemeteries might take and how best to mark the sacrifice of the hundreds of thousands of individuals with no known grave. He enlisted the help of the very best Britain's Empire had to offer – among them

the author Rudyard Kipling; architects Edwin Lutyens, Herbert Baker and Reginald Blomfield; and garden designer Gertrude Jekyll. But no consensus was reached and the public and press were demanding answers.

Almost in desperation, Ware approached the Director of the British Museum, Sir Frederic Kenyon, for help. Kenyon visited the battlefields, and upon his return produced a report for the Commission printed in early 1918. This small, typed, blue-covered pamphlet – *War Graves: How the Cemeteries Abroad will be Designed* – is one of the most important documents in the Commission's history. Within its pages Kenyon settled the internal debate. He reinforced the principles under which their work would be carried forward. He had seen beyond the devastated landscape, sown thickly with its wooden crosses, and articulated the gardens, headstones and memorial features that

seem so familiar to us now. He reiterated the importance of equality of treatment; that the cemeteries should be laid to fine horticulture to ensure there should be nothing gloomy about their appearance; that headstones and not crosses would be the appropriate form of grave marker; that Blomfield's Cross of Sacrifice would represent the faith of the majority; and that Lutyens' Stone of Remembrance would represent those of all faiths and none.

At last it appeared as if the work to commemorate the fallen might begin. As the war ended, the work of finding, identifying and moving the bodies – many of which had lain in the bullet-strewn open of No Man's Land for years – began. Grave markers were erected and grounds tended. Gardeners were recruited from the ranks of recently discharged servicemen. Many went on to marry into local communities and see their

Rudyard Kipling

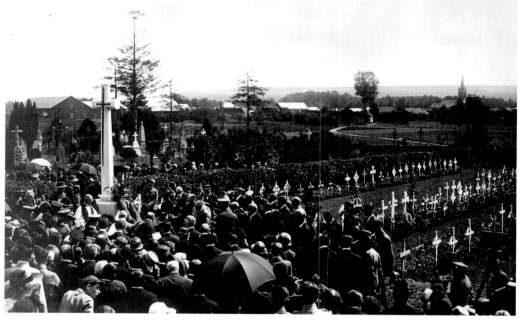

Unveiling of the Cross of Sacrifice in Bonnay Communal Cemetery Extension, France

sons and daughters work for the Commission. But with the war finally over, there grew dissenting voices to the Commission's very existence and certainly to its proposals to commemorate the dead. In particular, the decision to leave the dead where they had fallen was a cause of deep distress for many grieving families – as was the decision to use headstones, and not crosses, to mark the graves.

Within the archives at its Head Office in Maidenhead is a petition of more than 8,000 signatures imploring the Commission to reconsider the use of crosses – as well as letters both for and against the policy of non-repatriation of the dead. It is impossible to read these items and not be moved, and no doubt Ware and his colleagues were sympathetic. Yet they stood firm – with an almost quasi-religious belief in their vision and cause.

For a time, it looked as if Ware's vision was doomed to failure. As arguments grew more public and bitter, the issue came to a head in Parliament in 1920. The debate was fierce and emotive on both sides and the House dissolved without a clear decision, but actually, although opposition to the Commission was to continue, it would not threaten its existence again.

That was, in some part, due to the fact that events on the ground were starting to win the public over to the Commission's ideals. In 1920, Blomfield completed the Commission's first three 'experimental' cemeteries at Le Treport, Louvencourt and Forceville. On page 206 of this book is a picture of the small cemetery at Forceville – considered to be the most successful of the three designs. It was described by *The Times* newspaper at the time as 'The most perfect, the noblest, the most classically beautiful memorial that any loving heart or any proud nation

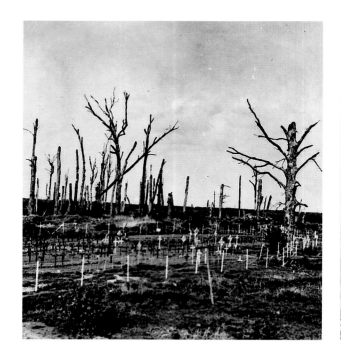

Ypres Reservoir Cemetery, Belgium

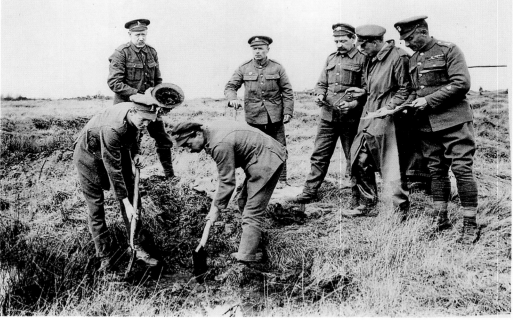

Searching for remains

could desire to their heroes fallen in a foreign land.' At last Ware's vision had been realised. Forceville was to become the template for an enormous building programme that would not be complete until 1938 with the unveiling of the Australian Memorial at Villers-Bretonneux. Just one year later, the Second World War would call upon the Commission's energies once more and extend its work around the globe.

Fabian Ware left the Commission in 1948 and died the year after. The legacy he left the world, in the cemeteries and memorials built and cared for by the organisation he created, is truly remarkable, and the ongoing remembrance of the Commonwealth war dead owes a great deal to his vision and efforts.

Today, the Commission's task is one of maintenance and engagement with the public. The 'Silent Cities', as Rudyard

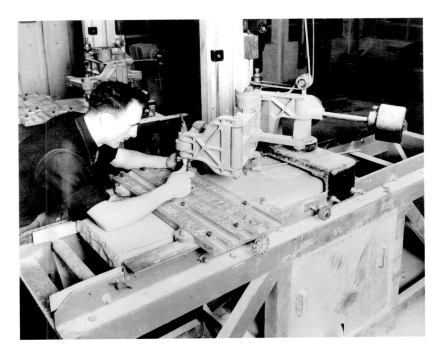

An early headstone-engraving machine

Kipling, the Commission's first literary adviser, called them, are to be found across the globe in a staggering 153 countries, and on every continent except Antarctica. They are as diverse as the engagements that were fought and the men and women that took part in them. They are maintained by a varied and dedicated workforce some 1,300 strong – the majority are gardeners and stonemasons – and supported by the Commonwealth nations of Australia, Canada, India, New Zealand, South Africa and the United Kingdom.

Although modern pilgrimage is more often to the graves of those we did not know, the many thousands who do visit each year return uplifted, inspired and comforted by the experience – with a renewed determination to remember the fallen. It is our hope that the images in this volume will inspire you to visit and to remember and give you a glimpse into the scale of the Commission's task and some of the people who carry it out. Why do we still care? Why do we maintain these places? Why do people in their hundreds of thousands visit them each year?

The answers lie in the pages of the visitor's books to be found at each cemetery and memorial; in the emails and phone calls from a grateful public to the Commission's offices; in the inscriptions on the headstones and memorials themselves; in the Commission's archives; and in the pages of this book. The simple truth is because there is something deeply human about the Commission's work; deeply human about the physical act of remembering, of visiting these places and touching the stones, walking the grass, and reading the inscriptions. It still matters to us – both as individuals and nations – because the men and women we remember still matter to us.

As the exhortation that is repeated every Remembrance Day from Laurence Binyon's poem 'For the Fallen' affirms – we will remember them.

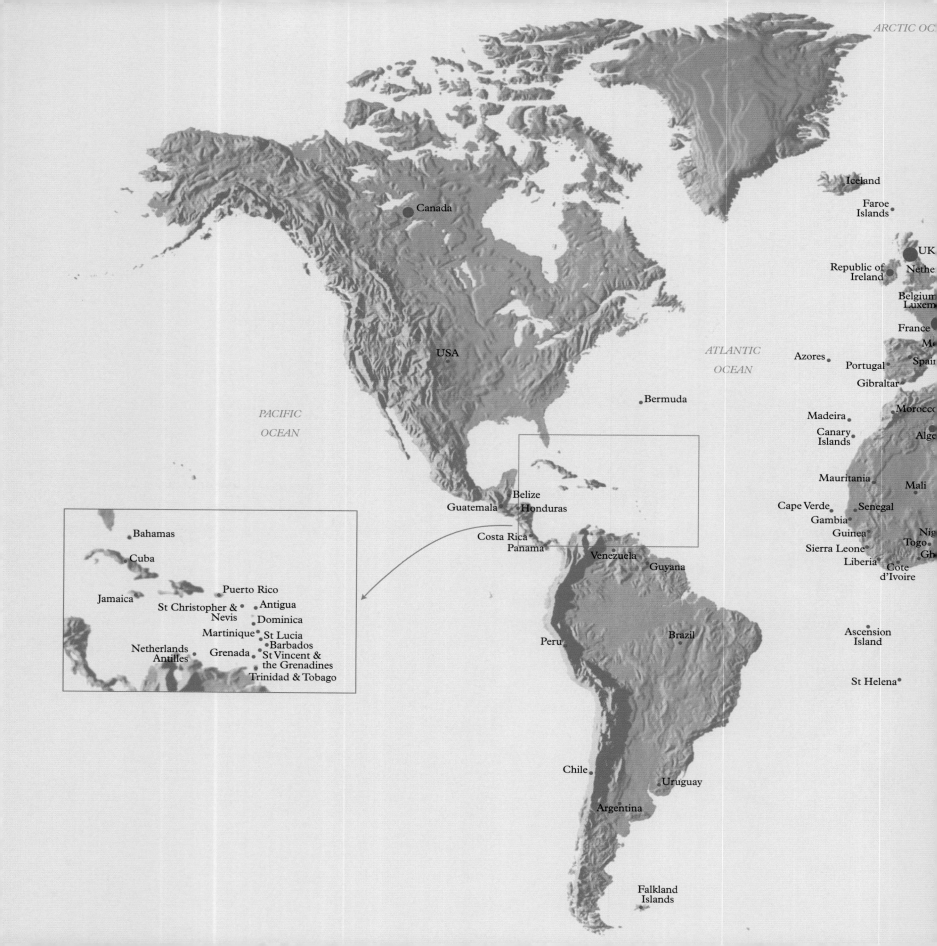

ARCTIC OC

Iceland

Faroe
Islands

UK

Republic of Nethe
Ireland

Belgium
Luxem

France

M

Azores Spain

Portugal

Gibraltar

ATLANTIC
OCEAN

Canada

Bermuda Madeira Morocco

PACIFIC Canary Alge
OCEAN Islands

USA

Mauritania Mali

Belize Cape Verde Senegal

Guatemala Gambia Nig
Honduras Guinea Togo
 Gh
 Sierra Leone
Costa Rica Liberia Cote
Panama Venezuela d'Ivoire

Bahamas Guyana

Cuba

Jamaica Puerto Rico

St Christopher & Antigua Ascension
Nevis Island
 Dominica
Martinique
 St Lucia Peru Brazil
Netherlands Barbados
Antilles Grenada St Vincent &
 the Grenadines St Helena
 Trinidad & Tobago

Chile

Uruguay

Argentina

Falkland
Islands

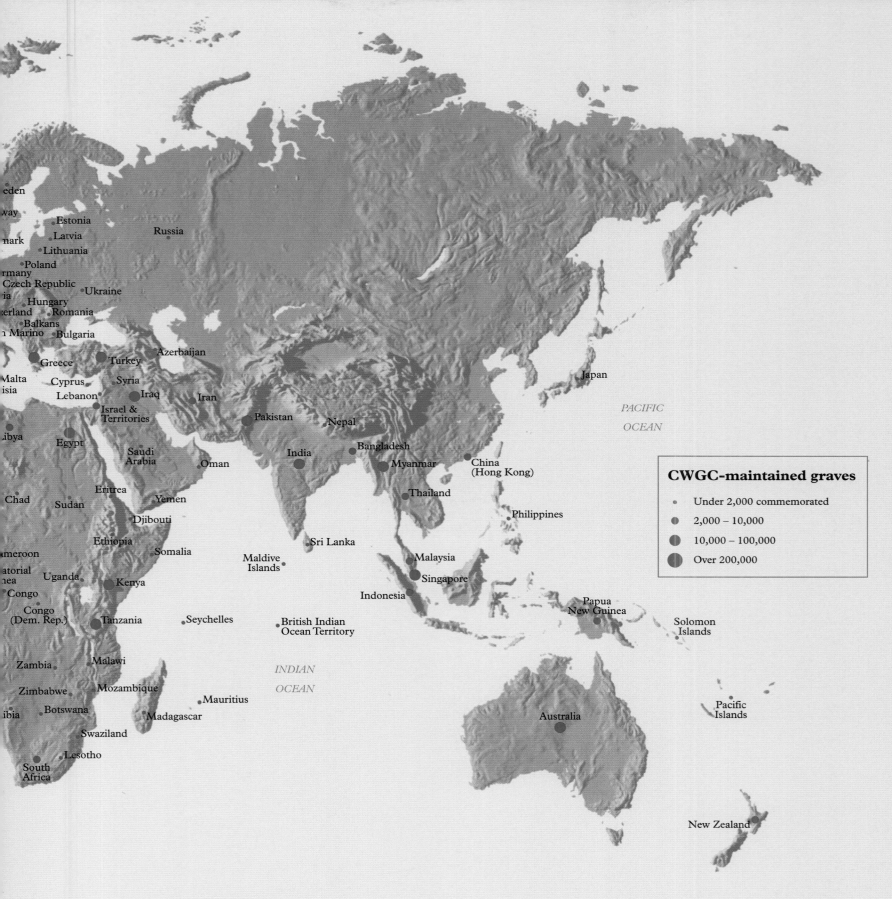

Estonia
Latvia
Russia
Lithuania
Poland
Czech Republic
Ukraine
Hungary
Romania
Balkans
Marino · Bulgaria
Azerbaijan
Greece
Turkey
Malta
Cyprus
Syria
isia
Lebanon
Iraq
Iran
Israel &
Territories
Pakistan
Nepal
ibya
Egypt
Bangladesh
Saudi
Arabia
Oman
India
Myanmar
China
(Hong Kong)
Chad
Eritrea
Sudan
Yemen
Thailand
Djibouti
Ethiopia
Philippines
meroon
Somalia
Sri Lanka
atorial
nea
Uganda
Maldive
Islands
Malaysia
Congo
Kenya
Singapore
Congo
(Dem. Rep.)
Indonesia
Tanzania
Seychelles
British Indian
Ocean Territory
Papua
New Guinea
Solomon
Islands
Zambia
Malawi
Zimbabwe
Mozambique
Mauritius
Pacific
Islands
ibia
Botswana
Madagascar
Australia
Swaziland
Lesotho
South
Africa
New Zealand

PACIFIC

OCEAN

INDIAN

OCEAN

SOUTHERN OCEAN

CWGC-maintained graves

· Under 2,000 commemorated

● 2,000 – 10,000

● 10,000 – 100,000

● Over 200,000

The photographs

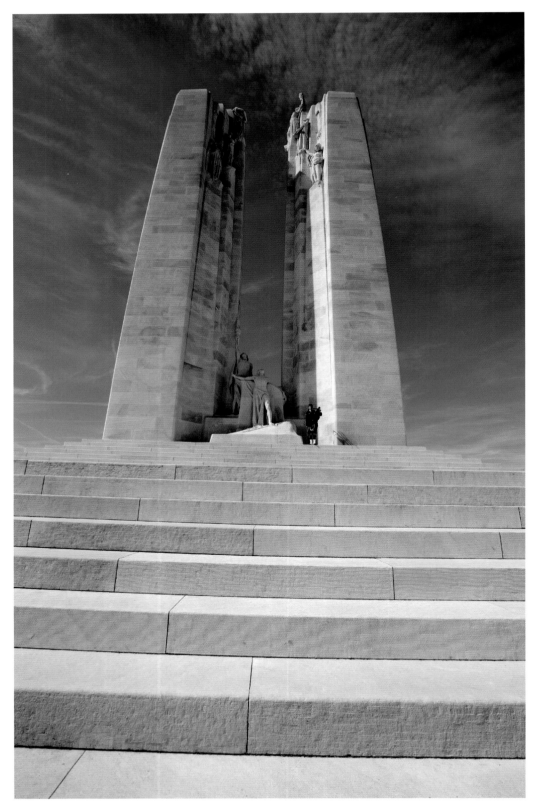

Without the dead we were helpless. So I have tried to show this in this monument to Canada's fallen, what we owed them and we will forever owe them.

Walter Seymour Allward

Vimy Memorial
Pas de Calais, France

On the opening day of the Battle of Arras, 9 April 1917, the four divisions of the Canadian Corps, fighting side by side for the first time, scored a huge tactical victory in the capture of Vimy Ridge. The victory is often described as a defining moment for Canada.

After the war, the highest point of the ridge was chosen as the site of the great memorial to all Canadians who served their country in battle during the First World War, and particularly to the 60,000 who gave their lives in France. It also bears the names of 11,000 Canadian servicemen who died in France – many of them in the fight for Vimy Ridge – who have no known grave.

Canadian sculptor and architect Walter Seymour Allward once told friends the form of the design came to him in a dream. His vision took 11 years to build and was unveiled on 26 July 1936 by King Edward VIII, in the presence of President Albert Lebrun of France and 50,000 Canadian and French veterans and their families. In his address the King noted, 'It is a memorial to no man, but a memorial for a nation.'

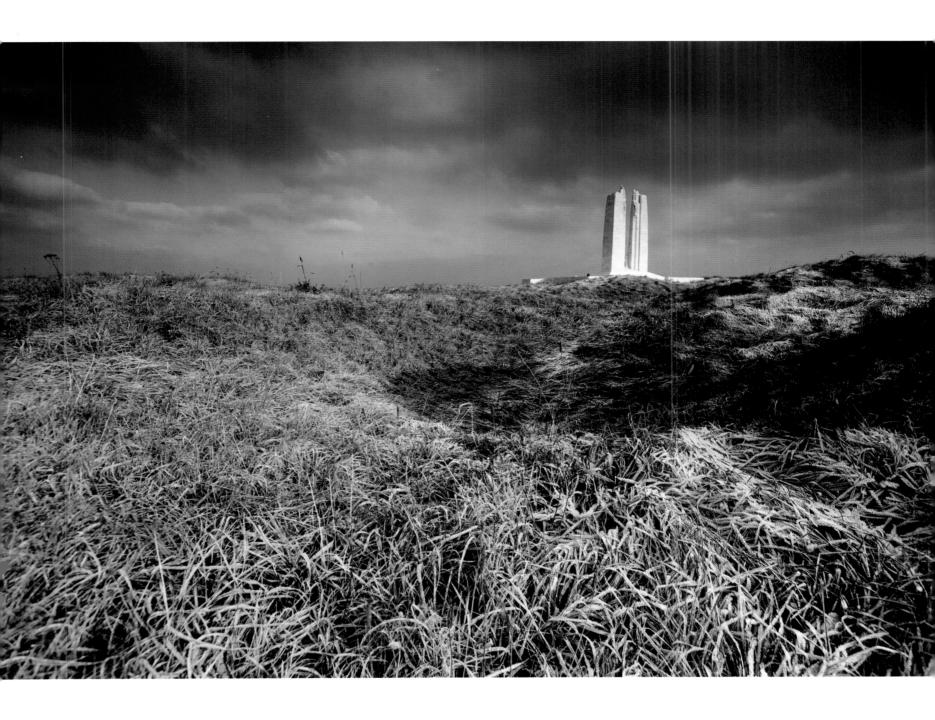

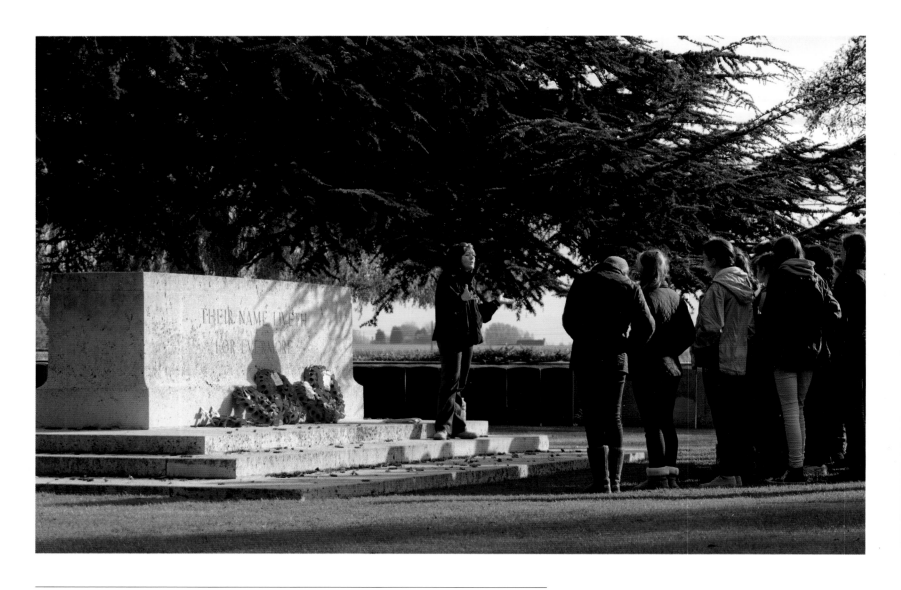

Lijssenthoek Military Cemetery

Poperinge, West-Vlaanderen, Belgium

Jo Hook, a member of the Guild of Battlefield Guides, engages a group of students in the history of the war at Lijssenthoek – the second largest CWGC cemetery in Belgium. Educating people about the war and the work of the Commission is vitally important to ensure the longevity of remembrance.

Among the graves of almost 10,000 servicemen is a single female grave, of Staff Nurse Nellie Spender, one of only two female Great War casualties buried in Belgium. Nellie was mortally wounded at the nearby Casualty Clearing Station at Brandhoek; she was in bed as the Germans shelled the area and died within a few minutes. She died on 21 August 1917, aged 26, after having only been at the Front for a few months.

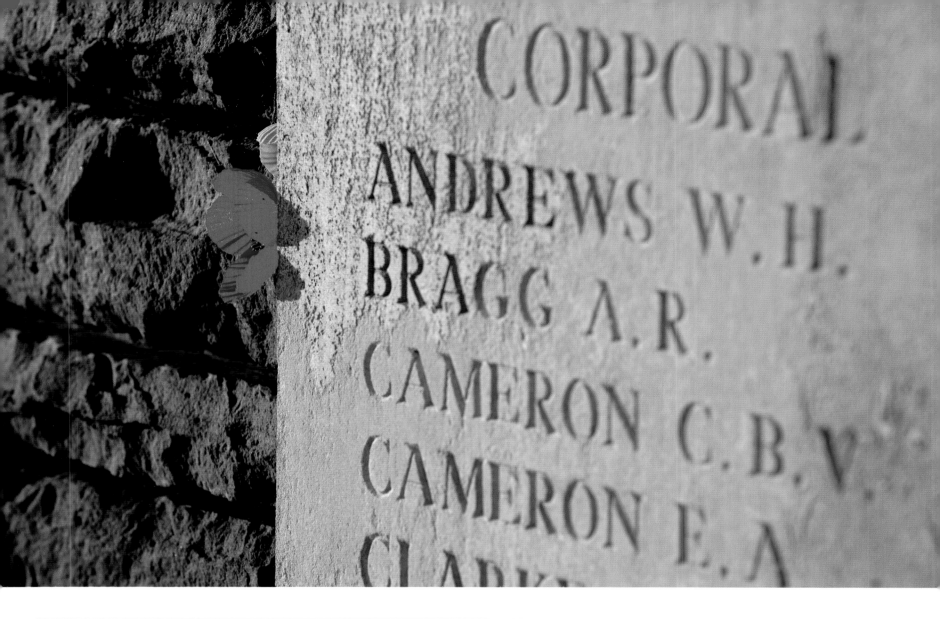

VC Corner Australian Cemetery and Memorial
Fromelles, Nord, France

VC Corner Cemetery is the only uniquely Australian cemetery on the Western Front. It was formed after the Armistice and contains the graves of 410 Australian soldiers who were killed during the Battle of Fromelles in July 1916 and whose bodies were found on the battlefield. As none of the bodies could be identified, it was decided not to mark the individual graves, but to record on a memorial the names of all the Australian soldiers who were killed in the engagement.

The battle was fought on 19–20 July 1916. It was intended to prevent the Germans sending reinforcements to the Somme, some 70km to the south. In reality it was a costly failure. In just one night of fighting, over 5,300 Australian and more than 1,500 British soldiers were killed, wounded, or captured.

More than 120 of those originally listed on the memorial at VC Corner were subsequently identified and re-interred at Fromelles (Pheasant Wood) Cemetery in 2010 following the discovery of a mass grave near the village of Fromelles in 2008. The cemetery in Fromelles was the first new war cemetery to be built by the Commonwealth War Graves Commission in 50 years.

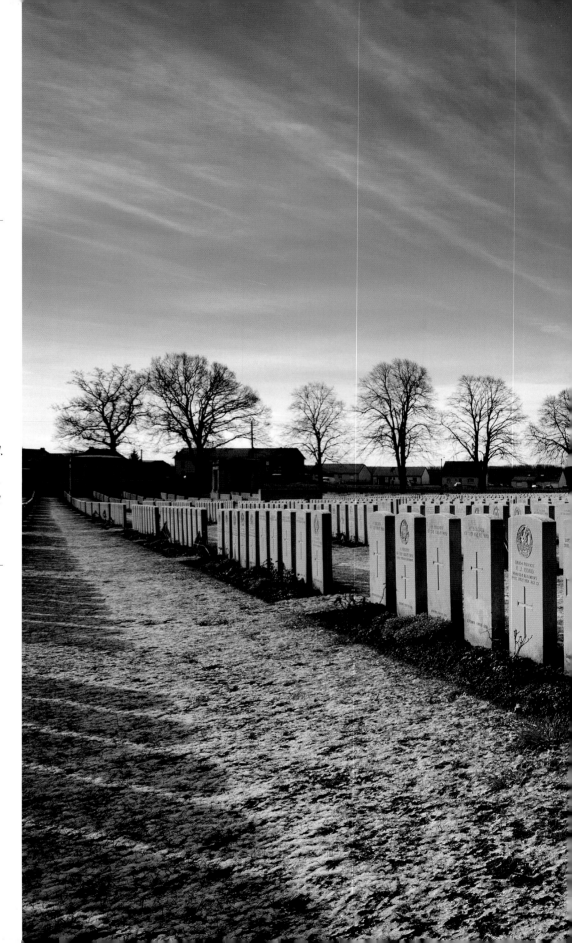

Delville Wood Cemetery
Longueval, Somme, France

Delville Wood Cemetery was constructed after the Armistice. Almost all of the 5,500 burials date from July, August and September 1916. Delville Wood was sometimes known as Devil's Wood, and the fighting there during the battle of the Somme was particularly ferocious.

The Official History of the Great War 1914-1918 records the courage of the South Africans holding the wood:

The South Africans had covered themselves with glory at Delville Wood, which is now laid out as a memorial to their dead. In spite of terrible losses, they had steadfastly endured the ordeal of the German bombardment, which seldom slackened and never ceased, and had faced with great courage and resolution repeated counter-attacks delivered by fresh [German] troops. Since their first advance into the wood on the morning of 15th July they had defied all attempts to drive them completely from it.

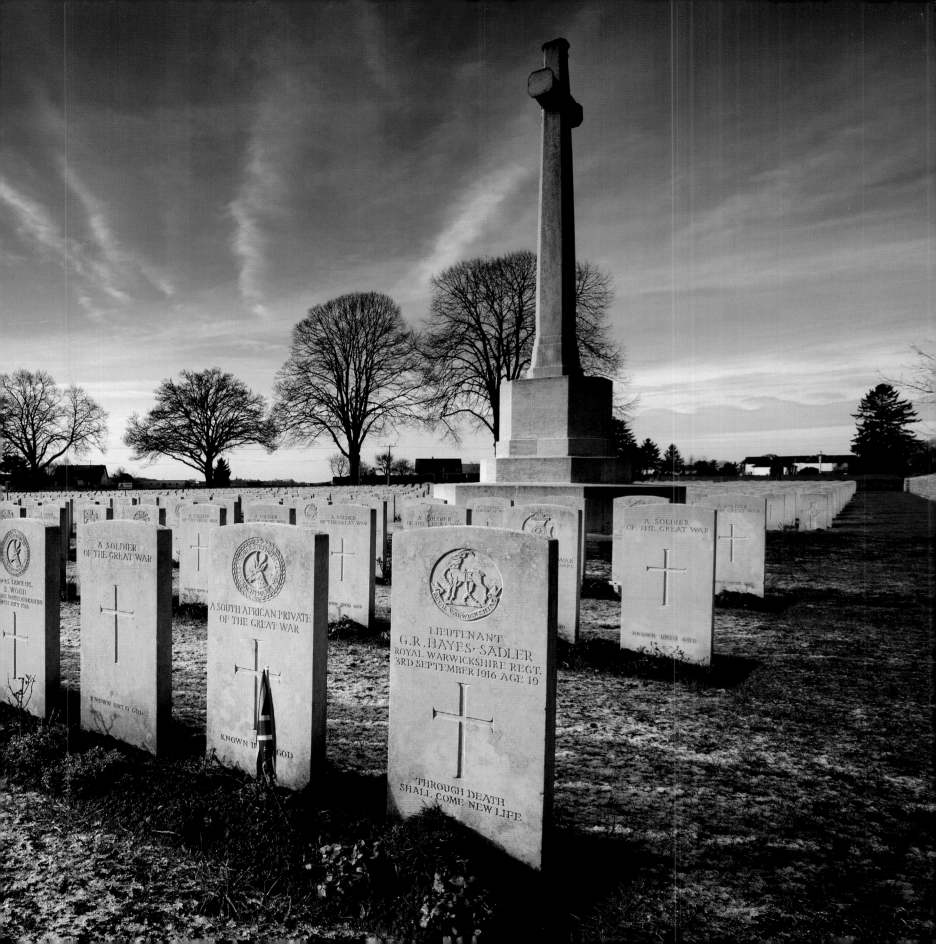

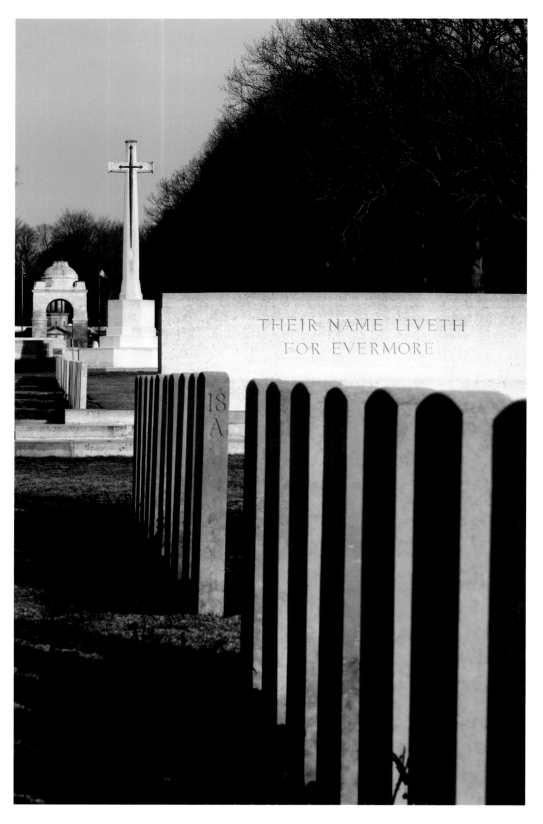

Delville Wood Cemetery

Longueval, Somme, France

Described as 'the bloodiest battle hell of 1916', the battle of Delville Wood is of particular importance to South Africa. In July 1916, the South African 1st Infantry Brigade fought here continuously for six days. When eventually relieved, they had suffered losses of 80 per cent of their strength. Opposite the cemetery stands the South African National Memorial – a memorial to all South Africans who have died in war.

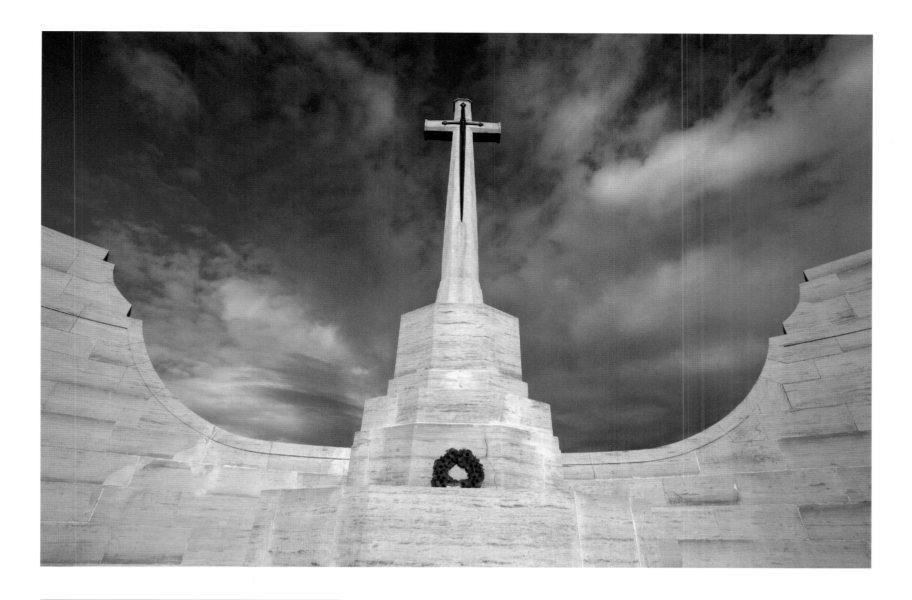

Loos Memorial

Pas de Calais, France

The Loos Memorial surrounds Dud Corner Cemetery
and commemorates over 20,000 officers and men who
have no known grave. It was unveiled by Sir Nevil Macready
on 4 August 1930. Macready was the Adjutant General
of the British Army and instrumental in supporting the
Commission's early work.

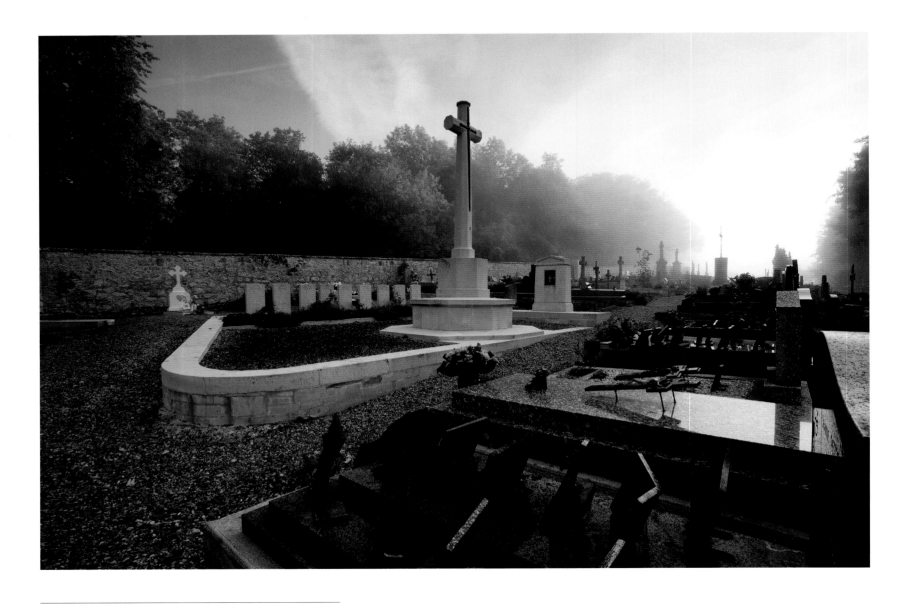

Soupir Communal Cemetery
Aisne, France

This small plot of 16 graves within a public village cemetery,
all of which were brought here after the war, dates from
September–October 1914, when the Brigade of Guards
were engaged in heavy fighting here. The plot contains a
high proportion of officers – including the grave of Captain
Lord Guernsey, who served as Heneage Greville Finch.

Tomb of the Unknown Soldier
Australian War Memorial, Canberra, Australia

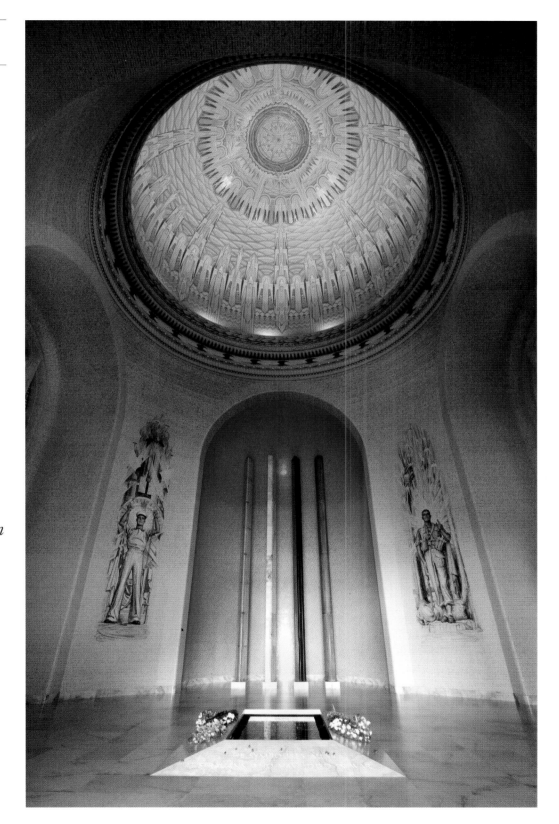

*We do not know this Australian's name
and we never will.*

We do not know his rank or battalion.

*We do not know where he was born,
nor precisely how he died ...*

*We will never know who this Australian
was ... he was one of the 45,000
Australians who died on the Western
Front ... one of the 60,000 Australians
who died on foreign soil.*

*One of the 100,000 Australians who
died in wars this century.*

He is all of them.

And he is one of us.

Prime Minister The Hon. P J Keating MP
at the funeral service of the Unknown Australian
Soldier, 11 November 1993

To the memory of those Natives of the South African Labour Corps who crossed the seas in response to the call of their great Chief, King George V, and laid down their lives in France, for the British Empire, during the Great War 1914–1918, this Memorial is erected by their comrades

Inscription in English, Sesuto and Isixosa on the memorial
to all men of the Corps who died in France

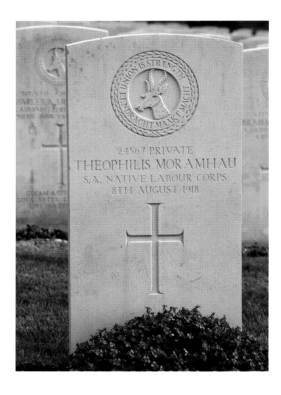

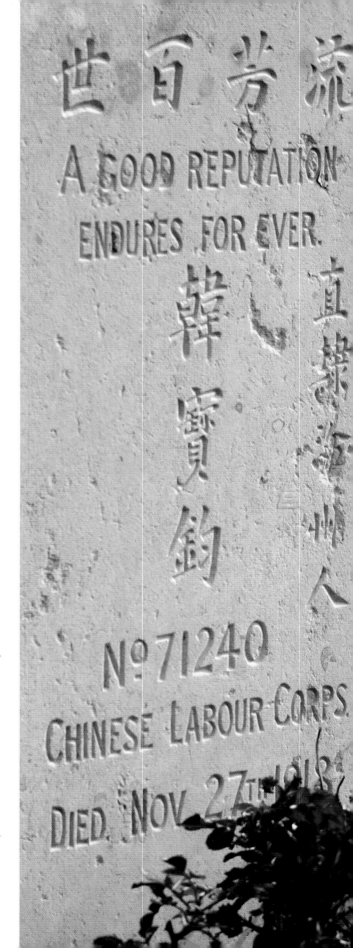

Arques-la-Bataille British Cemetery
Seine-Maritime, France

The South African Native Labour Corps came to France early in 1917 and No.1 General Labour Hospital was established at its camp at Arques-la-Bataille. Most of the burials in the cemetery, of which there are almost 400, are of men of the Corps, many of whom died at the hospital.

Right: The graves of members of the Chinese Labour Corps are engraved with one of four proverbs chosen by their comrades – *Faithful unto death*, *A good reputation endures forever*, *A noble duty bravely done* and *Though dead he still liveth*.

世百芳流
A GOOD REPUTATION
ENDURES FOR EVER.
李濬之　山東壽光縣人
Nº 67318
CHINESE LABOUR CORPS.
DIED. DECR 1918.

雖死猶生
THOUGH DEAD HE STILL
LIVETH.
張觀禮　山東黃縣人
Nº 71341
CHINESE LABOUR CORPS.
DIED. DECR 6TH 1918.

世百芳流
A GOOD REPUTATION
ENDURES FOR EVER.
何玉富　山東張山縣人
Nº 4164
CHINESE LABOUR CORPS.
DIED. MAX 13TH 1919.

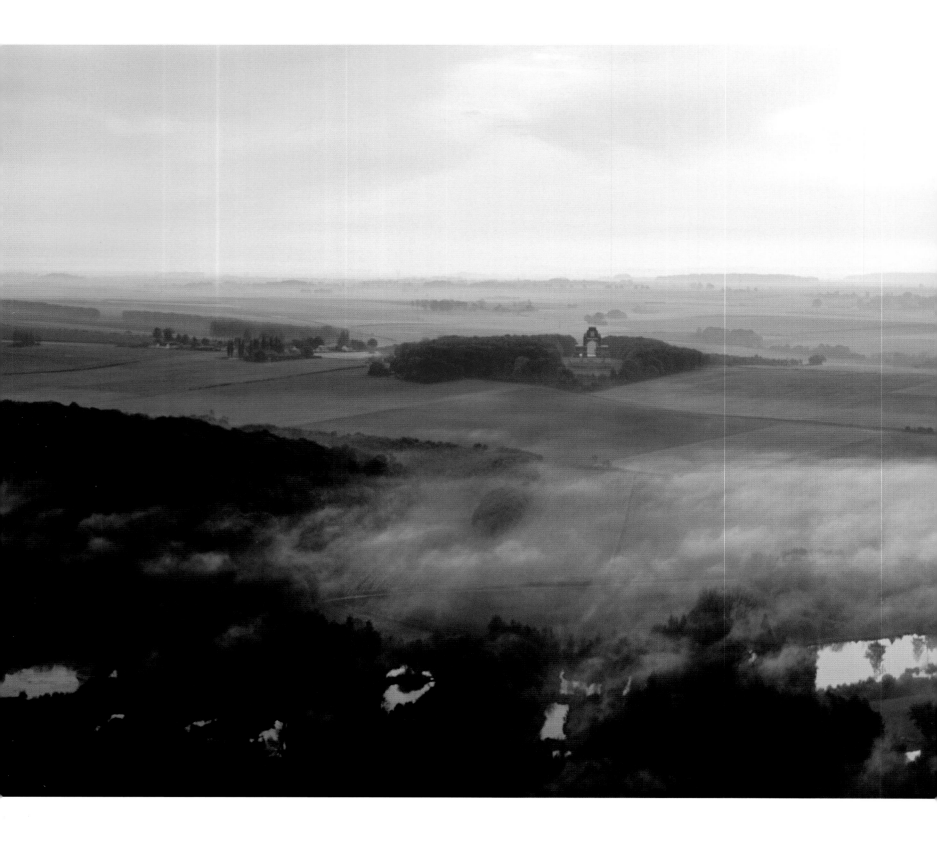

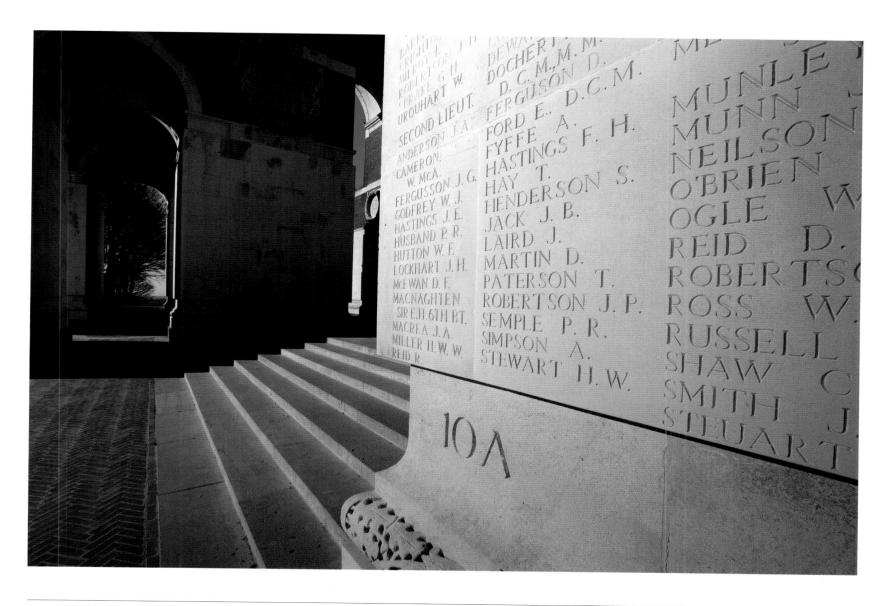

Thiepval Memorial
Somme, France

Described by architectural historian Gavin Stamp as 'the absolute, ultimate pure monument', the Thiepval Memorial, the Memorial to the Missing of the Somme, is the largest Commonwealth war memorial in the world. Designed by Sir Edwin Lutyens, the memorial bears the names of more than 72,000 officers and men of the United Kingdom and South African forces who died in the Somme sector before 20 March 1918 and have no known grave.

The Somme Offensive was the main Allied attack on the Western Front during 1916. The name 'Somme' will forever be remembered for the first day of the offensive, 1 July, when of the 120,000 British soldiers that took part, almost half became casualties, over 19,000 of them dead. By the time the offensive was called off in mid-November, the Commonwealth forces had suffered 420,000 casualties – 125,000 dead.

The river seen at the bottom of the photograph, left, is reported to have been an inspiration for J R R Tolkien in his writing.

Nieuport Memorial
West-Vlaanderen, Belgium

Celebrated British sculptor and decorated veteran of the Western Front, Charles Sargeant Jagger's three magnificent lions stand guard at each point of the triangular base of the Nieuport Memorial.

The memorial was designed by William Bryce Binnie, an Imperial War Graves Commission architect of 'immense ability', who had served with the Royal Highland Regiment during the war and was twice decorated for bravery.

The memorial commemorates more than 560 Commonwealth officers and soldiers who were killed in Allied operations on the Belgian coast during the First World War and have no known grave. Twenty of those commemorated served with the Royal Naval Division and were killed or mortally wounded during the siege of Antwerp in October 1914. Almost all of the remainder fell in heavy fighting in the region of Nieuport in the summer of 1917.

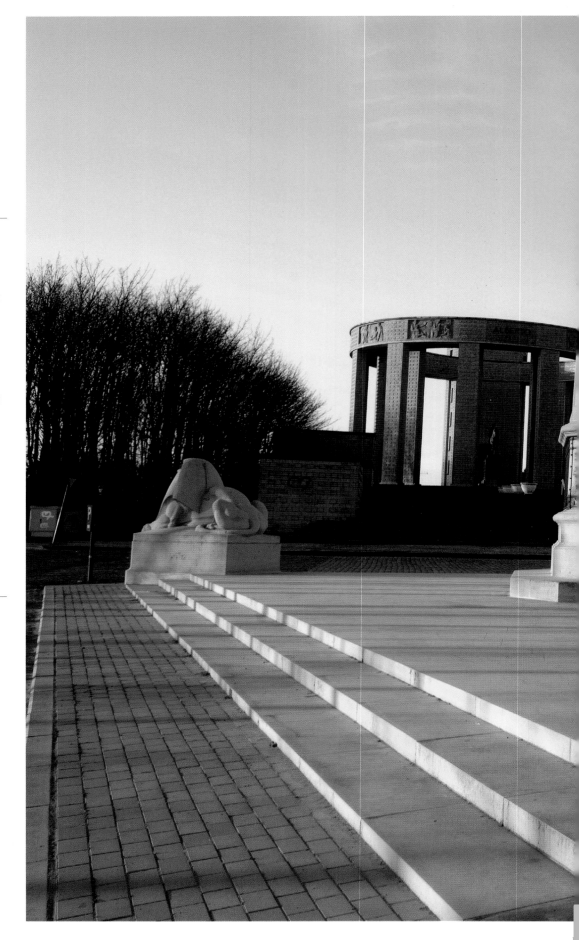

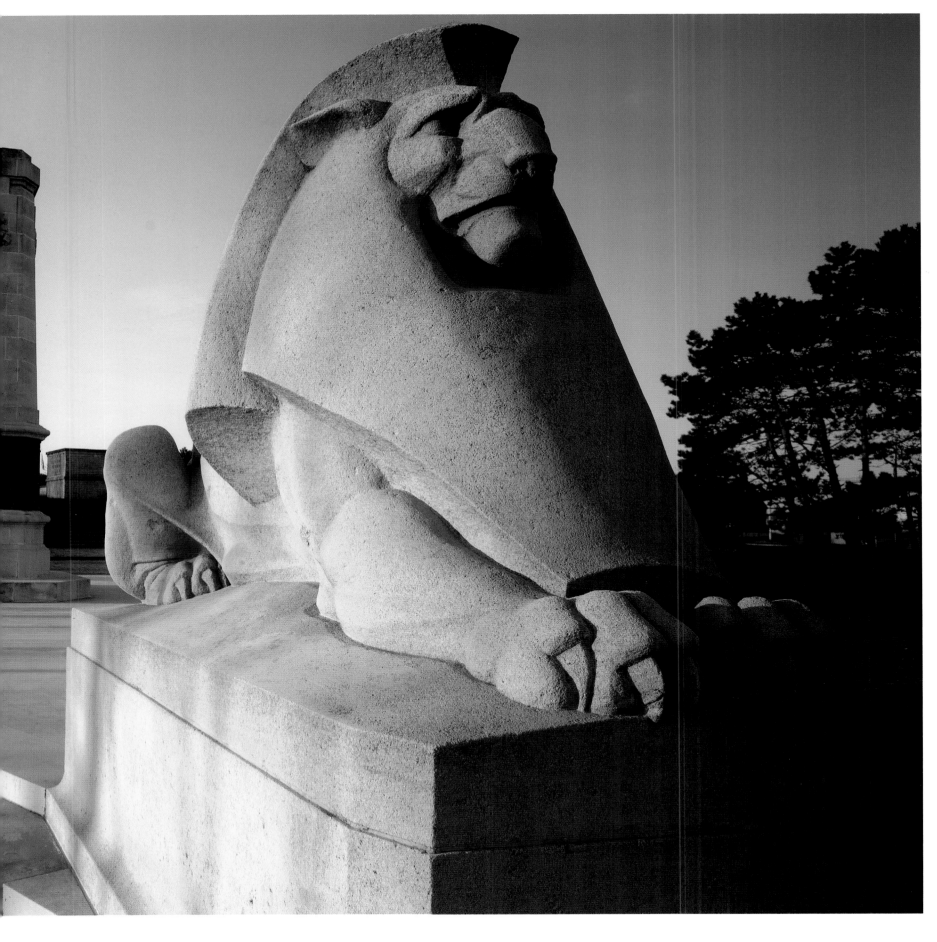

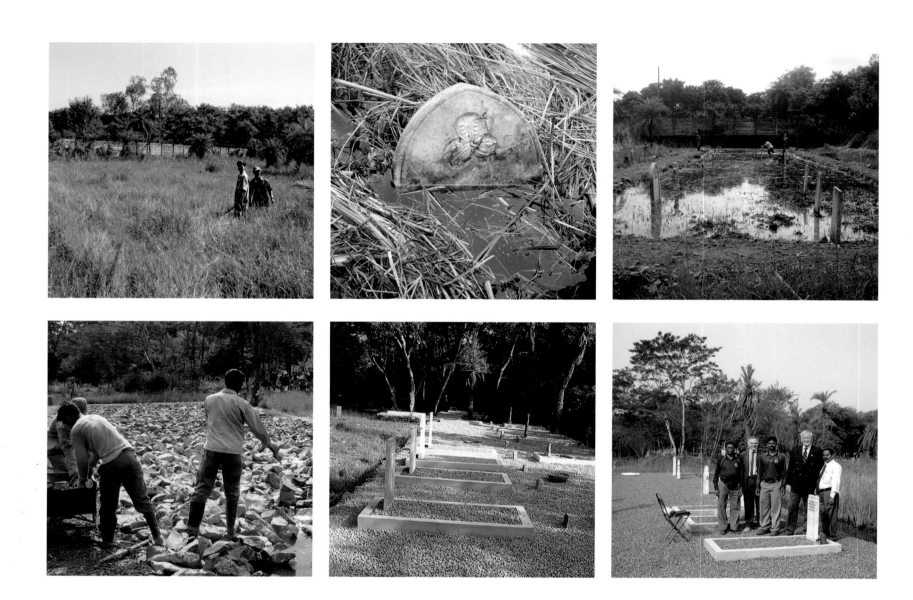

Caldecott Road Kirkee New Cemetery
India

The reinstatement of First World War isolated graves in India, known as 'Cantonment Graves', is a long-term project for the CWGC. At the time of India's independence, these graves, scattered in 131 remote locations across the country, were declared 'un-maintainable' – the 2,500 casualties commemorated instead on memorials in Chennai, Delhi and Kirkee.

Fifty years later, and with access now possible, the CWGC is reinstating these sites. To date, more than 90 of the original locations have been found and almost 2,300 graves securely marked.

The images above show the challenges posed by these sites. The first stage of the project involved physically locating the graves, before site clearance and permanent marking could take place. The transformation is quite remarkable.

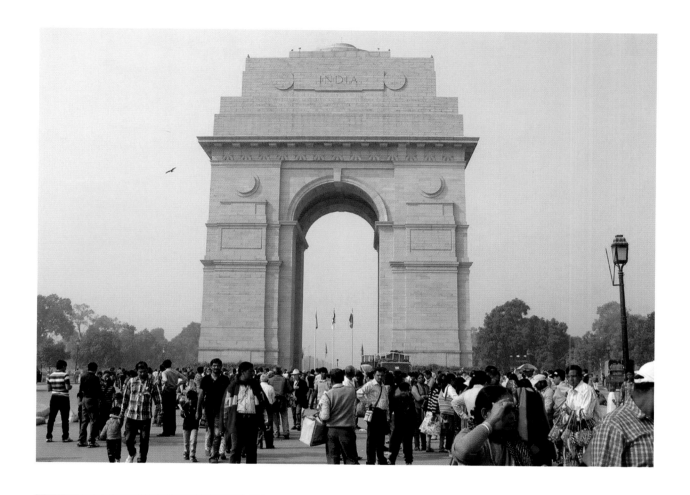

Delhi Memorial (India Gate)
India

Situated at the heart of Delhi, the Lutyens-designed India Gate is the national monument of India. It commemorates the 70,000 Indian soldiers who lost their lives during the First World War – the majority of whom are commemorated by name outside the confines of India.

The memorial also bears the names of more than 13,500 British and Indian soldiers killed in the Northwestern Frontier in the Afghan war of 1919.

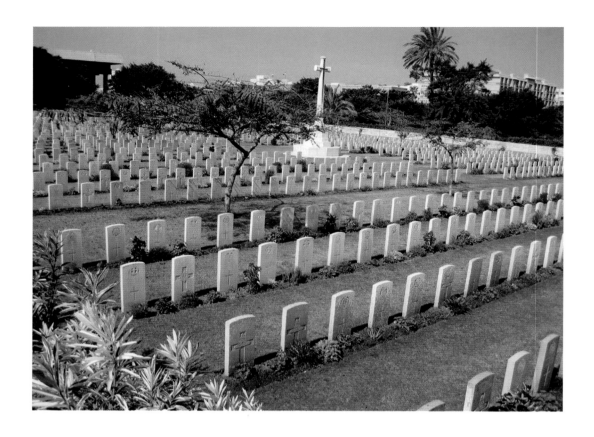

Alexandria (Hadra) War Memorial Cemetery
Egypt

In March 1915, the base of the Mediterranean Expeditionary Force was transferred to Alexandria from Mudros and the city became a camp and hospital centre for Commonwealth and French troops.

After the Gallipoli campaign of 1915, Alexandria remained an important hospital centre during later operations in Egypt and Palestine and the port was much used by hospital ships and troop transport ships bringing reinforcements and carrying the sick and wounded out of the theatres of war. This cemetery was begun in April 1916 and continued in use until December 1919. During the Second World War, Alexandria was again an important hospital centre, taking casualties from campaigns in the Western Desert, Greece, Crete, the Aegean Islands and the Mediterranean. The cemetery was extended and used from 1941.

There are now 1,700 First World War burials in the cemetery and over 1,300 from the Second World War.

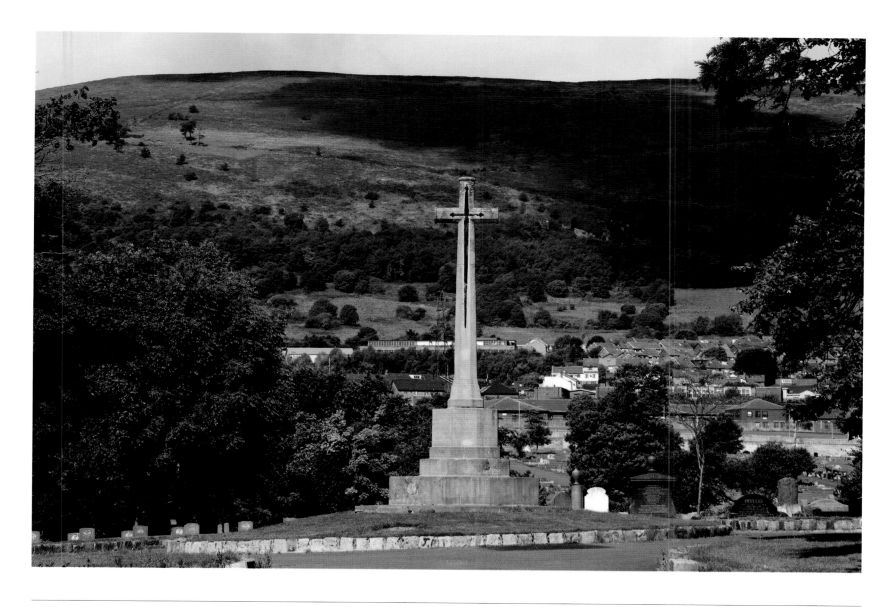

Belfast City Cemetery
County Antrim, Northern Ireland

In Belfast City Cemetery, the Cross of Sacrifice stands against the hills rising northwest of the city. In 1916 an area of the cemetery was dedicated to soldiers who died serving in the First World War. Almost 300 Commonwealth service personnel were buried there. Those whose graves could not be marked by headstones are listed on a screen wall memorial in Plot H.

More than 5,500 Commonwealth war dead are buried or commemorated at some 1,000 locations throughout Ireland. The majority are Irish casualties who died in the United Kingdom and whose bodies were taken home for burial by their families, but many are men who lost their lives in ships sunk in Irish waters and whose bodies were washed ashore. Around 210,000 Irishmen served in the British forces during the First World War, while many others of Irish descent served with the forces of other Commonwealth nations or those of America. As many as 50,000 Irishmen died in the war.

Haslar Royal Naval Cemetery
Hampshire, England

The 'Admiralty markers' in Haslar Royal Naval Cemetery reveal Gosport's long connection with the Royal Navy and are a stark contrast to the more common white gravestones. The No. 5 Squadron Royal Flying Corps – connected to the Haslar Royal Naval Hospital – was based here just before the outbreak of the First World War.

While many of the nearly 800 graves are scattered throughout the cemetery, 42 officers and men of HM submarine *L55* are buried collectively, with their names inscribed on a screen-wall memorial within the site. The *L55* was sunk in the Baltic Sea in 1919 by Bolshevik vessels while serving as part of the Allied intervention in the Russian Civil War. The submarine was raised in 1928 and the crew repatriated to the United Kingdom.

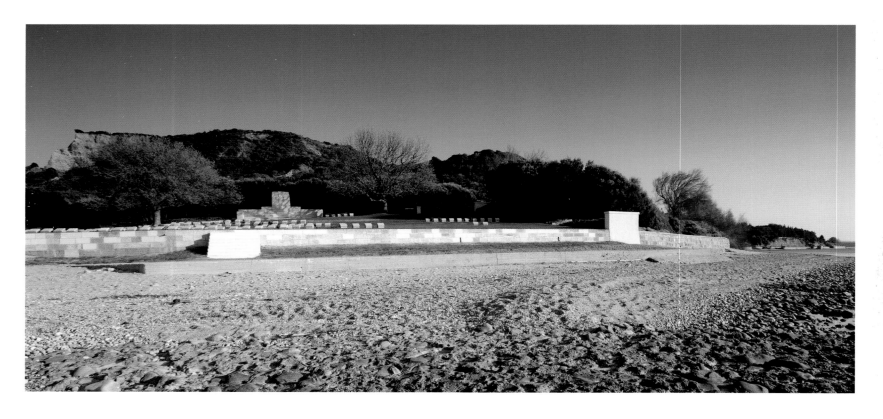

Ari Burnu Cemetery, Anzac
Gallipoli, Turkey

In the early hours of 25 April 1915, the Anzacs came ashore at Ari Burnu. The narrow beach was swept with machine-gun fire and there were heavy casualties.

Ari Burnu Cemetery contains over 250 burials. It is named after the promontory at the north end of Anzac Cove and was used throughout the occupation. In 1934 Atatürk wrote a tribute, right, to the Anzacs killed at Gallipoli:

Those heroes that shed their blood
And lost their lives...
You are now lying in the soil of a friendly country.
Therefore rest in peace.
There is no difference between the Johnnies
And the Mehmets to us where they lie side by side
Here in this country of ours...
You, the mothers,
Who sent their sons from far away countries
Wipe away your tears,
Your sons are now lying in our bosom
And are in peace
After having lost their lives on this land
They have become our sons as well.

Mustafa Kemal Atatürk, 1934

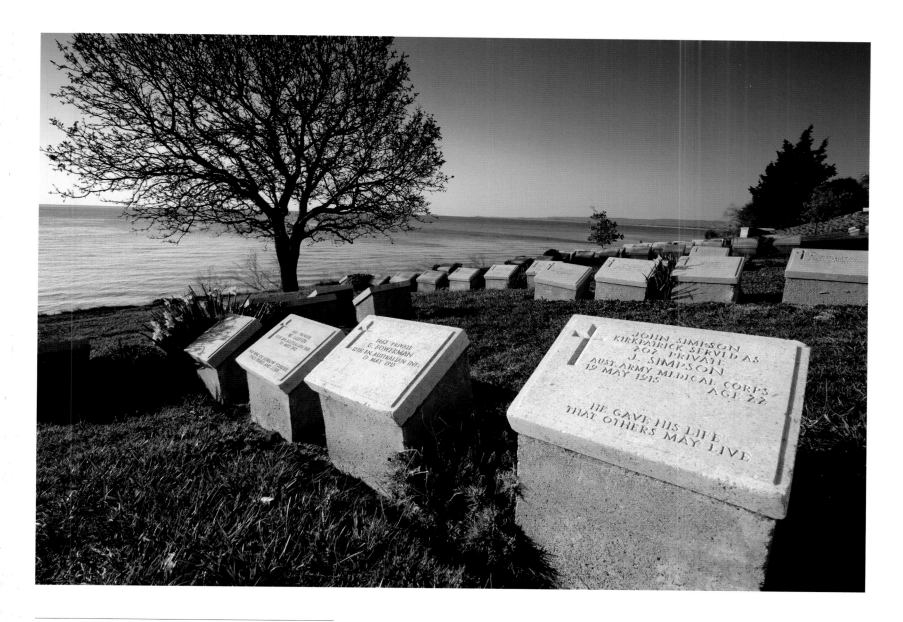

Beach Cemetery, Anzac
Gallipoli, Turkey

'He gave his life that others may live' is the inscription on
the grave of Private John Simpson Kirkpatrick. A stretcher
bearer with the Australian forces, Simpson obtained a
donkey and began carrying wounded soldiers from the front
line to the beach, for evacuation. He continued this work
for three and a half weeks, often under fire, until he and the
donkey were killed.

Croonaert Chapel Cemetery
Heuvelland, West-Vlaanderen, Belgium

South of Ypres, what was once a battlefield has now become
a peaceful farmland scene, the flat Belgian landscape giving
way to gently rolling hills. Croonaert Chapel was once a
shrine on the Wytschaete-Voormezeele Road. Before the
Battle of Messines in 1917, when Commonwealth forces
established Croonaert Chapel Cemetery here, it was located
in No Man's Land.

In October 1914, Adolf Hitler earned an Iron Cross 2nd
Class in an engagement near Croonaert Wood. During
the fighting and under heavy fire, Hitler helped rescue a
seriously wounded officer left out in the open.

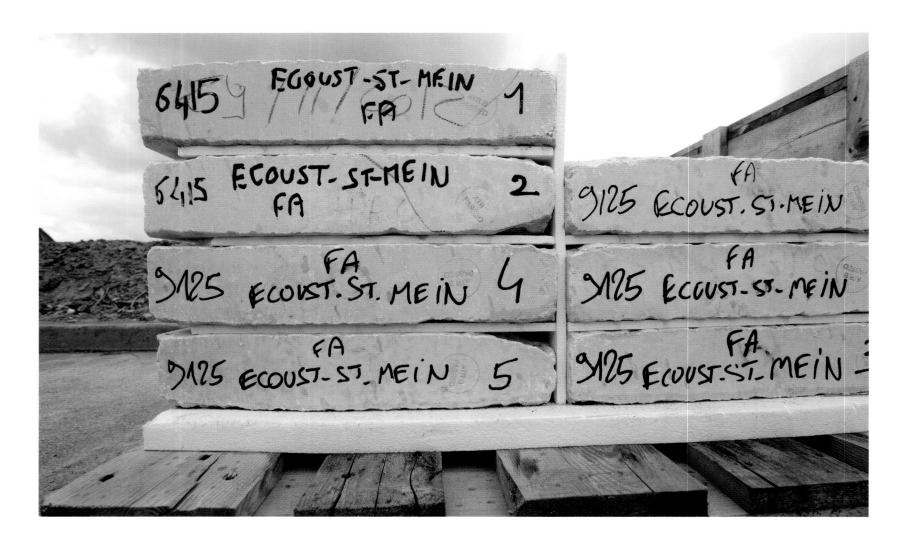

HAC Cemetery
Ecoust-St Mein, Pas de Calais, France

HAC Cemetery takes its name from the Honourable Artillery Company, the oldest regiment in the British Army. It was begun in April 1917 – the original burials in Plot I Row A – but was greatly enlarged after the war and now contains nearly 2,000 graves.

Almost 100 years after they were killed in action, Lieutenant John Harold Pritchard and Private Christopher Douglas Elphick of the Honourable Artillery Company were re-interred here on 23 April 2013. Seven unidentified soldiers were also re-interred. The remains of the soldiers were discovered during farming activities in August 2009 in Bullecourt. The service was attended by both Lt Pritchard's and Pte Elphick's families and HRH Prince Michael of Kent, who is Honorary Regimental Colonel of the Honourable Artillery Company.

Above: New headstones, manufactured at the Commission's offices in Arras, awaiting delivery to HAC Cemetery.

Right: Each year, approximately 20 sets of remains are found on the former Western Front. Each case is carefully investigated by the relevant government before the serviceman or woman is buried, with full military honours, in the closest CWGC cemetery.

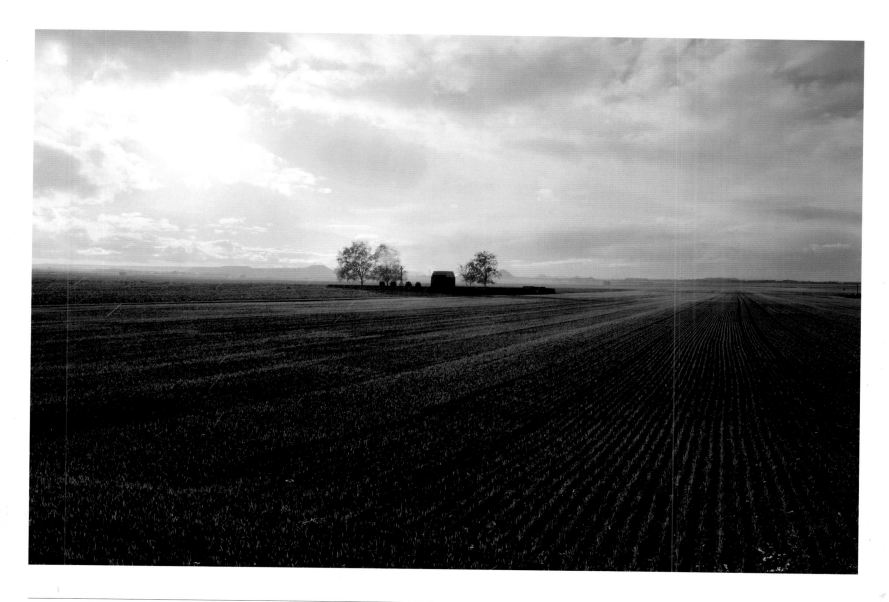

Bois-Carre Military Cemetery

Haisnes, Pas de Calais, France

Named after a small copse, Bois-Carre Military Cemetery was begun in
September 1915, and used largely by the 16th (Irish) Division until August
1916. It contains over 200 burials and has an irregular layout due to the
difficult conditions under which the graves were made – the cemetery being
close to the front line.

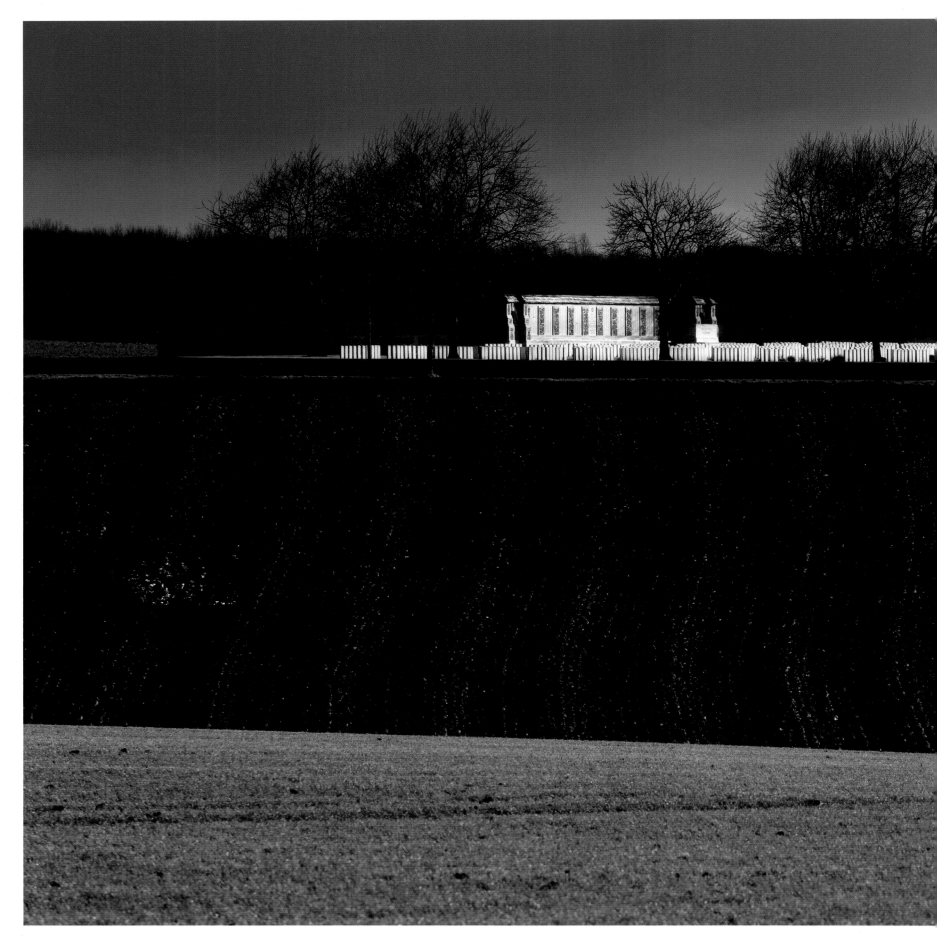

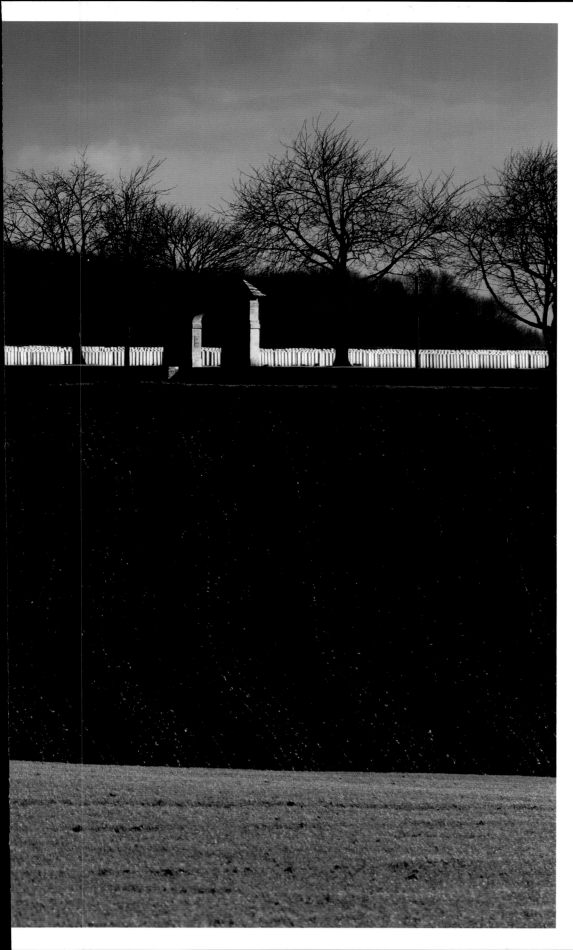

Caterpillar Valley Cemetery and New Zealand Memorial
Longueval, France

Caterpillar Valley was the name given by the army to the long valley that rises eastwards, past Caterpillar Wood, to the high ground at Guillemont. The cemetery was originally very small – just 25 graves – but was greatly enlarged after the Armistice. It now contains over 5,500 graves.

In November 2004, the remains of an unidentified New Zealand soldier were exhumed from this cemetery and entrusted to New Zealand. He was laid to rest within the Tomb of the Unknown Warrior at the National War Memorial in Wellington, New Zealand.

The memorial commemorates more than 1,200 officers and men of the New Zealand Division who died in the Battles of the Somme in 1916 and whose graves are not known. This image shows clearly the varying textures of the land and the uplands of the Somme.

More images of this cemetery overleaf

53

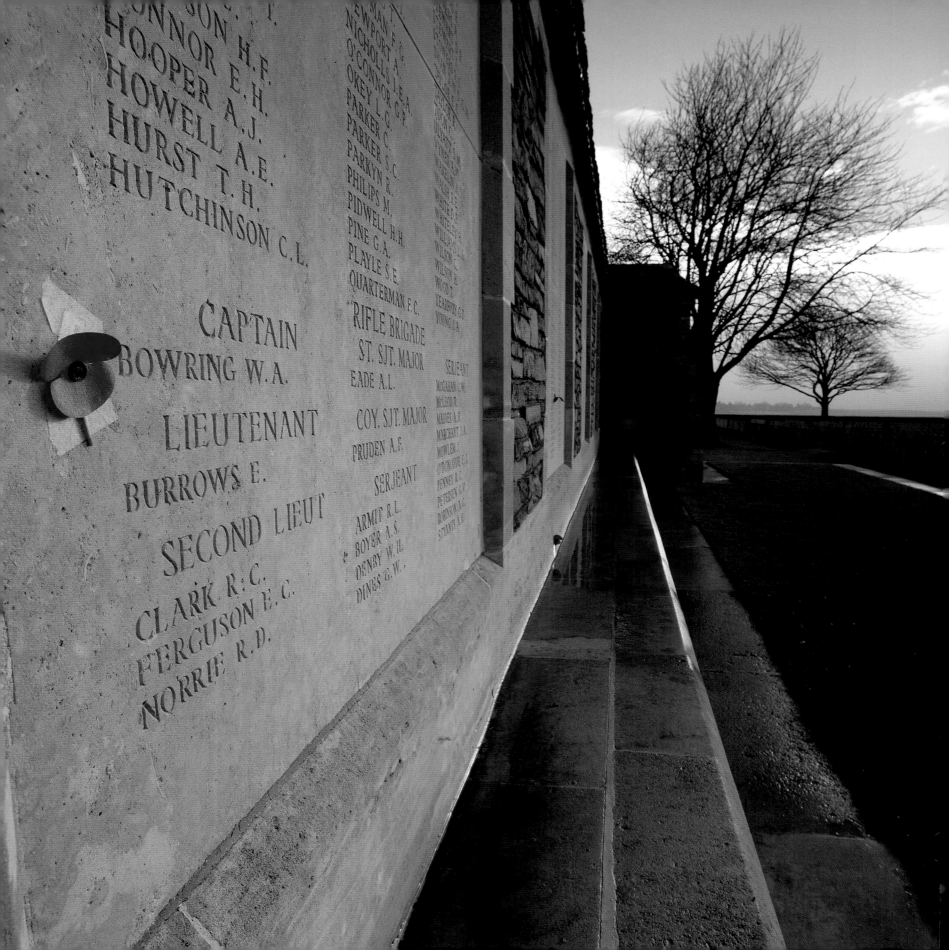

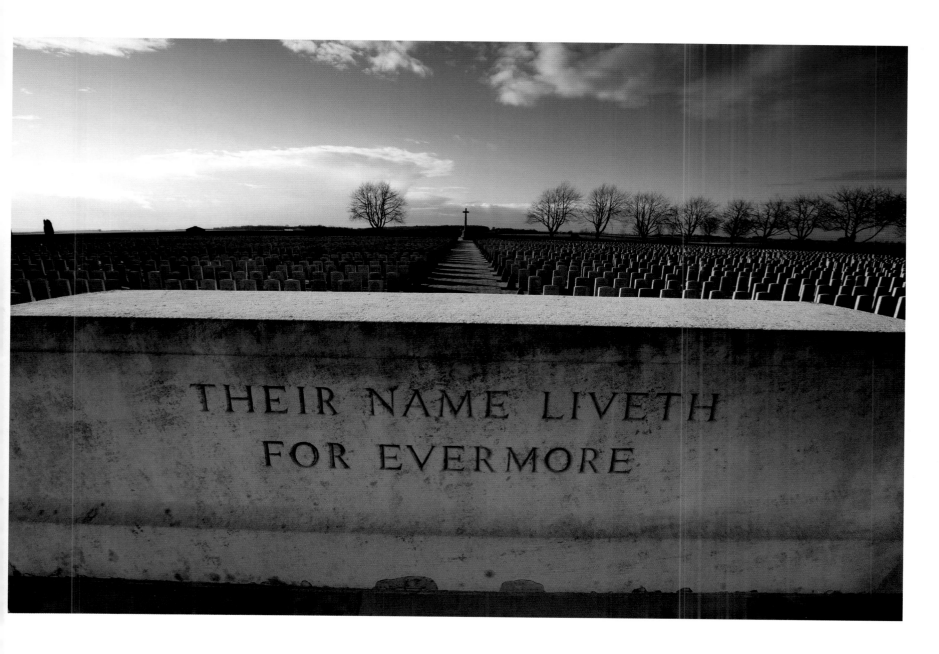

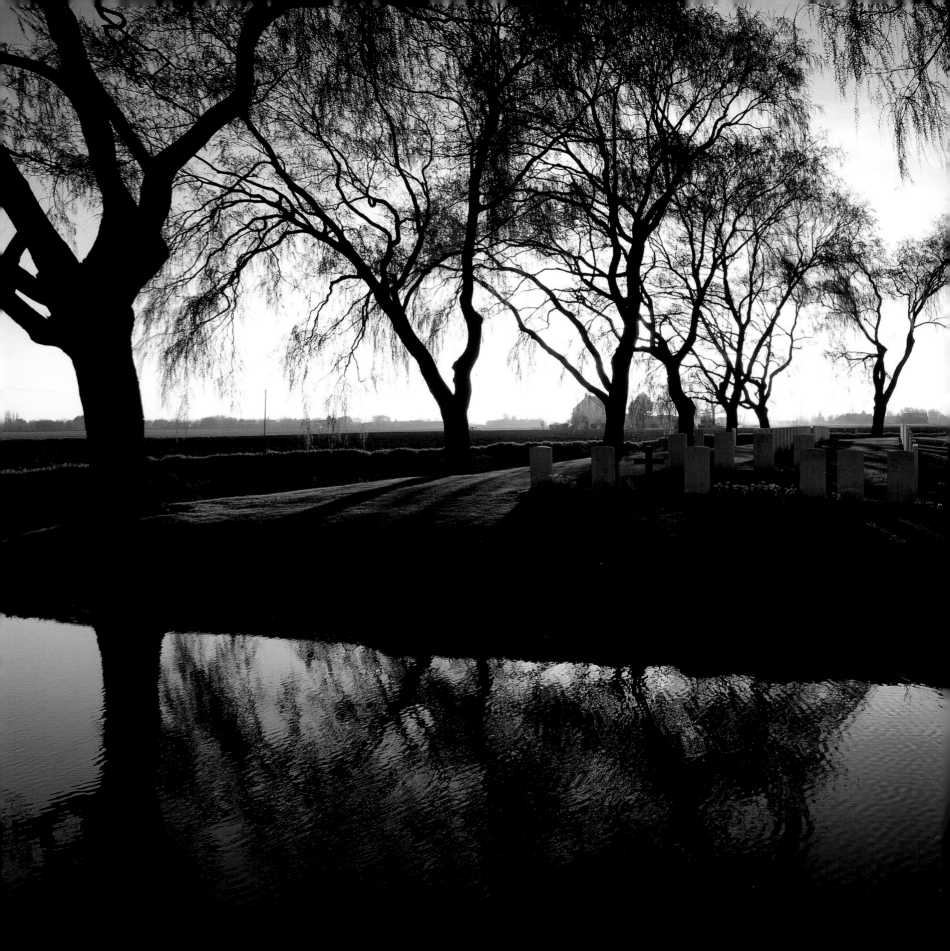

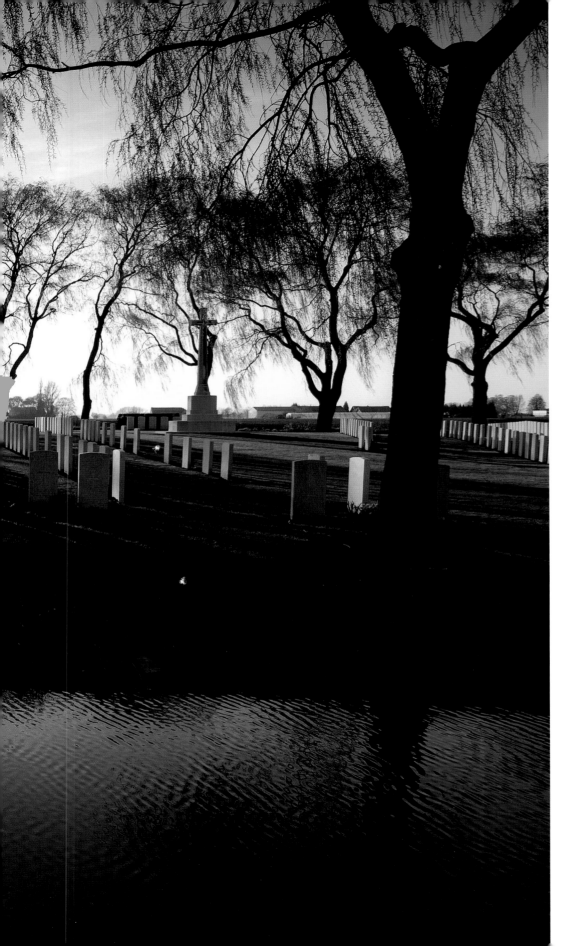

Le Trou Aid Post Cemetery
Fleurbaix, Pas de Calais, France

Thought by many to be one of the most beautiful Commonwealth cemeteries, Le Trou Aid Post is surrounded by a narrow moat and sheltered by weeping willow trees.

The cemetery was started in October 1914 when British soldiers serving in the Fleurbaix sector began burying their fallen comrades beside a regimental aid post and dressing station. It was located not far from the support trenches that led to the front line.

Le Trou now contains more than 350 burials.

Buttes New British Cemetery
Polygon Wood, Zonnebeke, West-Vlaanderen, Belgium

Spectral in the early morning light, Buttes New British Cemetery is connected to the adjacent Polygon Wood Cemetery by a walled avenue. The wood was the scene of fierce fighting throughout the war.

Rising above the cemetery, the final resting place for over 2,000 Commonwealth dead, is the Butte and the Fifth Australian Division's memorial – one of five dedicated to the divisions of the Australian Imperial Force who served on the Western Front. The bank on which it stands was previously a firing range. Despite heavy casualties, the Battle of Polygon Wood in September 1917 was the most decisive Australian victory on the Western Front.

The New Zealand Memorial, which stands in the cemetery, commemorates a further 378 New Zealanders who have no known grave. Most died in day-to-day occupation of the trenches hereabouts between November 1917 and February 1918.

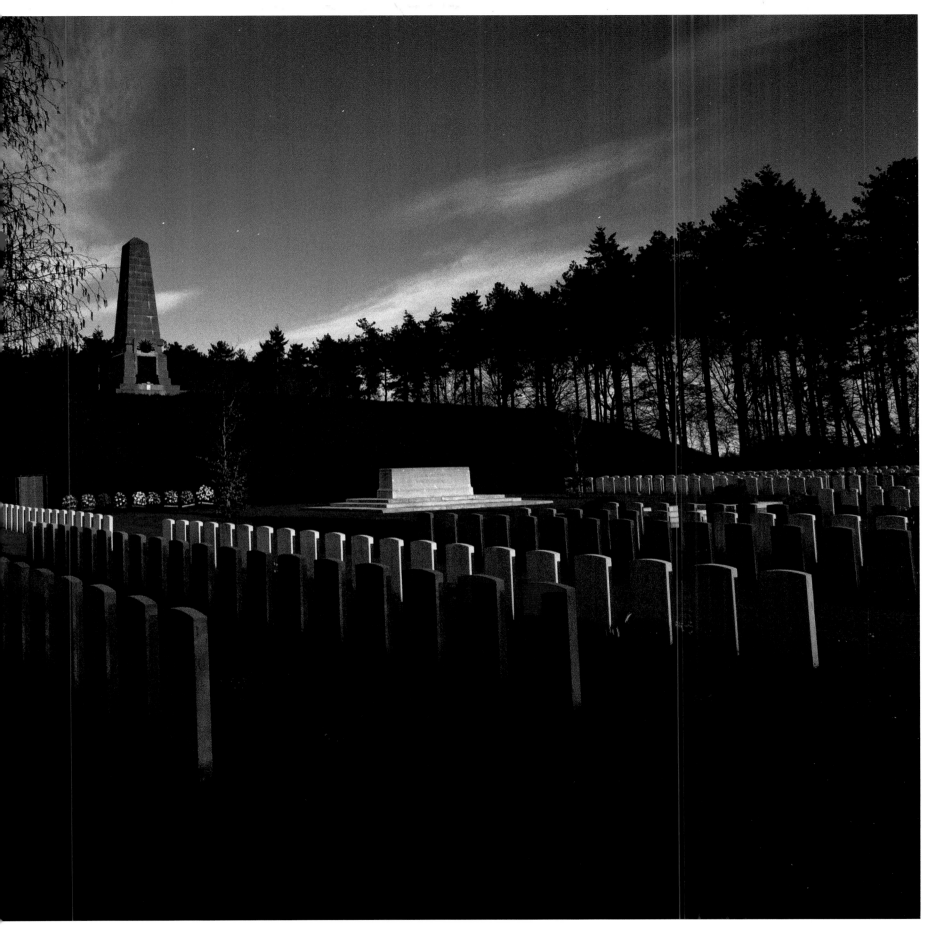

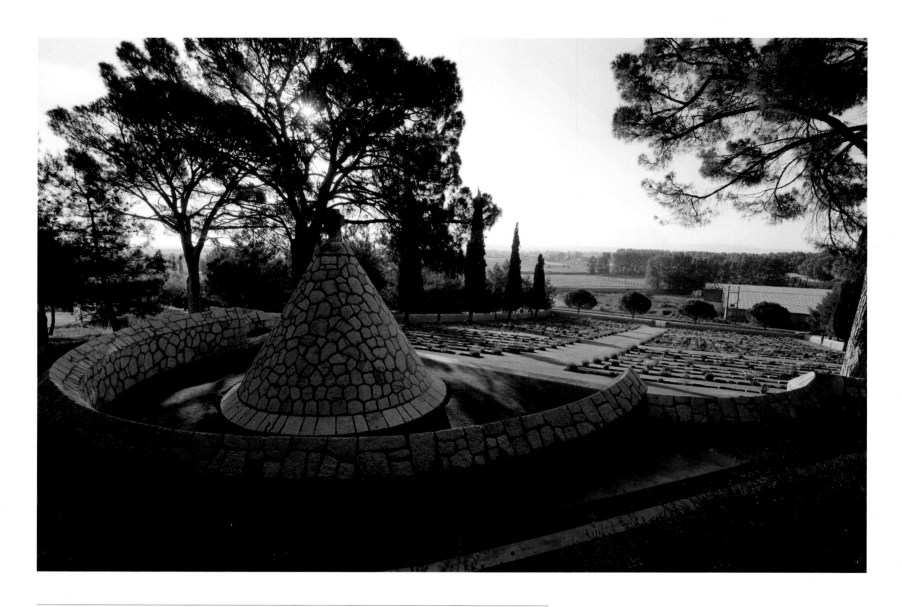

Karasouli Military Cemetery
Greece

Begun in September 1916, Karasouli Military Cemetery is the final resting place of more than 1,400 members of the Commonwealth forces who fought on the Macedonian front.

Originally used to bury those who had succumbed to wounds or sickness in nearby casualty clearing stations, it was later enlarged when graves were brought here from smaller cemeteries which lay at the foothills and ravines of the mountains around Lake Doiran. Many had names given by fighting troops: Horseshoe Hill, Whaleback, Worcester Post, Bastion Hill, Crow Hill, Kidney Hill, Scratchbury Hill and Christmas Ravine.

Doiran Military Cemetery
Greece

Two brigades of French and Commonwealth troops landed at Salonika in October 1915. Too late to avert Serbia's fall, they instead dug in and created a trench system to the north of the city.

For two years, members of what was known as the British Salonika Force fought skirmishes against the Bulgarian army along the front line, from Albania to the mouth of the River Struma in Greece. The chief enemy was sickness, on what was truly a 'forgotten front'.

By 1917, Salonika was home to an international force of around half a million men, famously dismissed by Georges Clemenceau as the 'Gardeners of Salonika'. In September 1918, the Allies launched an offensive, which finally broke through Bulgarian lines. By the end of the month, Bulgaria had become the first enemy power to sign an armistice.

The cemetery is the resting place of more than 1,300 Commonwealth servicemen, many of whom fell in September 1918 during the assault on Pip Ridge. Risk of earthquake means the CWGC must adapt its approach to commemoration, so the familiar upright headstones of French and Belgian cemeteries give way to pedestal markers.

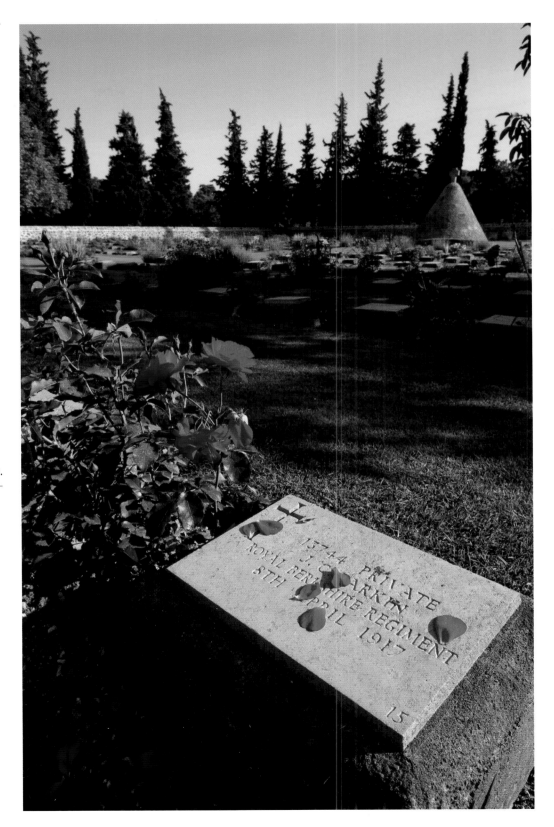

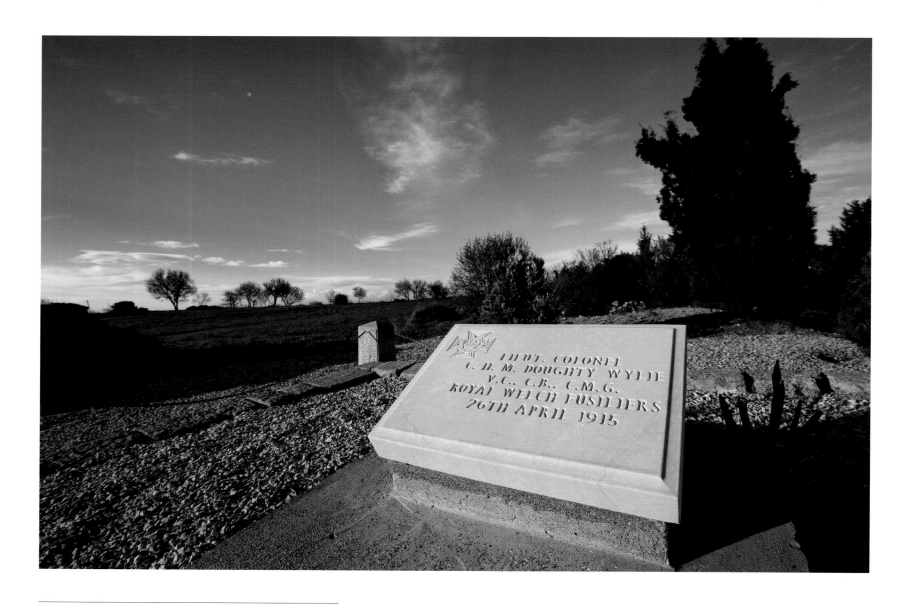

Seddel-Bahr Military Grave

Gallipoli, Turkey

The only grave of an Allied soldier to lie outside a war cemetery on the Peninsula, Lieutenant Colonel Charles Doughty-Wylie was a former British Consul to the Ottoman Empire. He was killed on the morning of 26 April by a sniper, while leading an attack on Turkish positions, and was posthumously awarded the Victoria Cross.

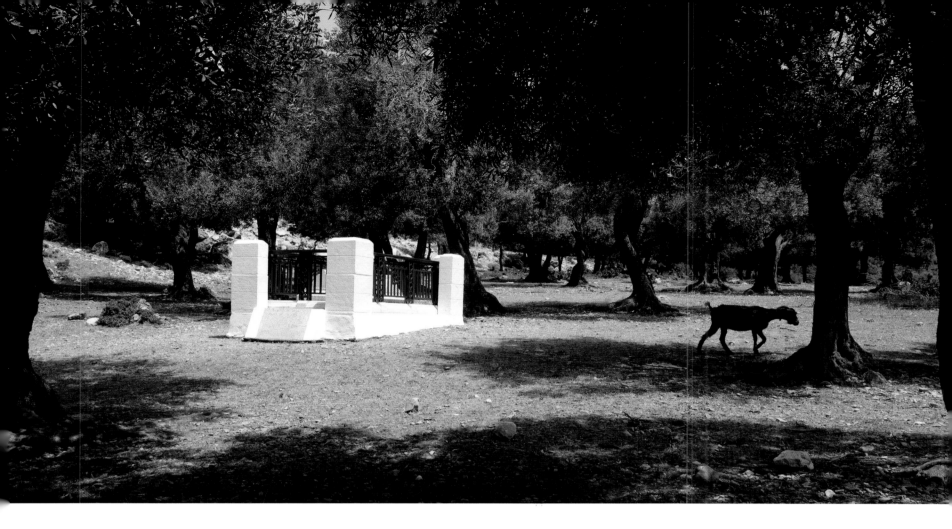

Rupert Brooke's Isolated Grave
Skyros, Greece

Rupert Brooke is perhaps best remembered for the opening lines of his poem 'The Soldier', right.
In many ways his words were prophetic – describing the function that Commonwealth war cemeteries
and memorials of the First World War have for many visitors.

Brooke sailed with the British Mediterranean Expeditionary Force on 28 February 1915, bound for
Gallipoli, but developed sepsis from an infected mosquito bite and died in the late afternoon of 23 April
1915 in a French hospital ship moored in a bay off the island of Skyros.

Brooke was buried that evening, in an olive grove on the island. The site was chosen by his close friend,
William Denis Browne, who wrote of Brooke's death:

*I sat with Rupert. At 4 o'clock he became weaker, and at 4.46 he died, with the sun shining all round his cabin,
and the cool sea-breeze blowing through the door and the shaded windows. No one could have wished for a
quieter or a calmer end than in that lovely bay, shielded by the mountains and fragrant with sage and thyme.*

If I should die, think only this of me:
That there's some corner of a foreign field
That is for ever England.

'The Soldier', Rupert Brooke

Grandcourt Road Cemetery
Grandcourt, Somme, France

Grandcourt was reached on 1 July 1916 by men of the 36th (Ulster) Division, but it was not taken until the night of 5/6 February 1917, when patrols of the Royal Naval Division found it deserted. It was in German hands again from April to August 1918.

The cemetery was made in the spring of 1917 when the Ancre battlefield was cleared. It now contains almost 400 burials and commemorations. Vehicle tracks, so clearly visible in this aerial view, show the care with which the land surrounding war cemeteries is farmed.

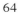

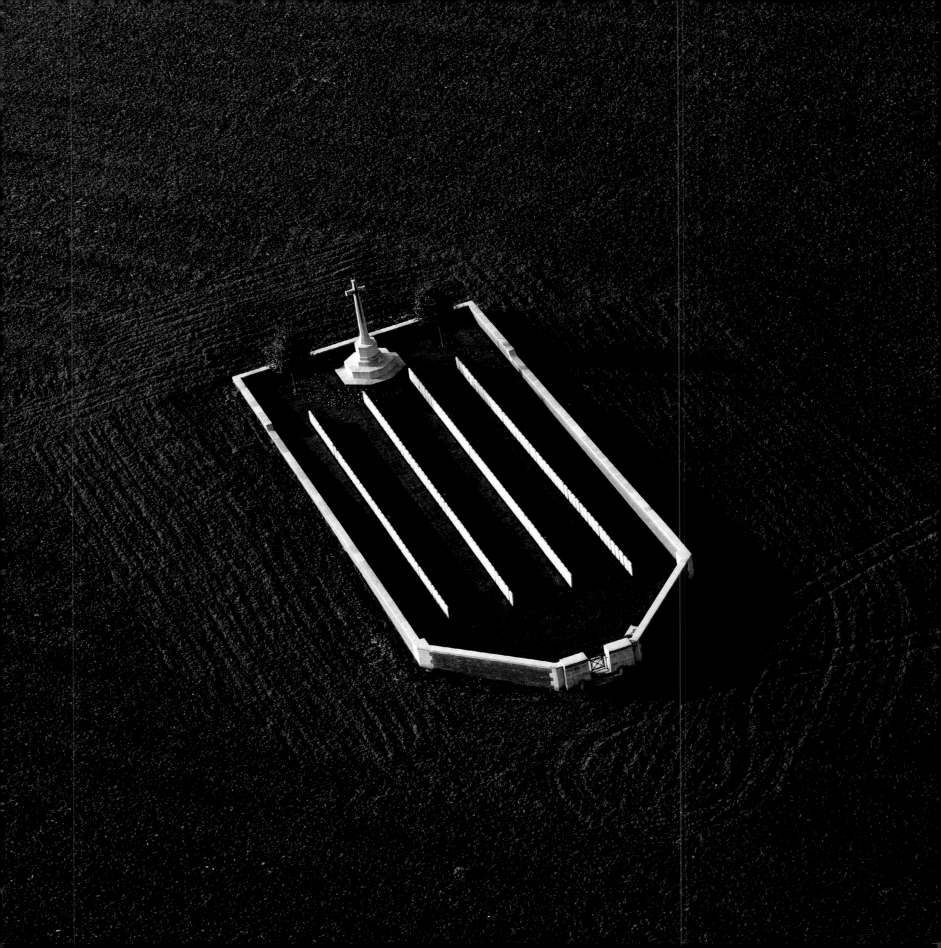

Voi Cemetery
Kenya

The origins of Voi Cemetery can be traced back to the burial of a civilian engineer (Mr O'Hara) in 1899, who was killed by one of the famous 'Man-eaters of Tsavo' lions.

During the First World War, Voi became a hospital centre and more than 100 burials were made in the cemetery. It now contains almost 140 Commonwealth burials of the First World War, one of which is unidentified.

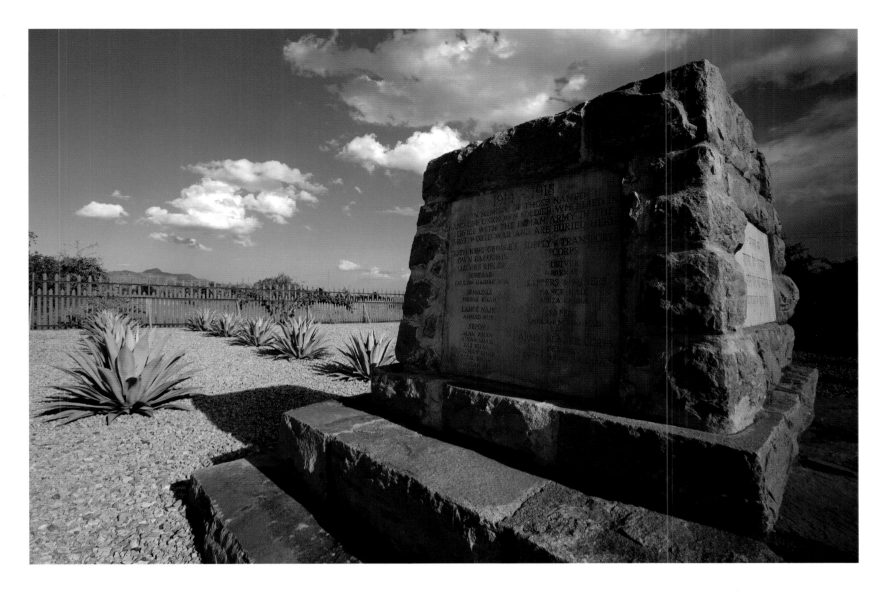

Maktau Indian Cemetery

Kenya

At Maktau a small British mounted force was ambushed and destroyed on 4 September 1915 and later a fortified camp, a reinforcement depot and an Indian clearing hospital were established here. The cemetery was used from March 1915 to May 1916 and contains just 16 graves.

I was struck by how different some of the cemeteries in Africa are to those in Europe – the CWGC adapting its approach to the local environment. I suspect the site is rarely visited but it is beautifully maintained.

Mike Sheil, photographer

Now God is in the strife,
And I must seek Him there,
Where death outnumbers life,
And fury smites the air

'A Mystic As Soldier', Siegfried Sassoon

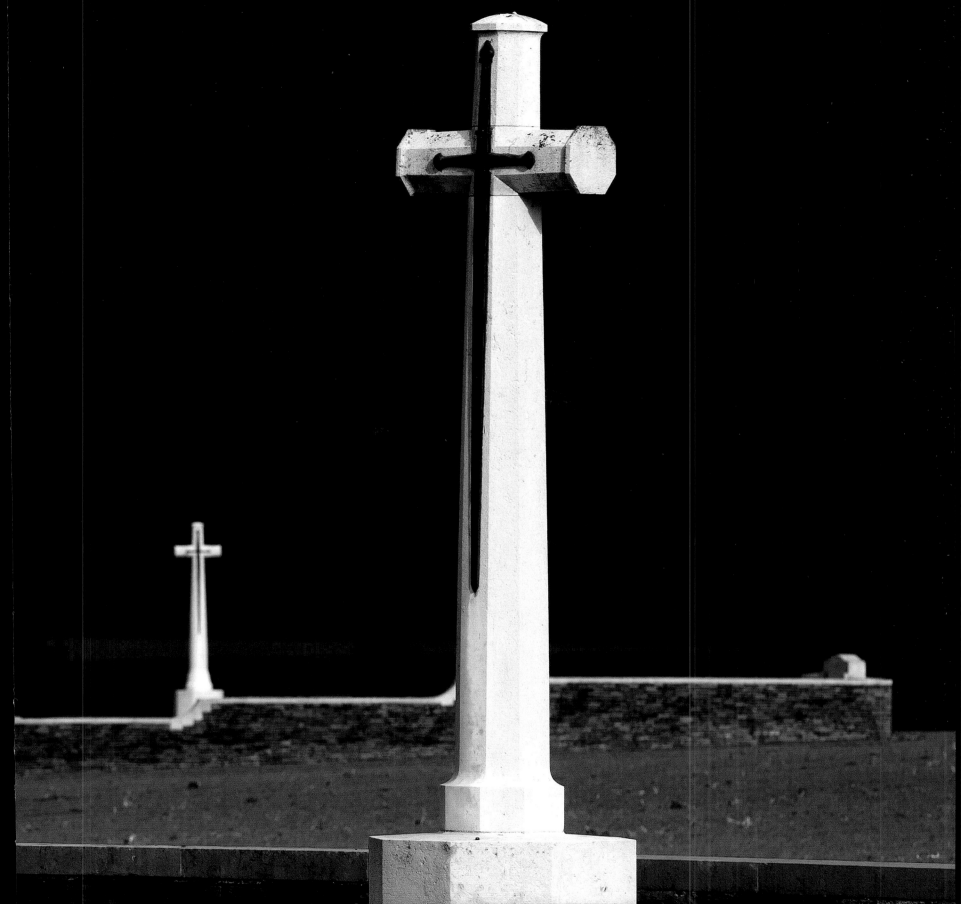

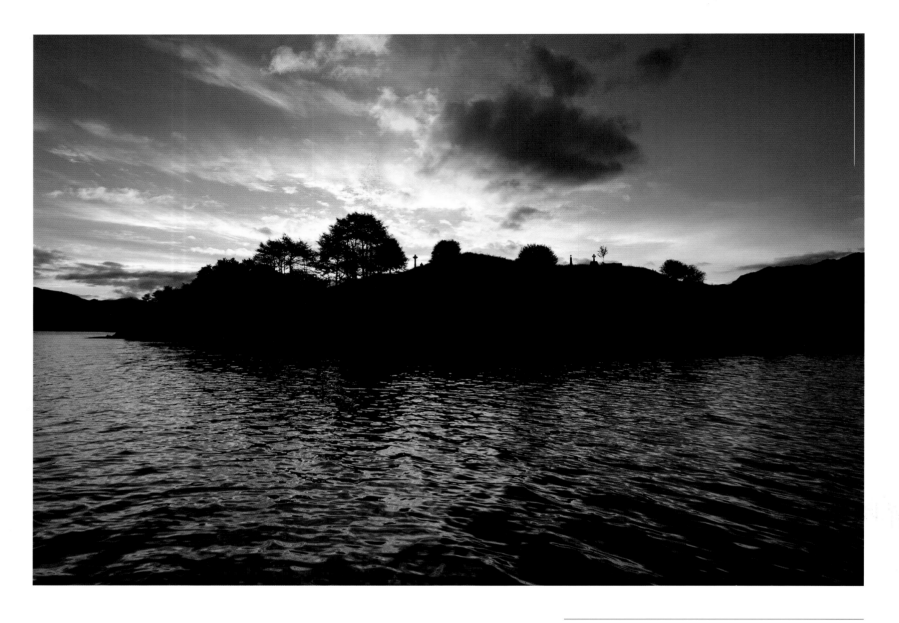

St Finnan's Isle Burial Ground

Inverness-shire, Scotland

St Finnan's Isle Burial Ground is on the tiny isle of
Loch Shiel. Known locally as the 'Green Isle', there is a
ruined chapel surrounded by ancient burial sites.
This ethereal location is the final resting place of
Deck Hand D Grant (facing page), who died on 30 May
1916 and lived just across the loch in the hamlet of Dalelia.
It is a unique place and remarkably evocative.

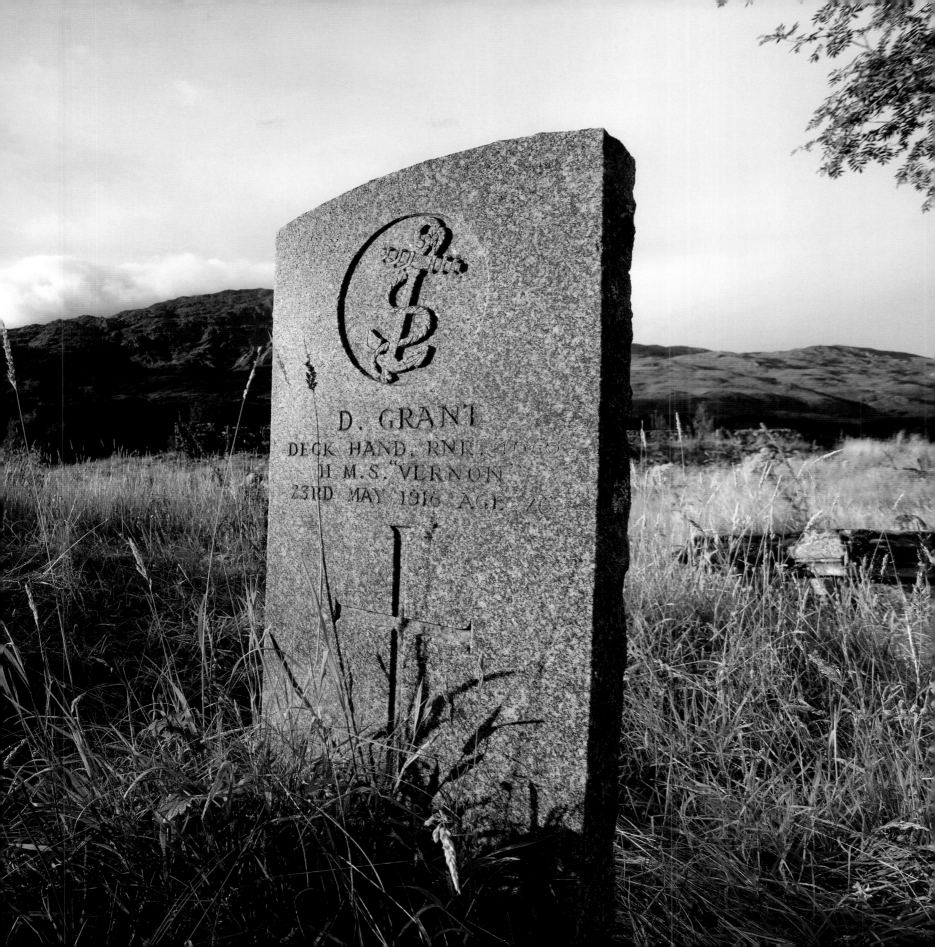

Etaples Military Cemetery
Pas de Calais, France

During the First World War, the area around the small fishing port of Etaples, known to your average Tommy as 'Eat apples', became the largest British military base in the world. Commonwealth army training and reinforcement camps and an extensive complex of hospitals occupied the sandy plains, dunes and fields.

Begun in May 1915, Etaples Military Cemetery is the largest Commonwealth war cemetery in France, with almost 11,000 burials. The Etaples base hosted as many as 20 hospitals by 1917, providing over 20,000 beds for sick and wounded men, along with specialist consultants and increasingly sophisticated treatment regimes. Those who could not be saved were buried on the hill facing the Channel, and home.

Of the vast complex of huts, roads, tents, rifle ranges, training facilities, ambulance parks, operating theatres, offices and cinemas that made up the Etaples base, only this cemetery remains. Among the many servicemen buried here are the graves of 20 women, including nurses, army auxiliaries and civilian volunteers of the YMCA and Scottish Church Huts organisations, killed in air raids or by disease.

By the latter part of the war, more than 2,500 women were serving at the Etaples base. Hailing from many parts of the British Empire, as well as France and America, they included ambulance drivers, nurses, members of the Voluntary Aid Detachment, and those employed by the Women's Army Auxiliary Corps in roles such as baker, clerk, telephonist and gardener.

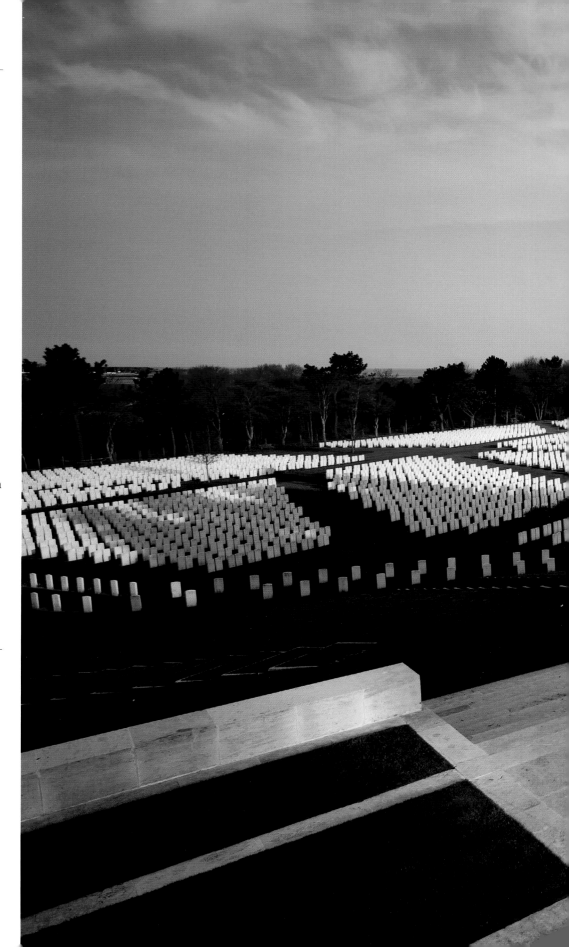

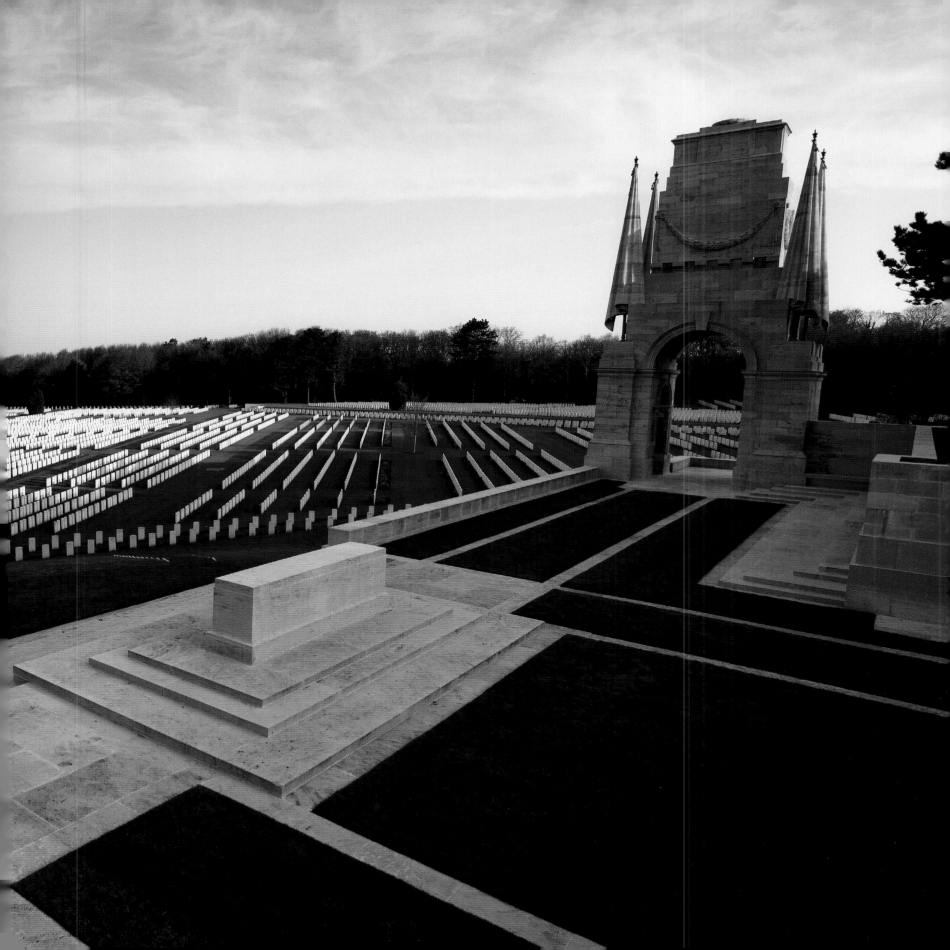

Dud Corner Cemetery
Loos, Pas de Calais, France

The name 'Dud Corner' comes from the large number of unexploded enemy shells found here after the Armistice (almost 30 per cent failed to go off). There were only five burials here originally but the cemetery now contains nearly 2,000 graves.

The bleak flat landscape of the Loos battlefield gives the modern visitor a glimpse of the difficulties the British army faced here during their attack on German positions in September 1915. Using poison gas for the first time, the British initially achieved success but losses on both sides were high.

With more than 20,000 dead, the Battle of Loos was instrumental in the dismissal of Sir John French as Commander-in-Chief of the British Expeditionary Force. He was succeeded by Haig in December 1915.

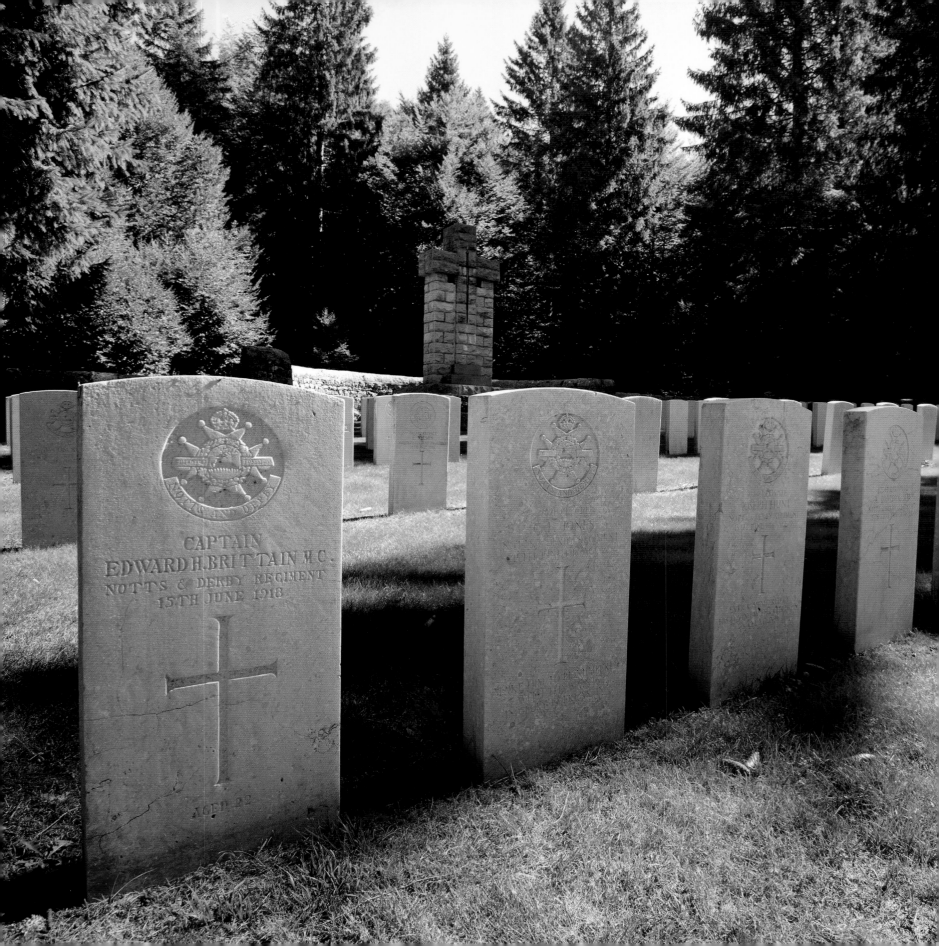

Granezza British Cemetery
Italy

Containing just over 140 First World War burials, Granezza is one of five Commonwealth cemeteries on the Asiago Plateau designed by the architect Sir Robert Lorimer. Although the cemetery is permanently open, deep snow makes it almost impossible to visit, except on skis, from November through to May.

The terrain and climate on the Italian front made fighting here particularly difficult. In 1918 the Austrians attacked in force and despite initial gains, were eventually defeated by an Allied force of Italian, French and British troops.

Edward, beloved brother of Vera Brittain, is buried here (far left). Her description of receiving the news of his death is incredibly moving:

June 15 1918
... there came the sudden clattering at the front door-knocker that always meant a telegram.

For a moment I thought that my legs would not carry me, but they behaved quite normally as I got up and went to the door. I knew what was in the telegram – I had known for a week ... I opened and read it in a tearful anguish of suspense.

'Regret to inform you that Capt. E H Brittain MC killed in action Italy June 15th.'

'No answer,' I told the boy mechanically and handed the telegram to my father who had followed me into the hall ...

Long after my family had gone to bed and the world had grown silent, I crept into the dining room to be alone with Edward's portrait ... He had been through so much – far, far more than those beloved friends who had died at an earlier stage of the interminable war, leaving him alone to mourn their loss ... And suddenly as I remembered all the dear afternoons and evenings when I had followed him on the piano as he played the violin, the sad searching eyes of the portrait were more than I could bear, and falling on my knees before it I began to cry, 'Edward! Oh, Edward!' in dazed repetition, as though my persistent crying and calling would somehow bring him back.

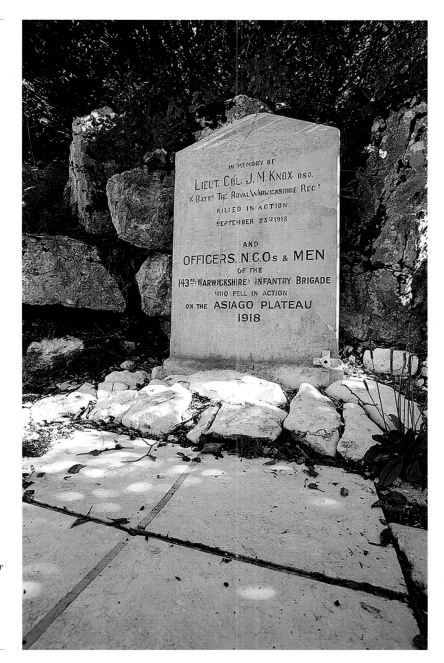

The Tomb of the Unknown Canadian Soldier
Ottawa National War Memorial Cemetery, Canada

In May 2000, the remains of an unidentified Canadian soldier who died in the First World War were repatriated from Cabaret Rouge British Cemetery in France and, with great ceremony, buried in a special tomb in front of the National War Memorial in Ottawa.

The Tomb of the Unknown Soldier was created to honour the more than 116,000 Canadians who sacrificed their lives in the two world wars and all Canadians, whether they be navy, army, air force or merchant marine, who died or may die for their country in all conflicts – past, present, and future.

Veterans Affairs Canada

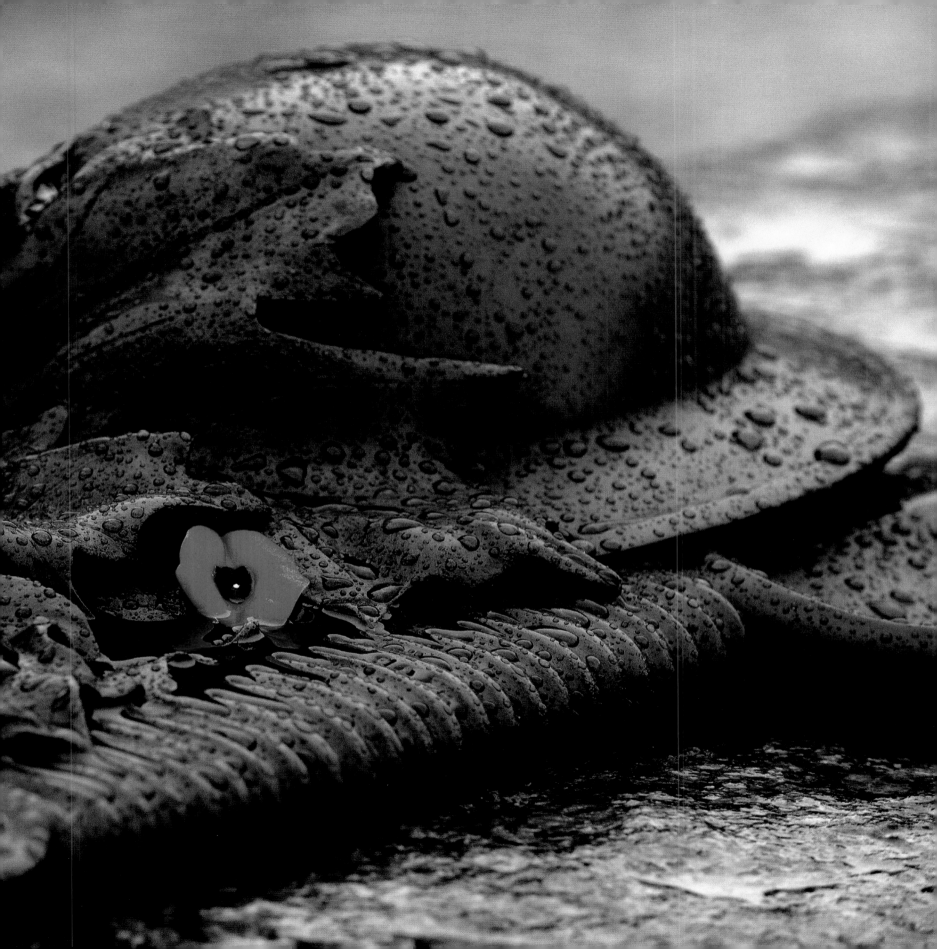

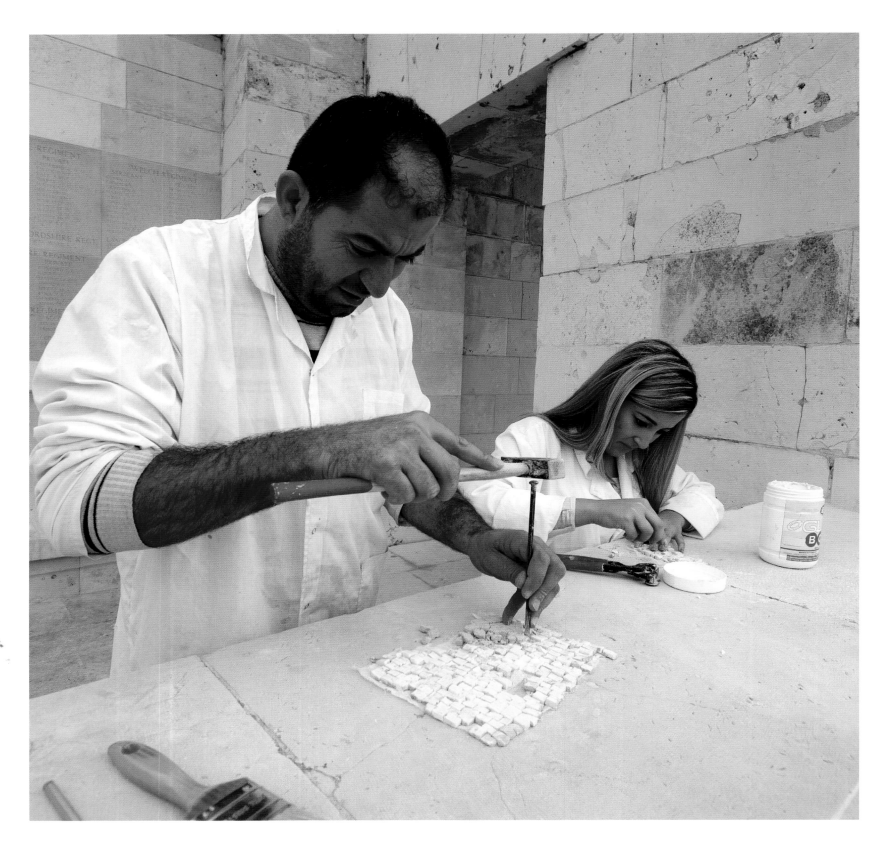

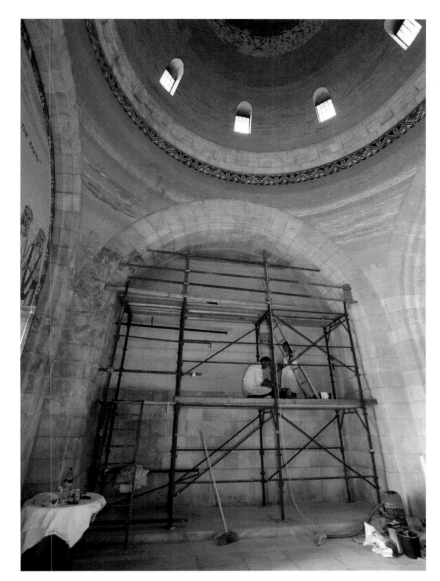
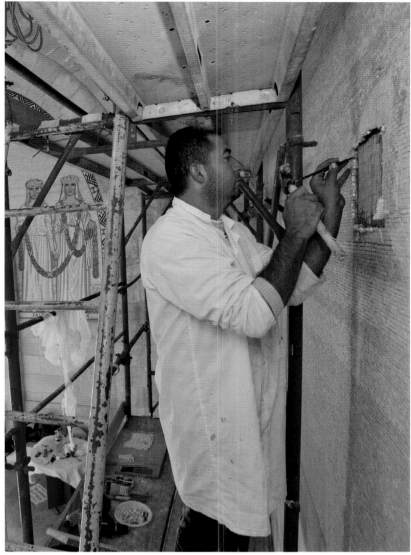

Jerusalem War Cemetery and Jerusalem Memorial

Israel and Palestine (including Gaza)

Almost 100 years after they were built, many of the Commission's memorials require increasing care. Here, specialists painstakingly restore the intricate mosaic, piece by tiny piece, that adorns the walls and ceiling of the Jerusalem Memorial.

The Jerusalem Memorial stands in Jerusalem War Cemetery. It commemorates 3,300 Commonwealth servicemen who died during the First World War in operations in Egypt or Palestine and who have no known grave.

It was designed by Sir John Burnet, with sculpture by Gilbert Bayes. The mosaic was designed by Robert Anning Bell, Professor of Design at the Royal College of Art in London. Among his work is the great mosaic in the tympanum at Westminster Cathedral.

Villers-Bretonneux Military Cemetery and Memorial

Somme, France

At 5.30am each Anzac Day, the Australian National Memorial at Villers-Bretonneux hosts a dawn service to commemorate the Australians and New Zealanders 'who served and died in all wars, conflicts, and peacekeeping operations.'

The memorial contains the names of over 10,000 Australians who died in France during the First World War and have no known grave. It consists of a large central tower flanked by two wing walls carrying the commemorative panels listing the missing.

The memorial was designed by Sir Edwin Lutyens and was the last to be completed by the CWGC. It was damaged during fighting in this area in the Second World War and some of these 'honourable battle scars' are visible on the memorial to this day.

They rest in peace, while over them all Australia's tower keeps watch and ward.

King George VI, July 1938

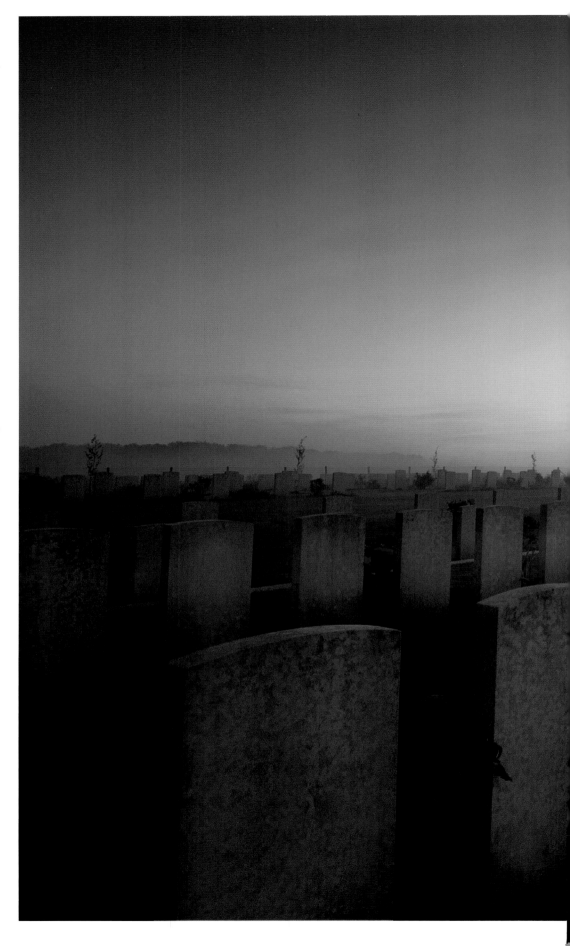

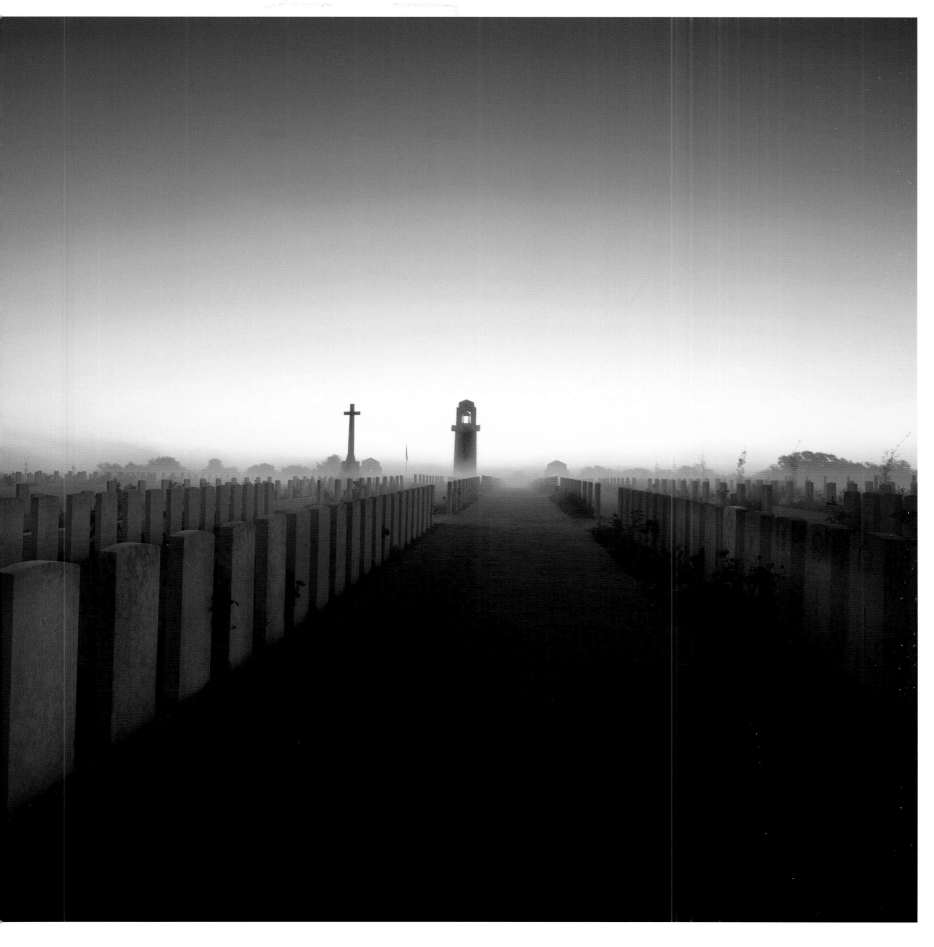

Lyness Royal Naval Cemetery
Orkney, Scotland

Craftsmen from the CWGC's United Kingdom Area replace headstone beams and erect new grave markers at Lyness Royal Naval Cemetery in Orkney. This work ensures the headstones remain legible and upright.

The cemetery was begun in 1915 when Scapa Flow was the base of the British Grand Fleet. Lyness remained as a Royal Naval base until July 1946 and the cemetery contains graves from both world wars.

There are almost 450 Commonwealth burials of the First World War – the majority are of officers, ratings, and members of the land forces lost from HMS *Hampshire*, *Vanguard*, *Narborough* and *Opal*.

The cemetery also contains the graves of 14 sailors of the German Navy – the High Seas Fleet was interned at Scapa Flow after the 1918 Armistice.

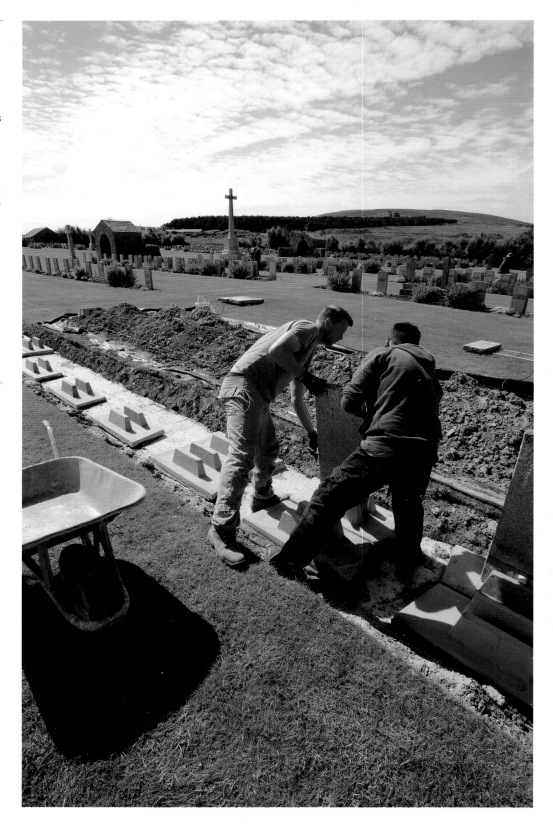

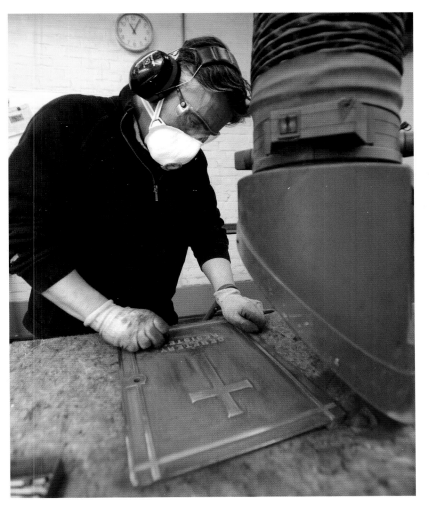

In the Workshop
Arras, France

A cemetery register box is rubbed down prior to re-bronzing. Register boxes are familiar features at war cemeteries and memorials. Rudyard Kipling, the Commission's first Literary Advisor, was the driving force behind the original registers. Each one contains a brief campaign history, details of the burials, a plan of the site and a book for visitors to sign.

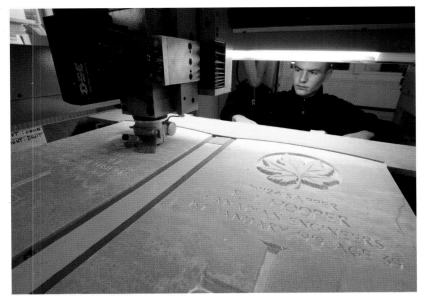

In the Workshop
Arras, France

Originally engraved by hand – a skilled stonemason might complete three headstones a day – the Commission's workshops in Arras use computer-controlled engraving machines to manufacture over 22,000 replacement headstones each year.

Mendinghem Military Cemetery

Poperinge, West-Vlaanderen, Belgium

Cemetery names often reflect the nicknames soldiers gave to trenches, buildings or topographical features. In the case of Mendinghem Military Cemetery (and the nearby cemeteries of Dozinghem and Bandaghem) the names given to the three casualty clearing stations around the Poperinge area reflect the dark humour of front-line troops, sometimes known as 'trench' humour.

Learning to 'read' a CWGC cemetery tells the visitor much about the events that unfolded here a century ago.

Headstone badges show the range of units and nationalities that took part; names and ages reveal the personal details of the fallen; dates of death might indicate a particular incident or engagement; and even the layout of the graves can reveal the circumstances under which burials were carried out.

The closeness of the grave markers here is common to cemeteries attached to dressing stations and reveals the sheer number of casualties these units often had to deal with – with time and numbers of dead necessitating the use of trench burials, with men laid next to one another, rather than individual graves.

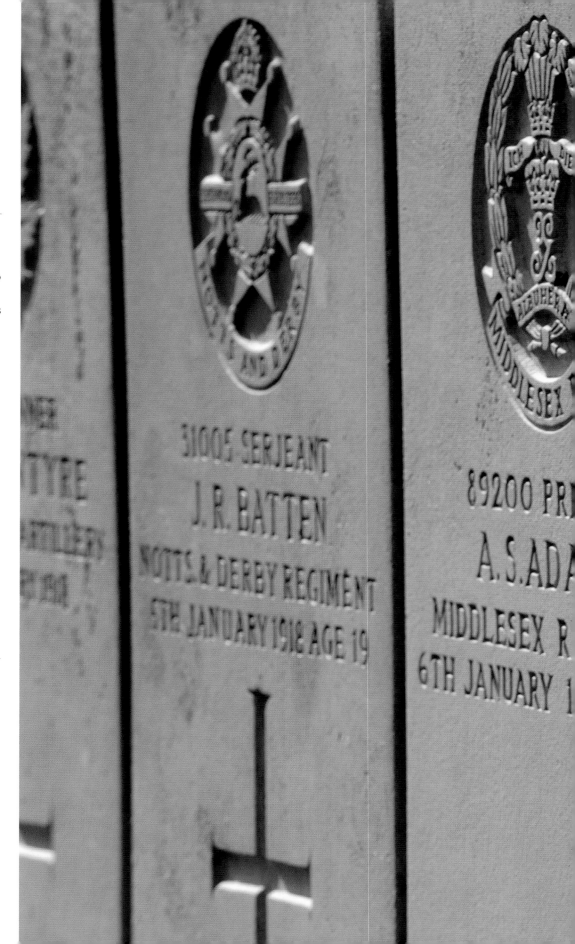

6799 PRIVATE
C. IVISON
MANCHESTER REGIMENT
5TH JANUARY 1918

185567 SAPPER
T. PARRY
ROYAL ENGINEERS
4TH JANUARY 1918 AGE 28

E 31

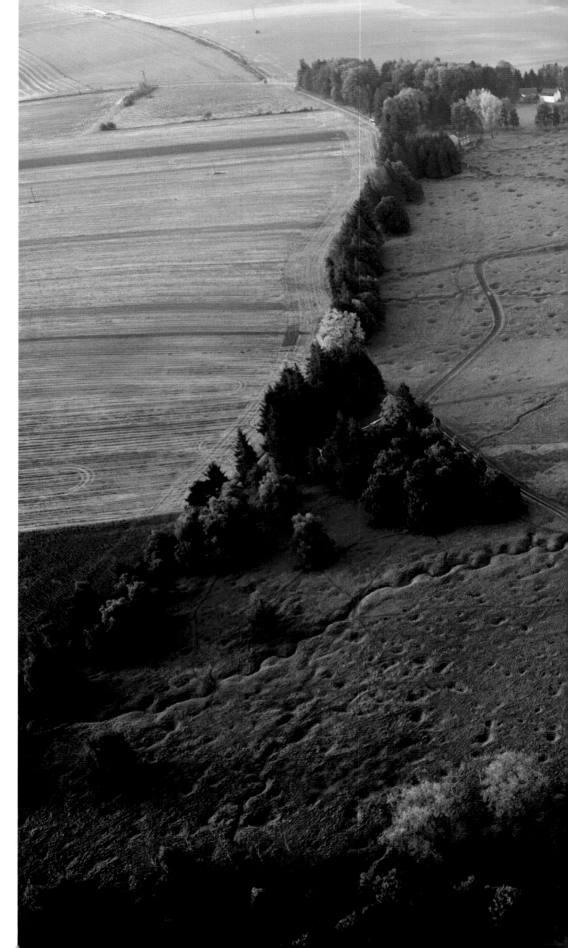

Beaumont-Hamel Memorial Park
Somme, France

This is one of the best preserved Great War sites left in France. The Park is a permanent memorial to the Newfoundland Regiment, which suffered huge losses here on the first day of the Battle of the Somme. Of the 800 men of the regiment who went into action on 1 July 1916, the roll call the next day revealed that 233 had been killed, 386 wounded, and 91 were missing. Such losses were devastating for the tightknit communities of Newfoundland.

The preserved trenches and battlefield terrain give the modern visitor an appreciation of the difficulties the men faced here in 1916. The memorial stands at the highest point of the park and consists of a great caribou cast in bronze, emblem of the Royal Newfoundland Regiment. At the base, three bronze tablets carry the names of over 800 members of the Royal Newfoundland Regiment, the Newfoundland Royal Naval Reserve and the Newfoundland Mercantile Marine, who gave their lives in the First World War and who have no known grave.

Within the Park are three Commonwealth cemeteries – Hawthorn Ridge No. 2, 'Y' Ravine and Hunter's – and two other Battle Memorials; those of the 51st (Highland) and the 29th Divisions. Hunter's Cemetery is visible in the bottom right of this photograph. Named after an army chaplain, it was a shell-hole in which were buried more than 40 soldiers of the 51st Division who fell in the capture of Beaumont-Hamel on 13 November 1916.

In a history of the Black Watch in the Great War, it states 'The chaplains, Gordon and Hunter, did splendid work on the days following the fight, searching the battlefield under continuous shellfire, and so well did they carry out this work that every missing man of the Battalion was accounted for.'

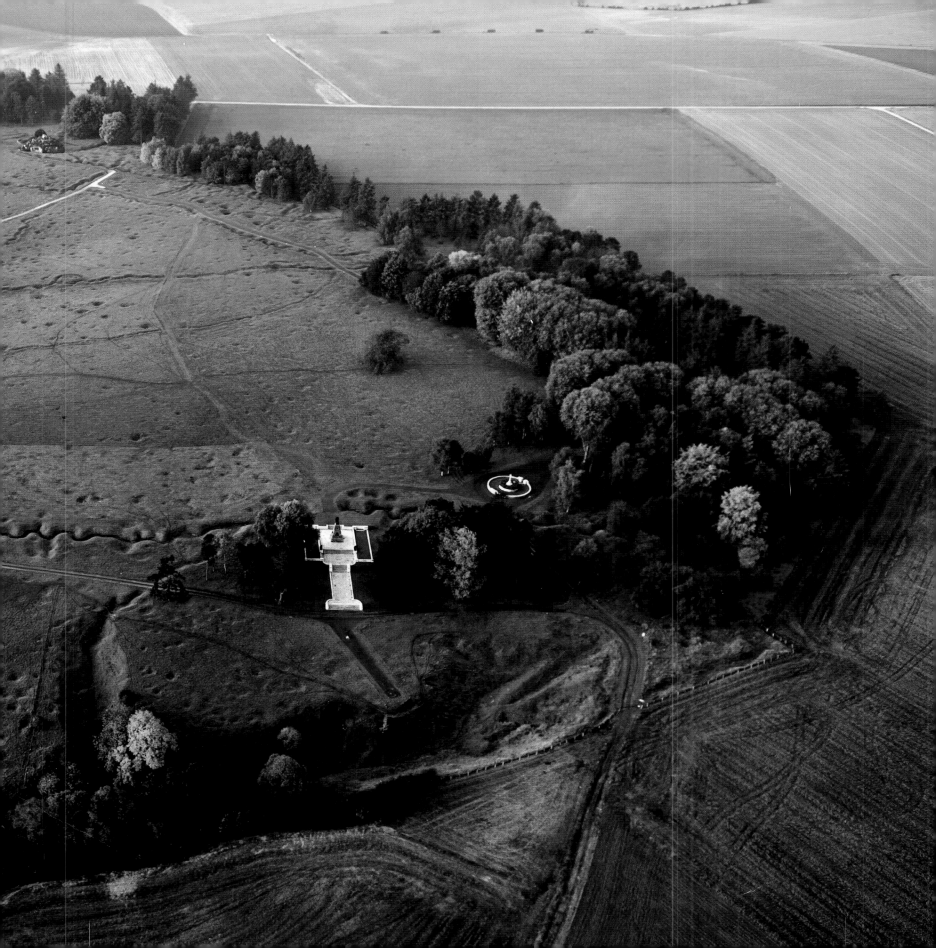

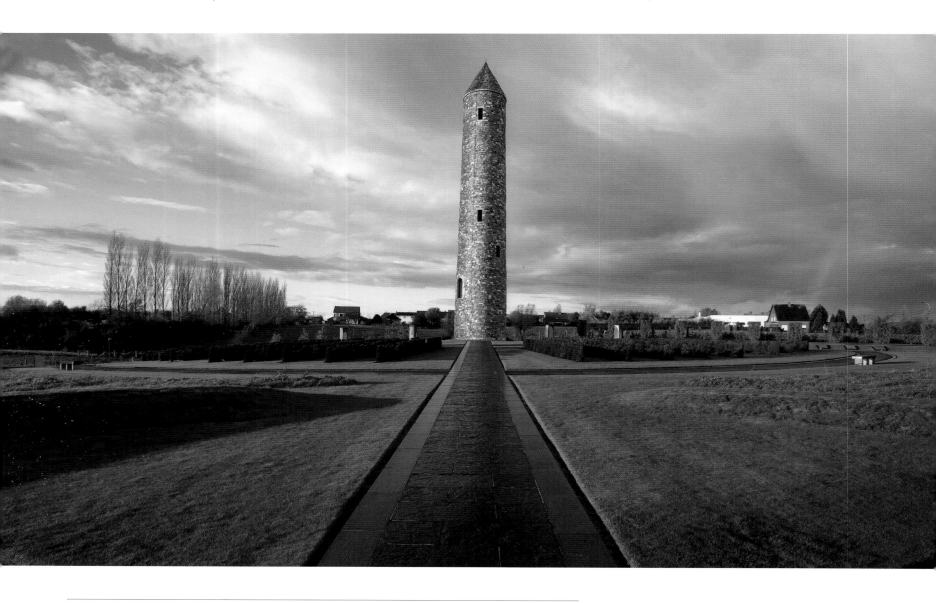

Island of Ireland Peace Park

Messines, West-Vlaanderen, Belgium

The Island of Ireland Peace Park in Messines is dedicated to the soldiers of Ireland, of all political and religious beliefs, who died, were wounded or went missing in the First World War.

The tower was built as a symbol of reconciliation. It is designed in such a way that the inside of the tower is lit by the sun only on the 11th hour of the 11th day of the 11th month – the exact time when the Armistice that ended the war came into force.

The park was officially opened on 11 November 1998 by the then President of Ireland, Mary McAleese, in the presence of HM Queen Elizabeth II and King Albert II of Belgium.

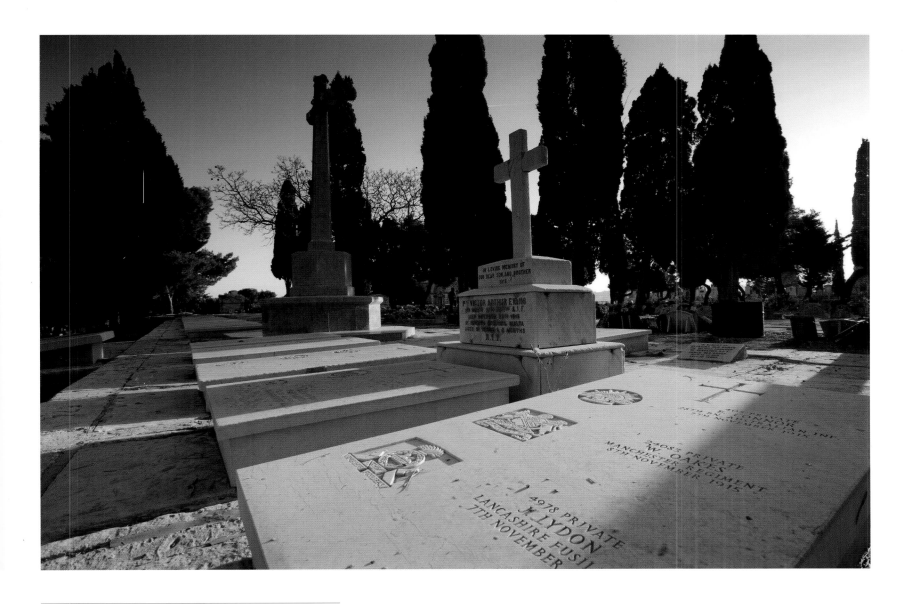

Addolorata Cemetery
Malta

The shallow earth on Malta resulted in an unusual form of commemoration for Commonwealth war dead. Collective burials were made, due to the fact that graves had to be cut into the underlying rock. Most of the graves are marked by recumbent markers bearing several carved inscriptions, and for the sake of uniformity, the same type of marker was used for single graves. The cemetery contains 250 Commonwealth burials of the First World War and 18 from the Second World War.

Brancourt-le-Grand Military Cemetery
Aisne, France

In April 1917, America entered the First World War, bringing her enormous reserves of manpower and industry to the Allies. By the Armistice, more than two million American soldiers had served on the Western Front, and some 50,000 of them had lost their lives.

Although no American servicemen are buried here, Brancourt-le-Grand was captured on 8 October 1918 by the 30th American Division and the 301st American Tank Battalion.

The cemetery was made behind a German cemetery (no longer there) in October 1918 and contains over 40 graves. This is quite a 'typical' CWGC cemetery in terms of style and layout.

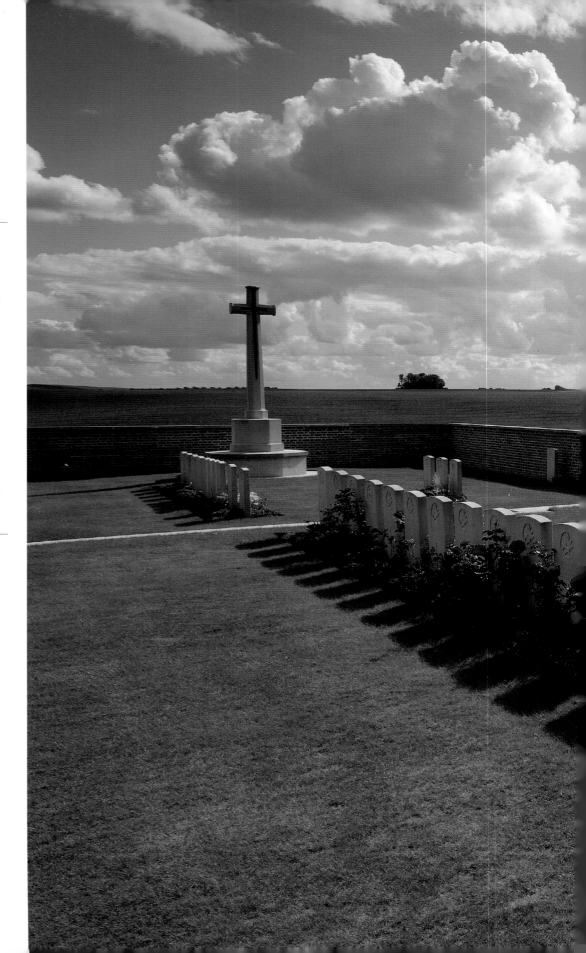

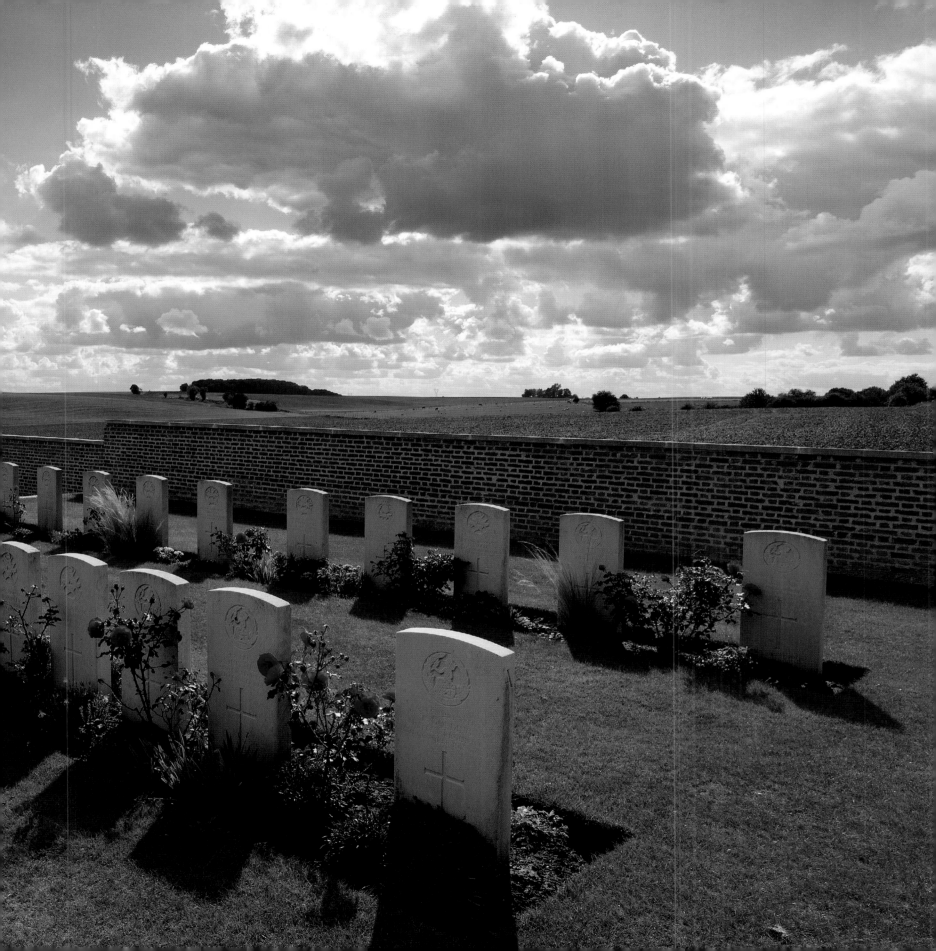

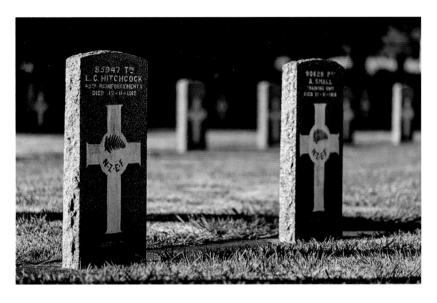

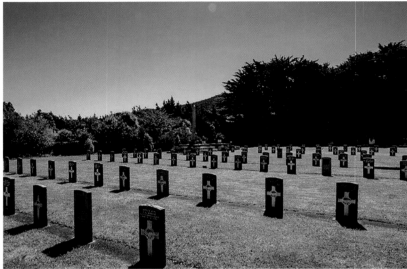

Featherstone Cemetery
South Wairarapa District, New Zealand

From a population of just over 1 million, more than 100,000 New Zealanders served overseas in the First World War – many of them young men who had never left home before. More than 18,000 died as a result of the war and over 40,000 more were wounded.

There are 180 Commonwealth burials of the First World War at Featherstone – a very large number due to the influenza epidemic that struck the large reinforcement camp that was established here in January 1916. The camp could house a maximum of 7,500 men and specialised in the training of the Mounted Rifles and the Artillery.

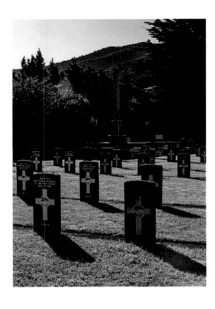
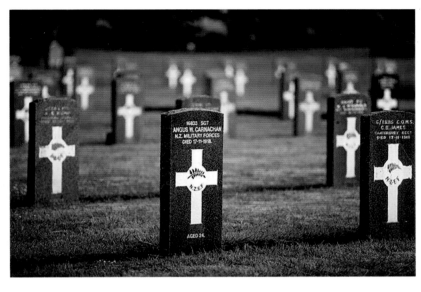
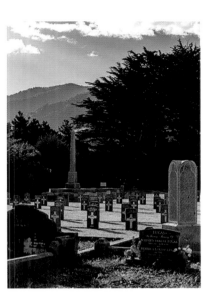
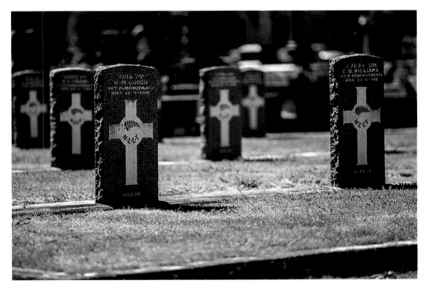
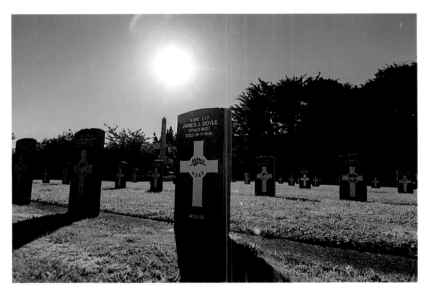

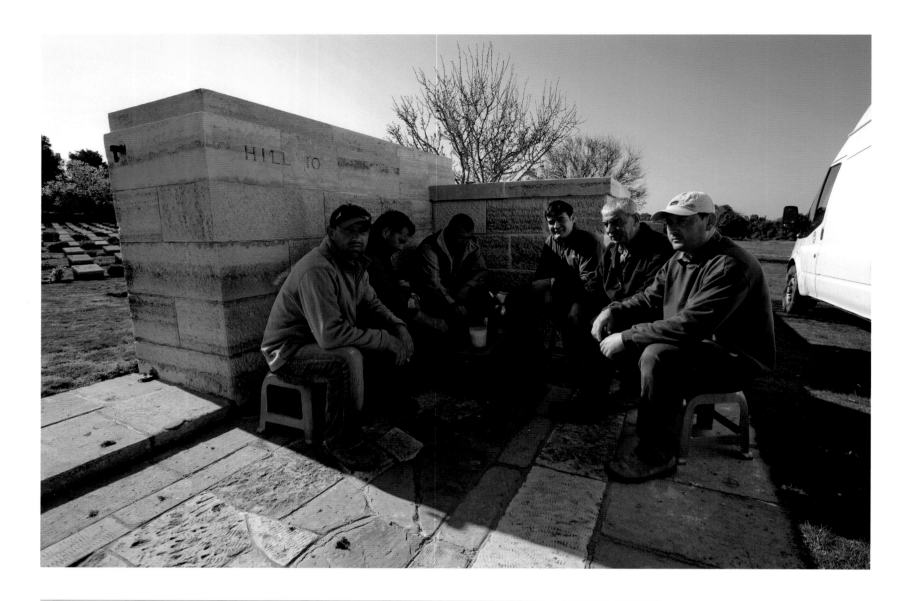

Hill 10 Cemetery
Gallipoli, Turkey

Hill 10, a low isolated mound to the north of a salt lake, was taken by the 9th Lancashire Fusiliers and the 11th Manchesters on the early morning of 7 August 1915. The cemetery was made after the Armistice by the concentration of graves from isolated sites and from the 88th and 89th Dressing Stations, Kangaroo Beach, 'B' Beach, 26th Casualty Clearing Station and Park Lane. There are now almost 700 servicemen of the First World War buried or commemorated in this cemetery. One hundred and fifty of the burials are unidentified but special memorials commemorate a number of casualties known or believed to be buried among them.

Worldwide the CWGC employs a dedicated workforce of almost 1,300 people – the vast majority of them gardeners and stonemasons – to care for the graves and memorials to the fallen.

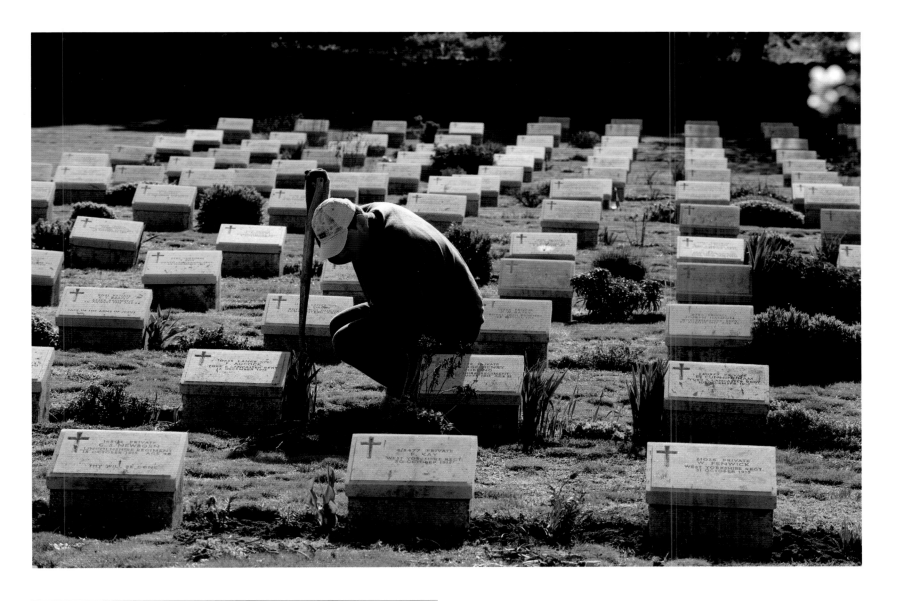

Hill 10 Cemetery
Gallipoli, Turkey

Ice-cold winters and dry, hot summers make the gardener's job a challenging
one on the Gallipoli Peninsula. Here, a CWGC worker tends the borders at
Hill 10 Cemetery. The CWGC's horticultural operation is one of the largest in
the world – measuring its borders not in metres, as a domestic gardener might,
but in kilometres.

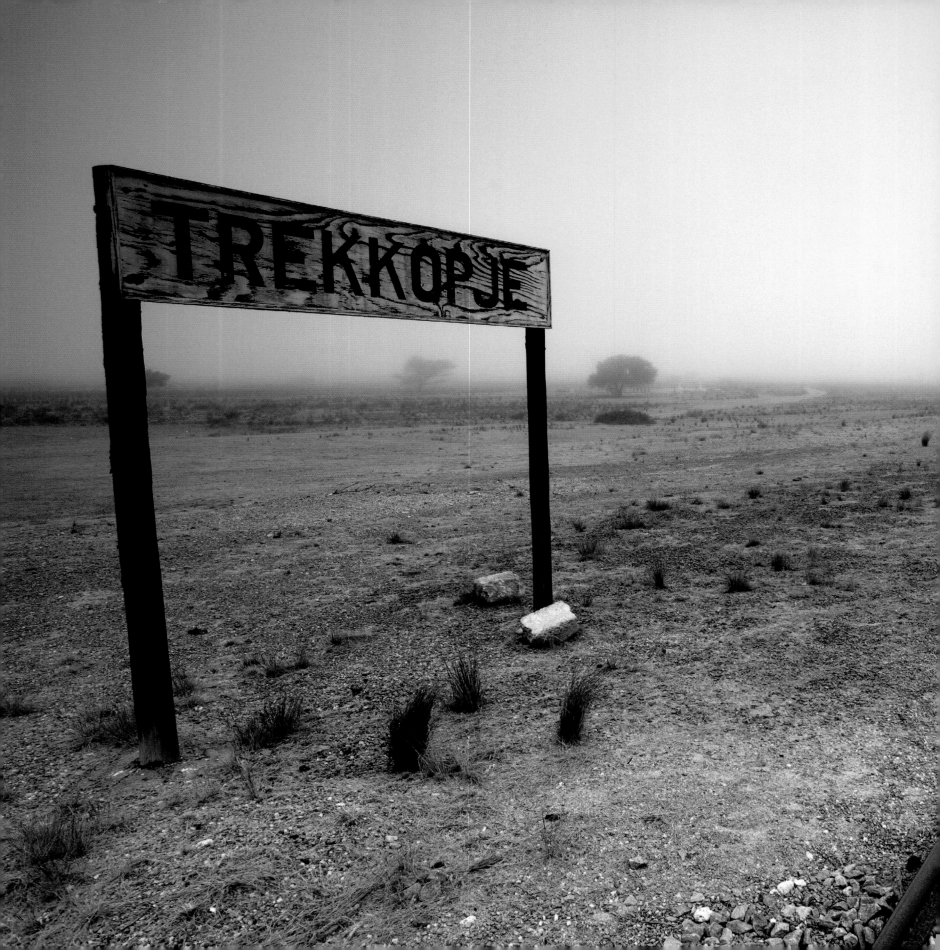

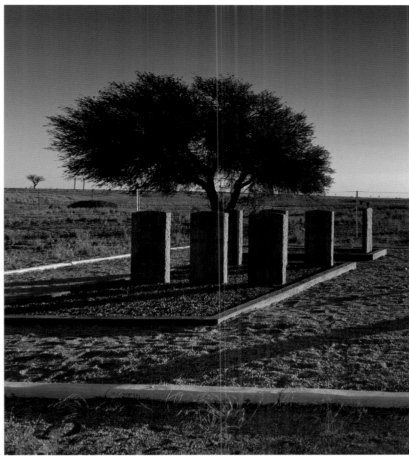

Trekkopje Cemetery
Namibia

In the Namib Desert of southwest Africa is one of the smallest Commonwealth war cemeteries in the world. The fighting that took place here between South African and German troops in April 1915 may now be almost forgotten, but the cemetery remains a permanent reminder of the engagement and its human cost.

In the early hours of 26 April 1915 German forces attacked the South African-held town at Trekkopje. After five hours of fighting the South Africans forced the Germans to retreat by attacking their flanks with machine guns mounted in armoured cars. Although the casualties were relatively light, the South Africans had won a decisive victory. Afterwards, German forces in southwest Africa were permanently on the defensive. All that remains of what was once a tiny railway depot is some track and the sign. The loneliness and isolation of this cemetery in the middle of the desert is very striking.

Hooge Crater

Ieper, West-Vlaanderen, Belgium

On 31 October 1914, the staff of the 1st and 2nd Divisions were wiped out when Hooge Chateau and its stables, the scene of fierce fighting throughout the war, were shelled.

Hooge Crater cemetery was begun early in October 1917 and originally contained just 76 graves. It takes its name from a mine crater, detonated nearby in July 1915. The circular depression at the entrance, in which the Stone of Remembrance is sited, represents the lost crater. The cemetery was greatly increased after the Armistice when graves were brought in from the battlefields of Zillebeke, Zantvoorde, Gheluvelt and others. Designed by Sir Edwin Lutyens, it commemorates almost 6,000 Commonwealth servicemen.

Pozieres British Cemetery and Memorial
Somme, France

The village of Pozieres and the ridge on which it stands were the scene of intense fighting over two weeks in July and August 1916. The village, which was completely destroyed in the fighting, was captured initially by the 1st Australian Division on 23 July and held despite almost continuous artillery fire and repeated German counter-attacks. By the time it was relieved on 27 July it had suffered over 5,000 casualties.

Pozieres British Cemetery contains over 2,700 burials. The cemetery is enclosed by the Pozieres Memorial, which commemorates over 14,000 British and South Africans who have no known grave.

The Pozieres ridge is more densely sown with Australian sacrifice than any other place on earth.

Charles Bean, official historian for Australia

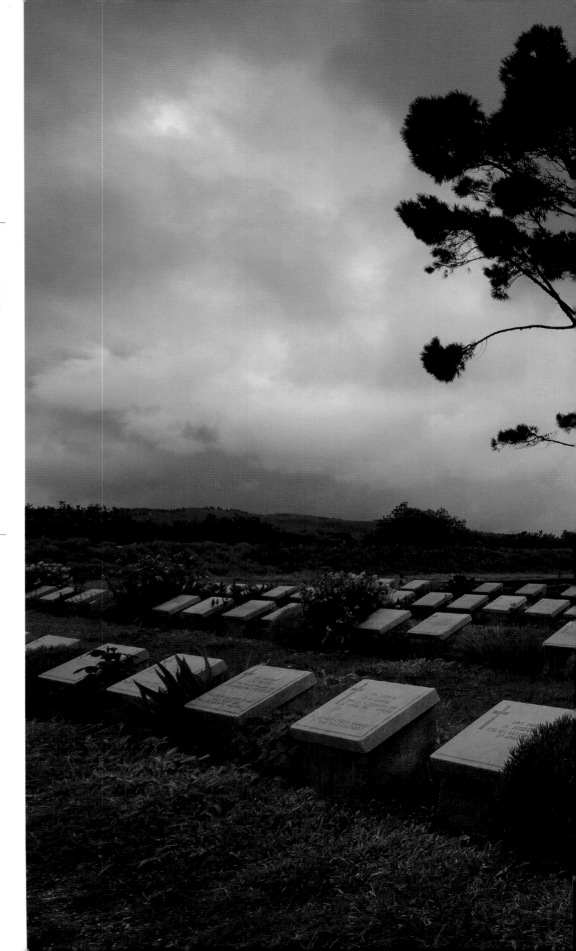

Lone Pine Cemetery and Memorial
Gallipoli, Turkey

On 25 April 1915 a single dwarf pine tree stood near where
the memorial is now situated. Within days the tree had been
shot away, but not before it gave its name to the position,
Lone Pine. The tree that stands there today is symbolic
of the original tree. Memorial 'Lone Pine' trees have also
been planted in Australia, New Zealand and Gallipoli to
commemorate the battle and the Gallipoli campaign in
general, seeded from specimens taken from Gallipoli.

The original battle cemetery of 46 graves was greatly
enlarged after the Armistice. There are now almost 1,200
Commonwealth servicemen buried here. A further 4,900
Australian and New Zealand servicemen who died in
the Anzac area and whose graves are not known are
commemorated on the memorial.

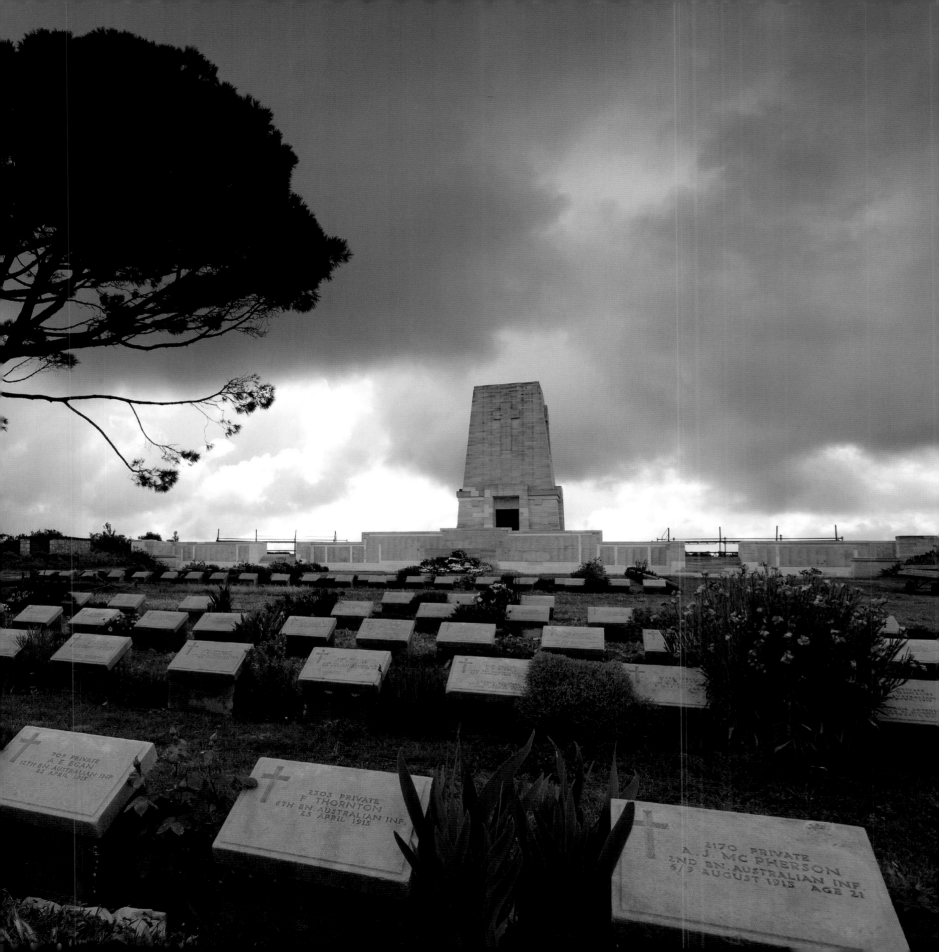

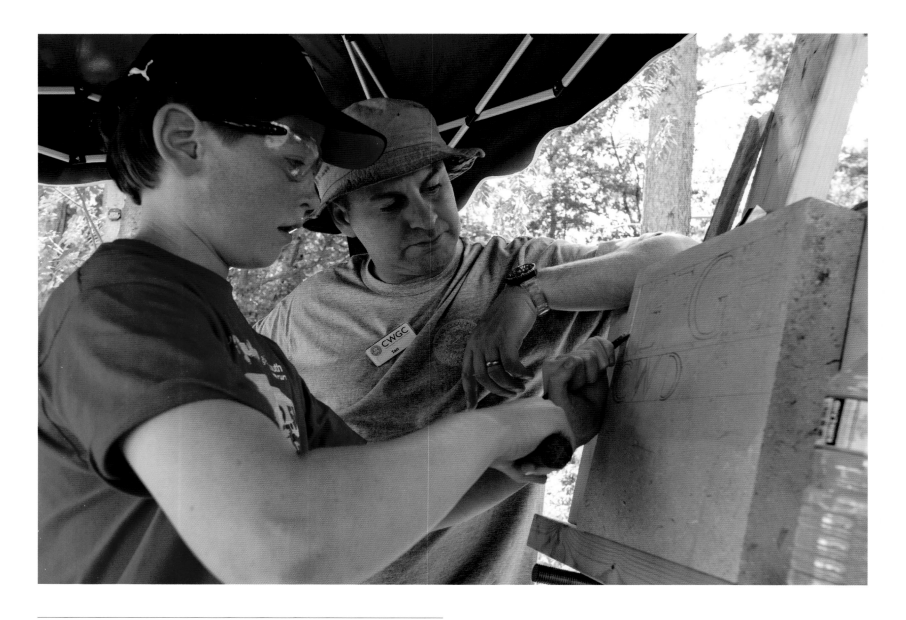

Brookwood Military Cemetery
Surrey, England

Brookwood Military Cemetery is the largest CWGC cemetery in the UK. In the summer of 2013 the CWGC held an open day at the cemetery – designed to raise awareness of this important commemorative site and to show the public the effort that goes into maintaining war graves and memorials.

Here, a young boy tries his hand at letter carving. The CWGC's stonemasons play a vital role in repairing and maintaining war graves around the world.

The Cambrai Memorial
Louverval, Nord, France

Charles Sargeant Jagger's reliefs on the Cambrai Memorial are staggering for their attention to detail. The tension captured in the hand of the man being lifted over the trench on a stretcher and the supreme effort of the stretcher bearers gives added poignancy to the names of the 7,000 men commemorated on this memorial.

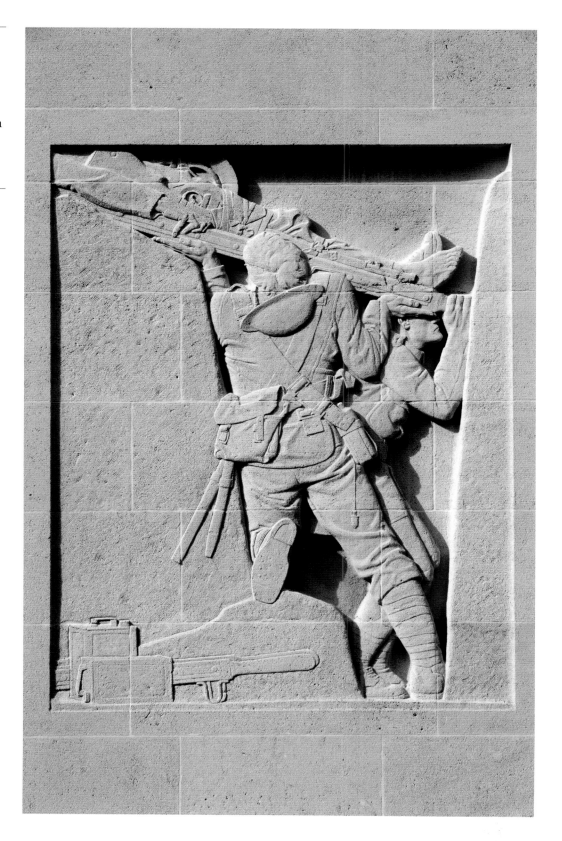

Cliveden War Cemetery
Buckinghamshire, England

Cliveden War Cemetery is in the grounds of Cliveden House, a National Trust
property in Buckinghamshire and former home to the Astor family.

Most of the 40 First World War burials here are Canadian, associated with the
Duchess of Connaught Canadian Red Cross Hospital – succeeded by the No.15
Canadian General Hospital – which was based in the grounds of the house
at nearby Taplow.

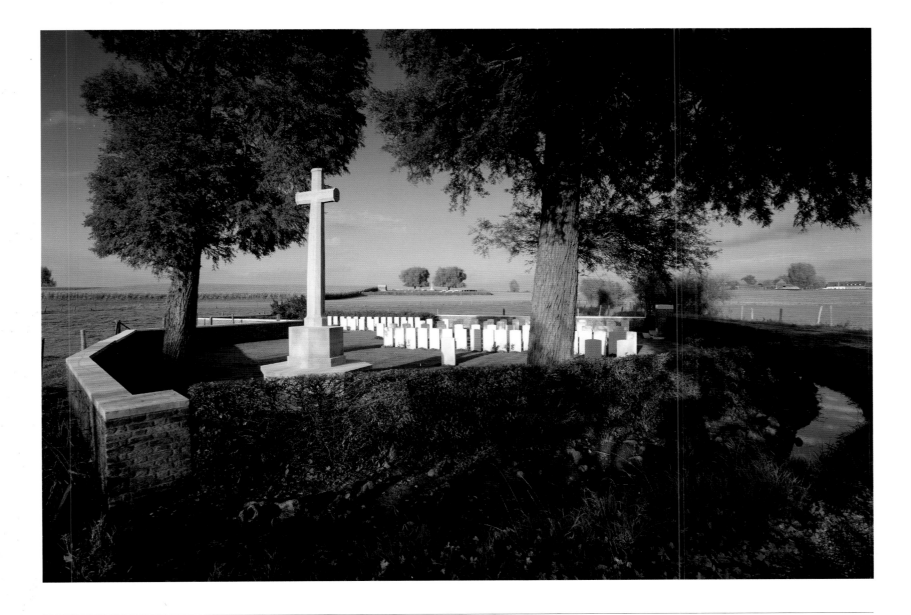

Mud Corner Cemetery
Comines-Warneton, Hainaut, Belgium

Mud Corner was the name given to a road junction on the northern edge of Ploegsteert Wood, very close to the front line. The cemetery contains just 86 graves and was begun on 7 June 1917, the first day of the Battle of Messines, and many of the soldiers in Plot I Row A were killed on that date.

The battle, which was a precursor to the much larger Third Battle of Ypres, known as Passchendaele, commenced with the detonation of 19 underground mines underneath the German lines. Allegedly audible in London, the effect of the mine explosions upon the German defenders was devastating. Some 10,000 men were killed during the explosion alone.

Two mines were not detonated during the battle and their precise location was lost. On 17 June 1955 one was detonated in a thunderstorm: the only casualty was a dead cow. The second mine remains undetected.

Mill Road Cemetery
Thiepval, Somme, France

Mill Road Cemetery was created in spring 1917, when the German withdrawal to the Hindenburg line allowed the battlefield to be cleared. At the Armistice, it contained just 260 burials, but was then greatly enlarged when graves were brought in from the battlefields of Beaumont-Hamel and Thiepval and from smaller cemeteries. It now contains over 1,300 burials.

The central headstones in the cemetery are laid flat because the German tunnel system that lies beneath renders the ground incapable of taking the weight of the cross beams on which the headstones rest.

Visible in the background are Connaught Cemetery (1,300 burials), and to the right, the Ulster Tower – a memorial to the men of the 36th (Ulster) Division who suffered heavy losses here on 1 July 1916.

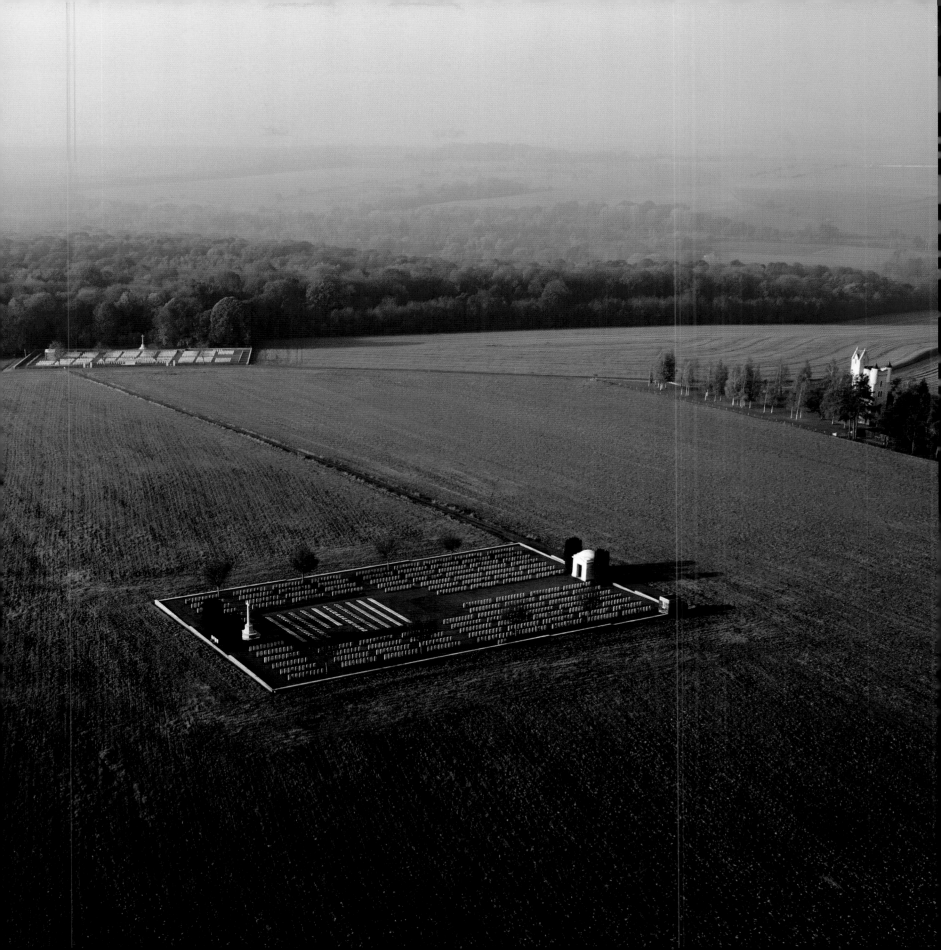

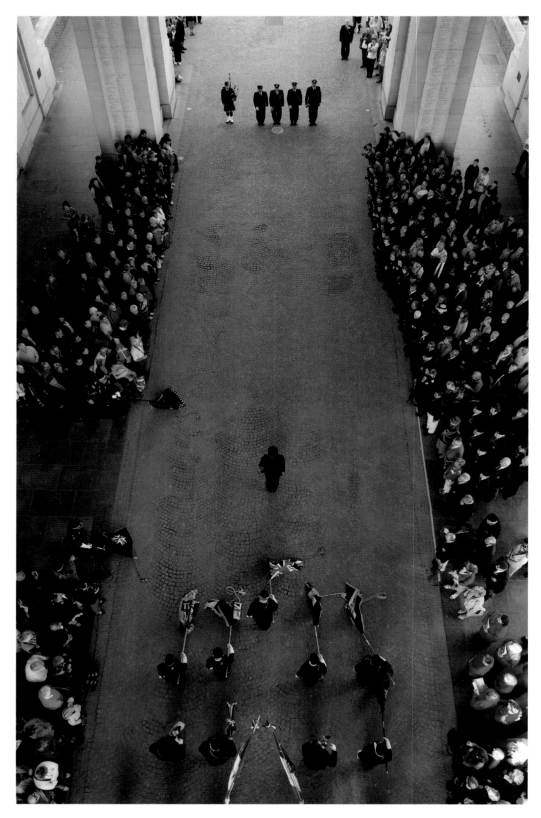

The Ypres (Menin Gate) Memorial

Ieper, West-Vlaanderen, Belgium

The Ypres (Menin Gate) Memorial stands on the site of the Menenpoort, the city's original gate, through which hundreds of thousands of men passed on their way to the front.

The names of over 54,000 officers and men who were killed in the Ypres Salient during the First World War, and who have no known grave, are inscribed on the memorial.

Every night at eight o'clock, the road beneath the gate is closed and the Last Post sounded by the buglers of the Last Post Association in remembrance of those who gave their lives.

He is not missing; he is here.

Field Marshal Lord Plumer at the inauguration of the Menin Gate, 24 July 1927

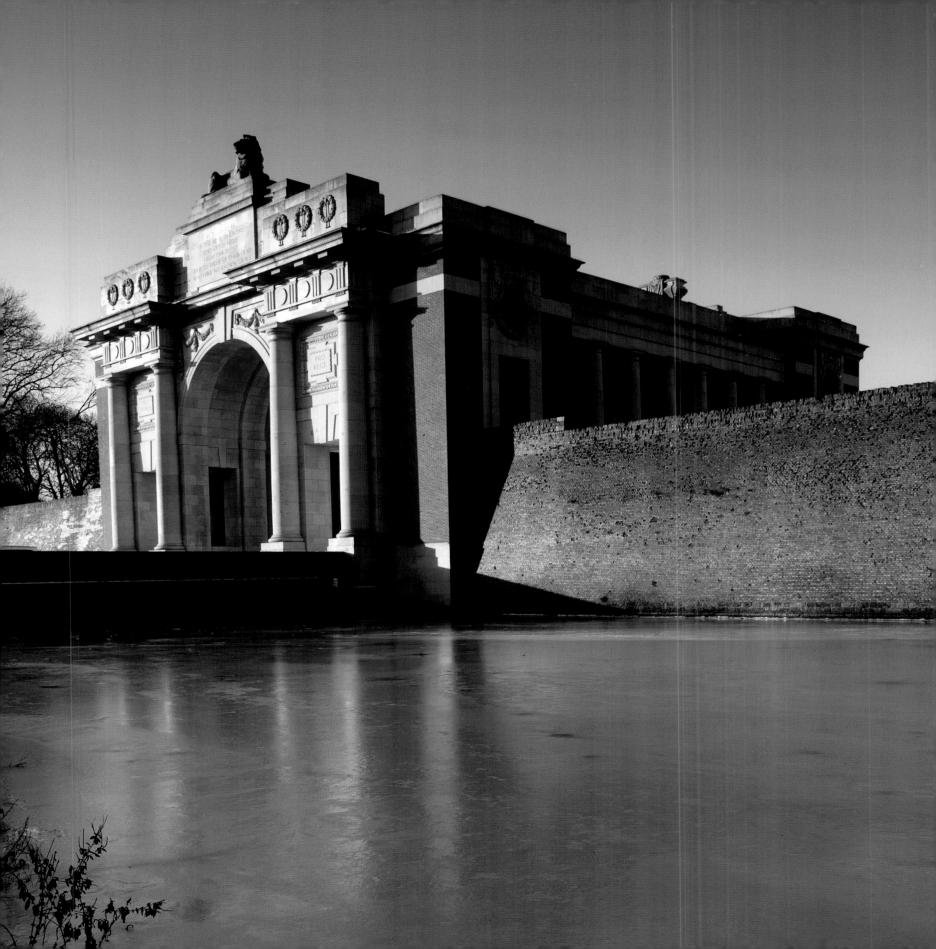

Hollybrook Memorial
Hampshire, England

The names of nearly 1,900 Commonwealth war dead are inscribed on the Hollybrook Memorial, Southampton. Almost a third of these names are those of the officers and men of the South African Native Labour Corps, who died when their ship the SS *Mendi* sank in the English Channel after colliding with another vessel on 21 February 1917.

Eyewitness stories of the bravery exhibited by the doomed men aboard the SS *Mendi* have become legendary. The most famous is that of the death dance that the men performed as the ship sank. They were led by the chaplain, the Reverend Isaac Wauchope Dyobha. He was heard calling out:

Be quiet and calm, my countrymen, for what is taking place is exactly what you came to do. You are going to die, but that is what you came to do.

Brothers, we are drilling the death drill.

I, an Xhosa, say you are my brothers. Zulus, Swazis, Pondos, Basothos and all others, let us die like warriors. We are the sons of Africa. Raise your war cries my brothers, for though they made us leave our assegais back in the kraals, our voices are left with our bodies.

To this day the *Mendi* is remembered in South Africa. An award for bravery and scholarship in schools is given in its name.

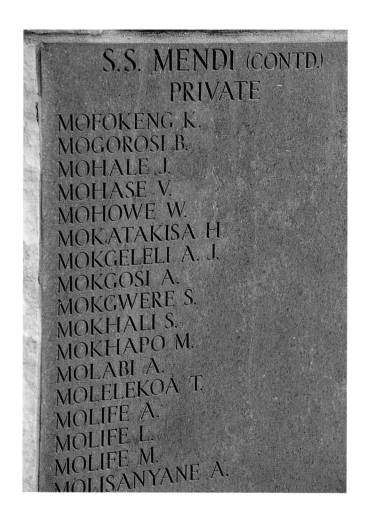

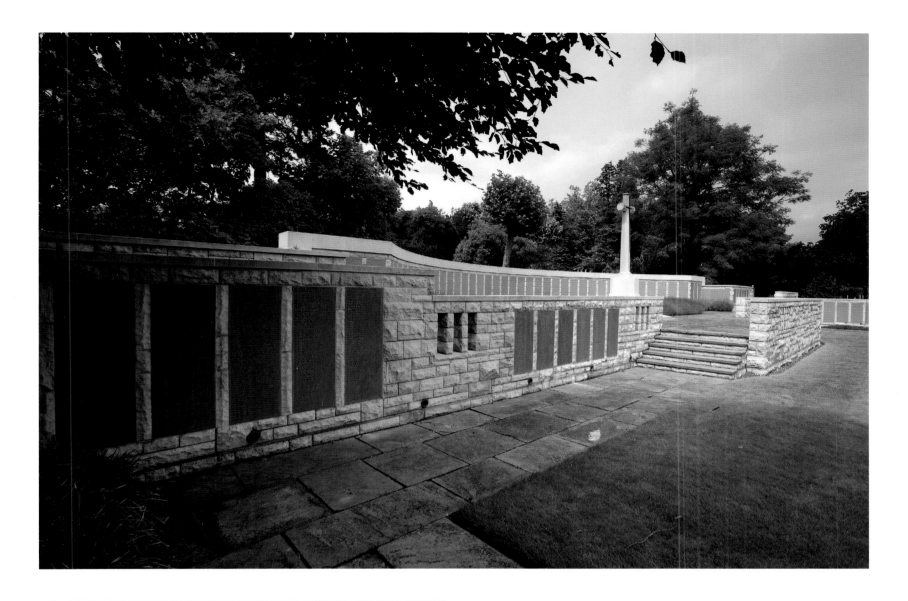

Hollybrook Memorial

Hampshire, England

The Hollybrook Memorial also bears the name of perhaps the best-known soldier of the war – Field Marshal Kitchener – who was drowned in 1916 when the ship taking him to negotiations in Russia was sunk by a German mine.

Despite his fame, the CWGC's commitment to equality of treatment means that in death, he is treated the same as the other servicemen on the memorial.

Bodelwyddan (St Margaret) Churchyard
Flintshire, Wales

The churchyard contains almost 120 graves from the First World War. The vast majority of these were Canadians who died of influenza at the nearby repatriation camp at Kinmel Park in 1919.

Up to 15,000 Canadian troops were stationed at Kinmel Camp in the months after the war ended in November 1918. They lived in poor conditions due to strikes that held up the fuelling of ships and caused food shortages.

Influenza or Spanish flu was a pandemic that killed between three to six per cent of the global population between 1918 and 1920. It first struck at Kinmel in late 1918, where the military hospital contained almost 1,300 beds in huts and under canvas.

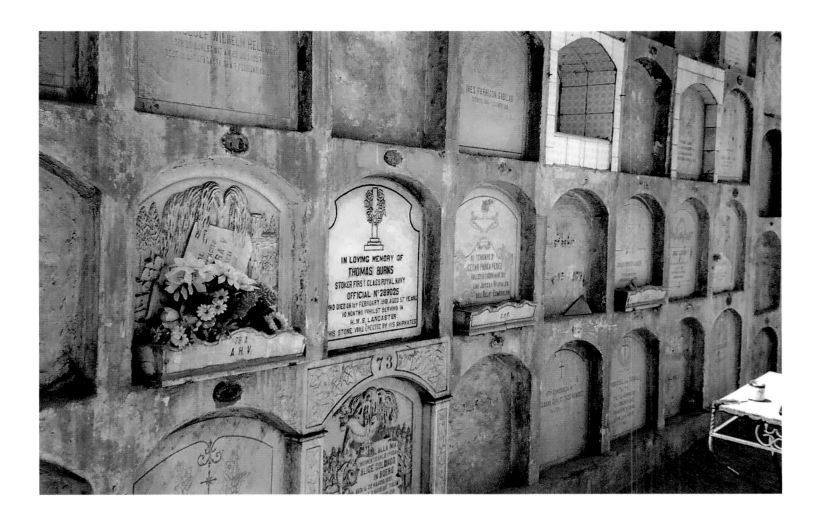

Antofagasta Cemetery
Chile, South America

One of five cemeteries in Chile, each containing just a single war grave, Antofagasta contains the grave of Stoker 1st Class Thomas Burns who died while serving on board HMS *Lancaster* – an armoured cruiser serving in the Pacific.

Many of the more remote graves the CWGC looks after around the world are those belonging to naval and merchant navy personnel.

We do not know what pain he bore,
we only know he nobly fell
and could not say goodbye

Personal inscription on a headstone

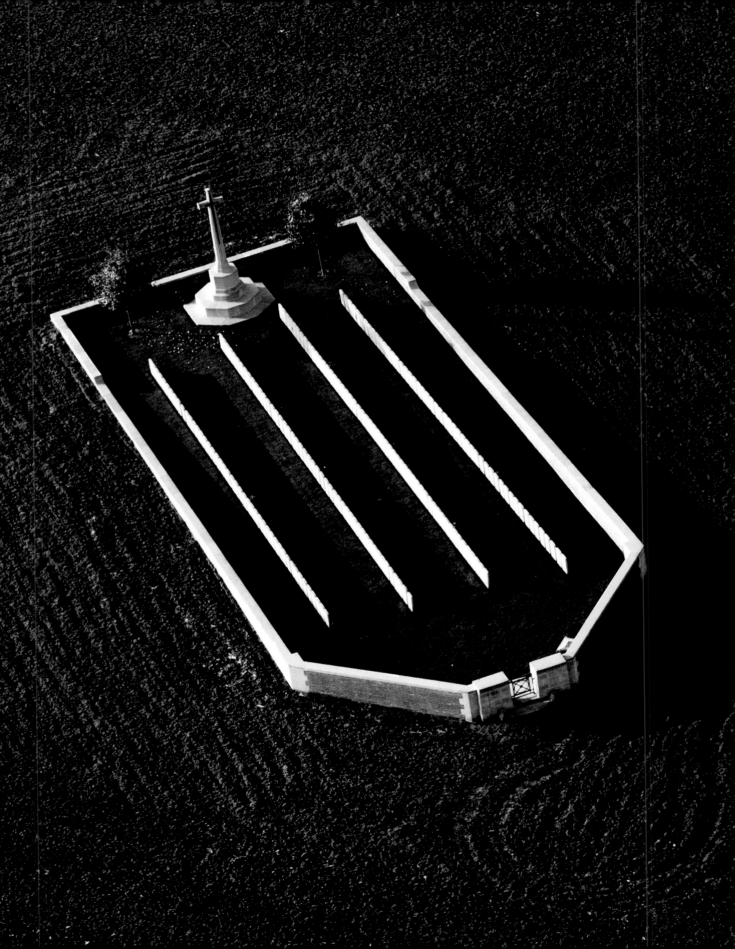

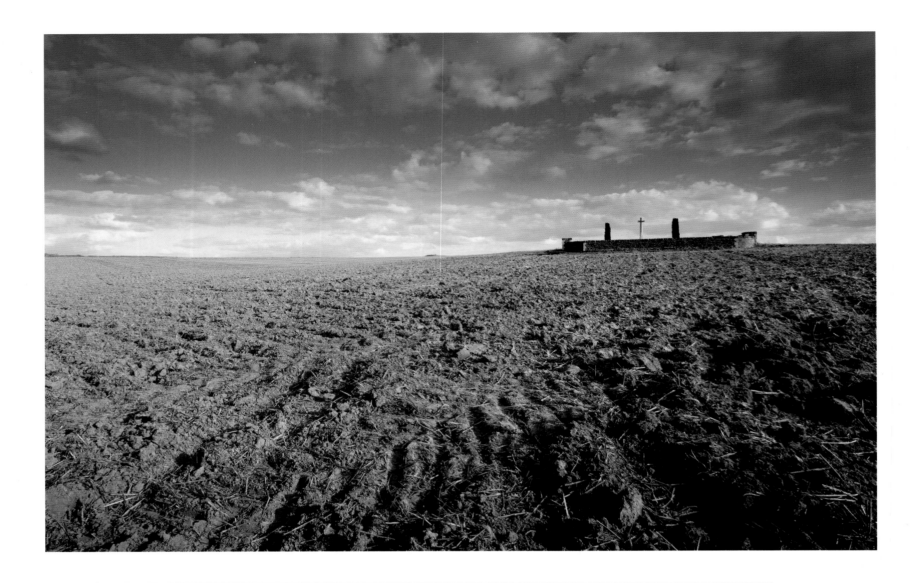

Guizancourt Farm Cemetery
Gouy, Aisne, France

All bar one of the 150 men buried in this cemetery died during the early part of October 1918. The cemetery was created shortly after the farm was captured by the 11th Sherwood Foresters and the 1st/8th Royal Warwicks (25th Division). Among those buried here is Lieutenant Evan Cecil Nepean – one of nine Royal Fusiliers officers to be killed on 4 October 1918. The regimental history suggests this was the highest number of officers killed in one action by any battalion of the Royal Fusiliers.

Evan was highly thought of by his brother officers – one described him thus: 'He was one of the bravest gentlemen that ever wore the King's uniform, and his death has been felt more than anybody's. He was a grand character, brave, loyal and courteous, always thinking of his men's comfort.' Another said: 'His loss is very great, he was so popular, and such a good soldier. He has always done well – his best. He was cheerful in all circumstances, and gallant in danger beyond anything. We have lost one of our best, one of the type we most wanted to be spared.'

Faffemont Isolated Grave

Combles, Somme, France

This lonely grave in a field is unique on the Somme.
It is the actual burial site of three soldiers, Captain
Richard Heumann, Company Sergeant Major B Milles
and Sergeant A W Torrance of the London Regiment
(Royal Fusiliers), who were killed at this spot on 10
September 1916 while sheltering in a shell hole, and in
which they were subsequently buried.

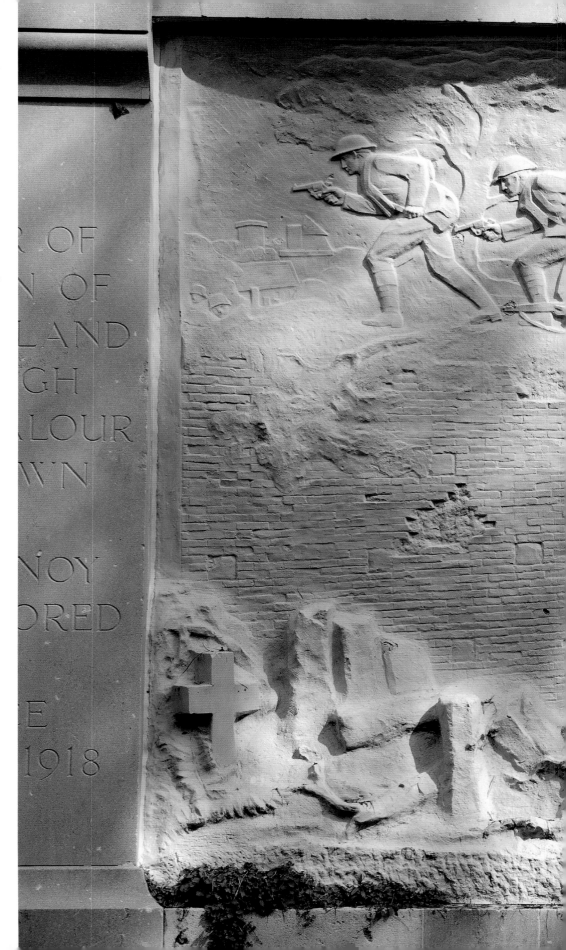

New Zealand Memorial
Le Quesnoy, Nord, France

Le Quesnoy was in German hands for almost all of the First World War. It was captured by the New Zealand Division on 4 November 1918, and the memorial depicts the moment when the New Zealand soldiers, led by Lieutenant Leslie Averill, managed to set up a ladder on the south side of the town and enter through a sluice gate. They took the German garrison by surprise and after much fighting in the streets, had captured the town by the evening of 4 November. The sculpture has been placed on the old city wall.

We walked around the town ... [to the memorial] and we laid a wreath there. I was standing next to a Frenchman who had tears streaming down his face. He was moved by the generosity of the New Zealanders all those years ago. It's something you don't understand when you're in New Zealand.

Todd Blackadder, captain of the New Zealand rugby team, the All Blacks

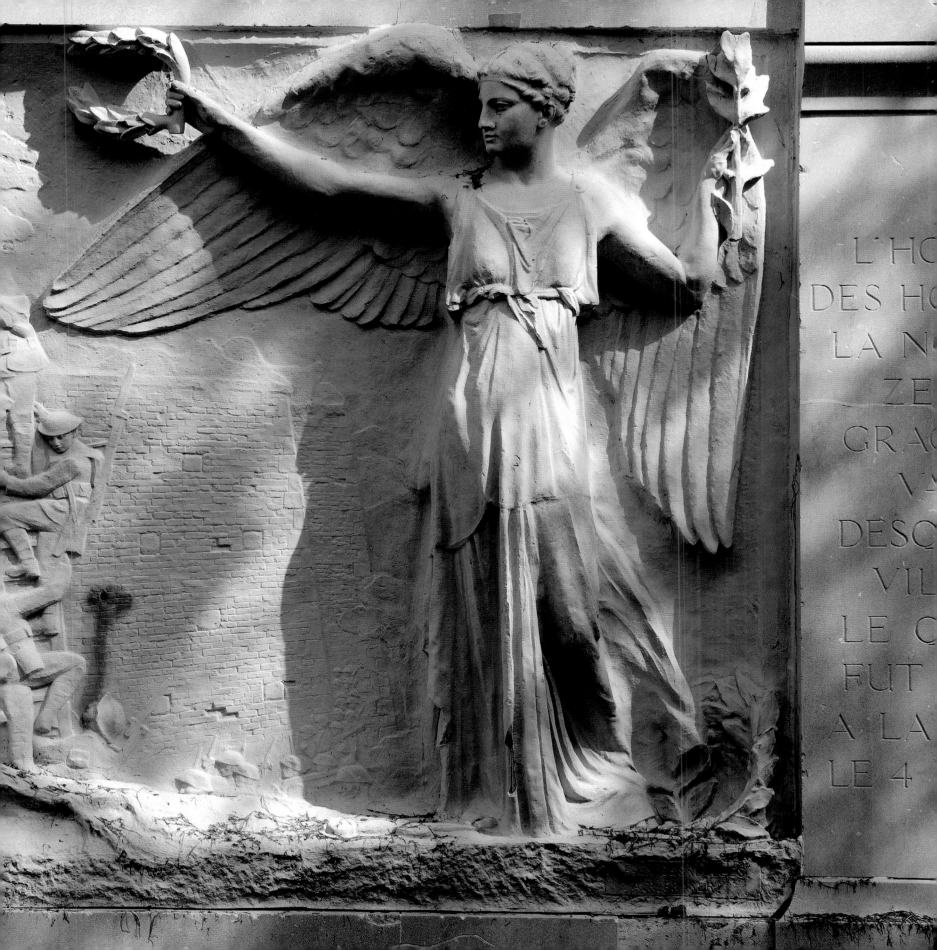

L'HO
DES HO
LA N
ZE
GRA
V
DESQ
VIL
LE C
FUT
A LA
LE 4

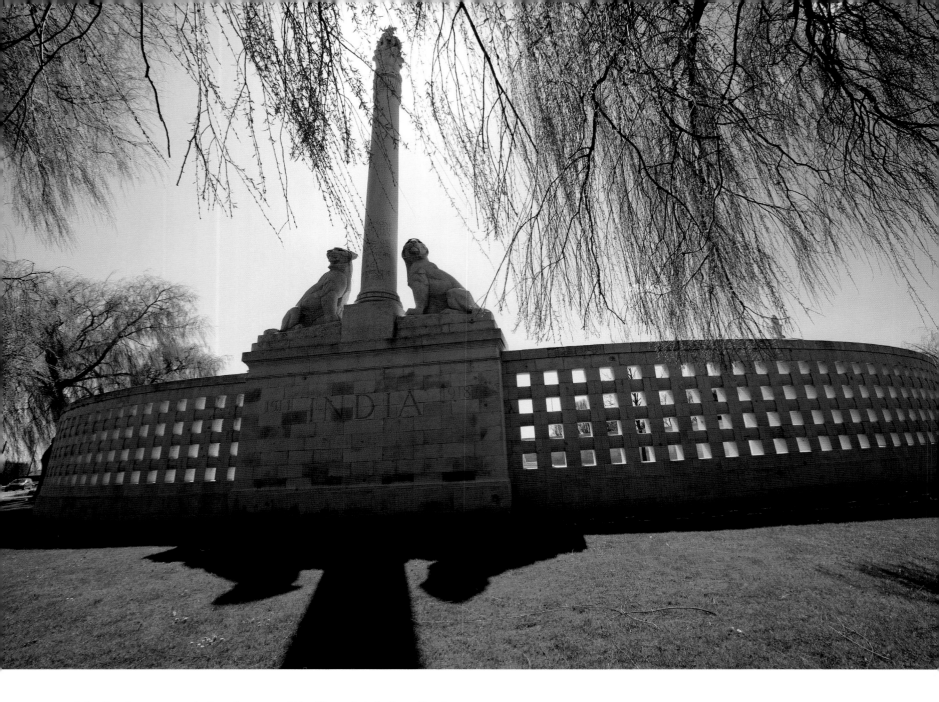

To the honour of the Army of India which fought in France and Belgium, 1914–1918, and in perpetual remembrance of those of their dead whose names are here recorded and who have no known grave.

Inscription on the memorial at Neuve-Chapelle

Neuve-Chapelle Memorial
Pas de Calais, France

The Indian Memorial at Neuve-Chapelle commemorates over 4,700 Indian soldiers and labourers who lost their lives on the Western Front during the First World War and have no known grave. The location of the memorial was specially chosen, as it was at Neuve-Chapelle in March 1915 that the Indian Corps fought its first major action as a single unit.

The memorial was designed by Sir Herbert Baker and unveiled by the Earl of Birkenhead on 7 October 1927. Lord Birkenhead, then Secretary of State for India, had served as a staff officer with the Indian Corps during the war. The ceremony was also attended by the Maharaja of Karputhala, Marshal Ferdinand Foch, Rudyard Kipling, and a large contingent of Indian veterans.

Return to your homes in the distant, sun-bathed East and proclaim how your countrymen drenched with their blood the cold northern land of France and Flanders, how they delivered it by their ardent spirit from the firm grip of a determined enemy; tell all India that we shall watch over their graves with the devotion due to all our dead.

We shall cherish above all the memory of their example. They showed us the way, they made the first steps towards the final victory.

Marshal Ferdinand Foch, 7 October 1927

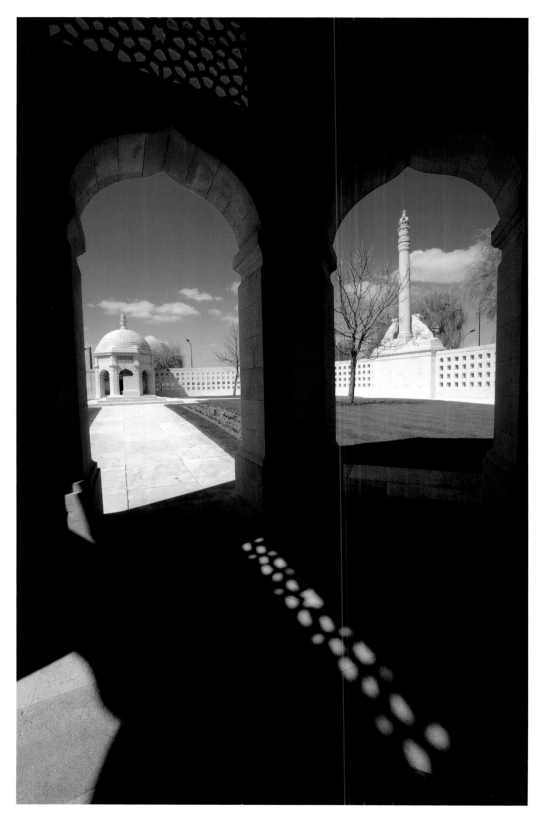

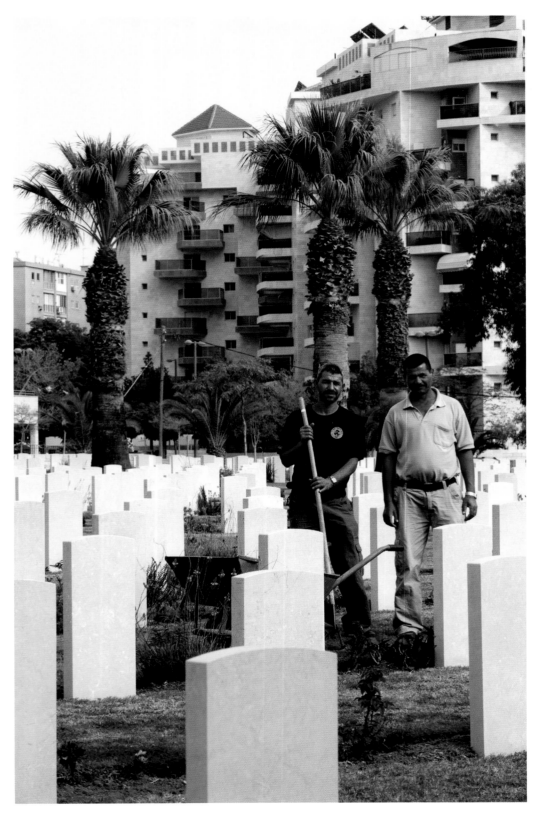

Beersheba War Cemetery
Israel and Palestine (including Gaza)

Ground workers stand proudly in the cemetery at Beersheba, which was established immediately after the fall of the town in October 1917. The cemetery remained in use until July 1918 and was greatly enlarged after the Armistice, when burials were brought in from a number of scattered sites. It now contains over 1,200 graves.

By October 1917, General Allenby's force had been entrenched in front of a strong Turkish position along the Gaza-Beersheba road for some months, but they were now ready to launch an attack, with Beersheba as its first objective. On 31 October, the attack was carried out – the 4th Australian Light Horse Brigade charged over the Turkish trenches into the town.

Beersheba has the distinction of being the final resting place of three recipients of the Victoria Cross – one of whom is Captain John Fox Russell VC, MC, RAMC. His citation in the *London Gazette* reads:

For most conspicuous bravery displayed in action until he was killed. Capt. Russell repeatedly went out to attend the wounded under murderous fire from snipers and machine guns, and, in many cases where no other means were at hand, carried them in himself, although almost exhausted. He showed the highest possible degree of valour.

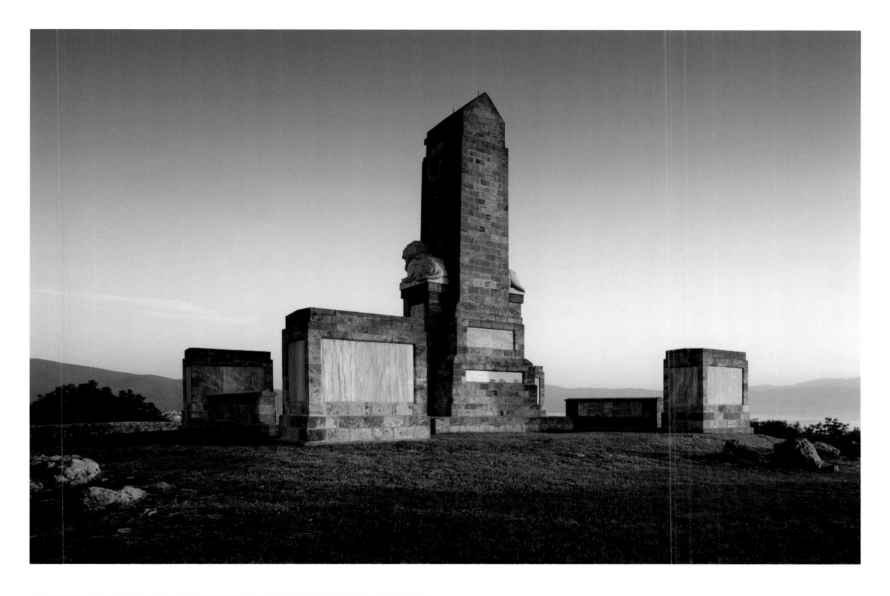

The Doiran Memorial
Greece

Designed by Sir Robert Lorimer with sculpture by Walter Gilbert, this marble-panelled memorial stands above Lake Doiran on what was known as Colonial Hill, looking out over the plains and into the foothills of the distant purple mountains. It is the battle memorial for the British Salonika Force, and commemorates by name more than 2,000 Commonwealth servicemen who died in Macedonia and have no known grave.

The Battle of Doiran is now a forgotten episode of the Great War, overshadowed by the doings of Haig in France and Allenby in Palestine.

Extract from Issue 46 of *I Was There*, published 1938/9

Morogoro Cemetery
Tanzania

Every CWGC employee I encountered on my travels was immensely proud to work for the organisation – no more so than here at Morogoro, where husband-and-wife team Shadrack Paull and Lusia Axalte look after the cemetery which remembers almost 400 Commonwealth war dead.

It said a lot about the organisation to me. The way it treats its staff and the importance they in turn place on the work to keep the memory of those who died in the First World War alive.

Mike Sheil, photographer

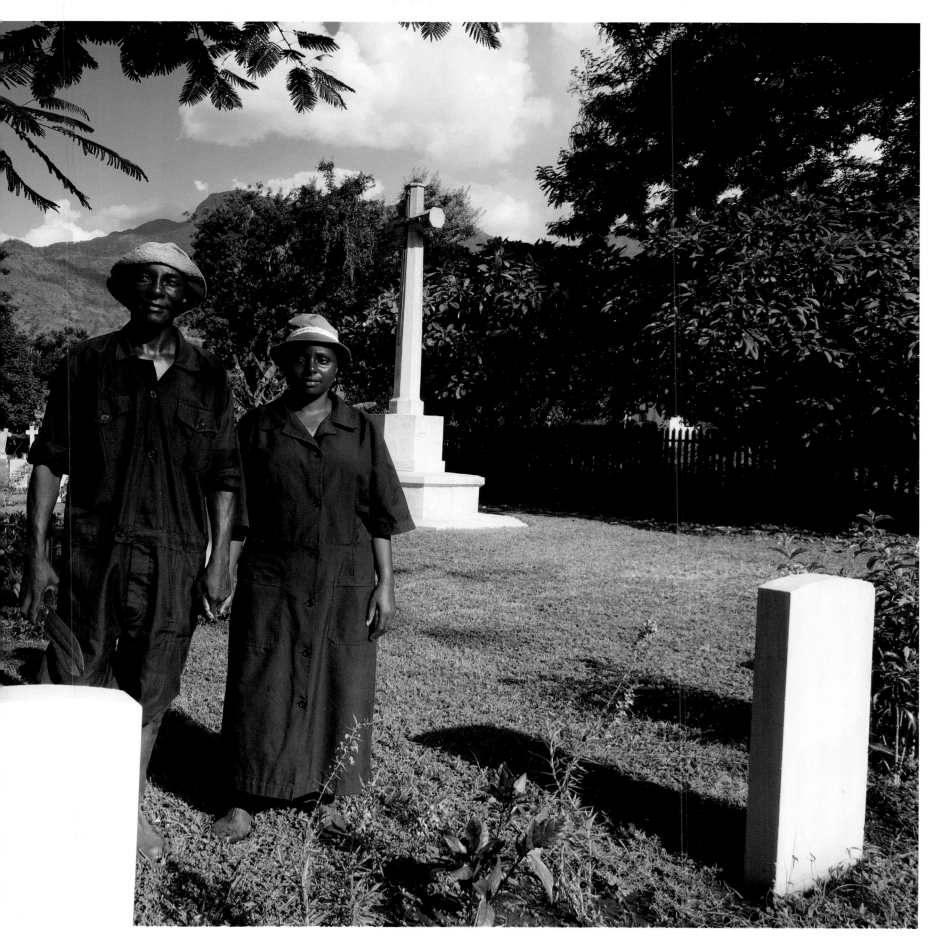

Scarp Burial Ground
Western Isles, Scotland

While it is uninhabited today, the island of Scarp – on the edge of the Outer Hebrides – was for centuries home to a close-knit community of crofters and fishermen. But the impact of the First World War was felt even here and Scarp lost two of its sons – Deck Hand D J MacLennan and Pioneer D Maclennan – in the conflict.

The graves of both men are marked by CWGC headstones in Scarp Burial Ground. Accessible only by boat from the nearby island of Harris, local crofter Murdo McLennan is responsible for the regular maintenance and cleaning of these headstones.

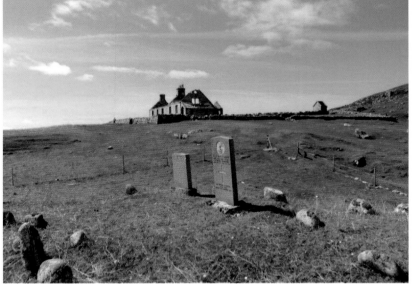

There are two headstones on Scarp. We have an agreement with a local crofter who keeps his sheep on the island; he cleans and checks the graves whenever he goes over.

Iain Anderson,
CWGC Regional Supervisor, Scotland

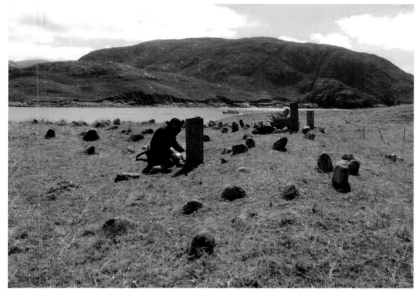
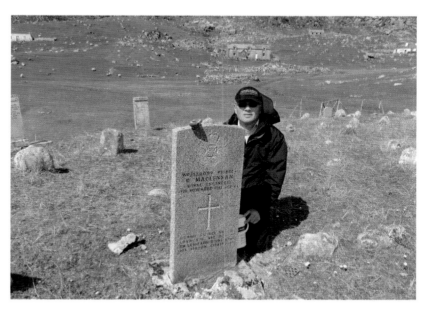
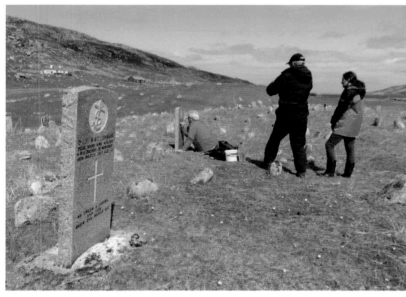
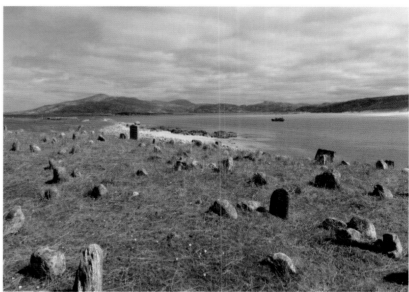

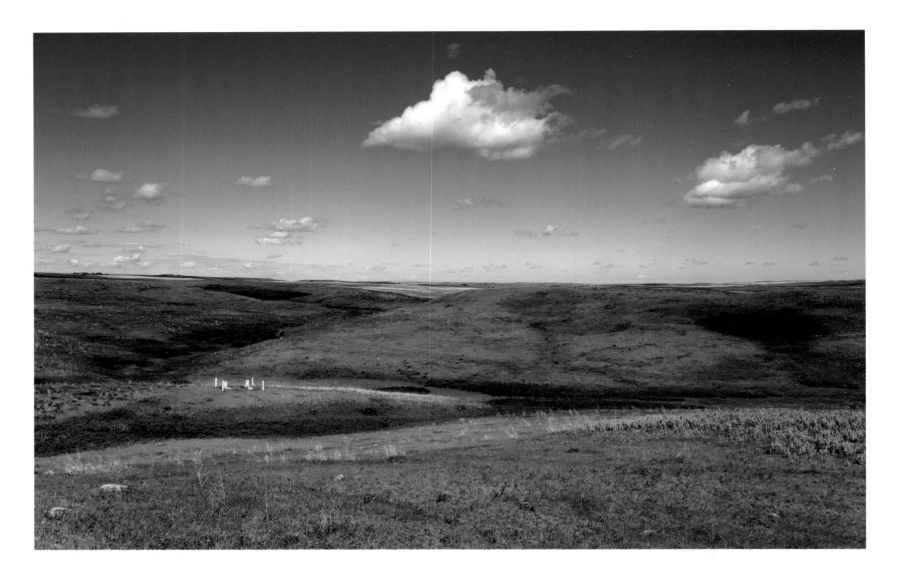

This is a lonely place. I can only imagine the mother's joy at the return of her son safe from the war, only to see him sicken and infect his brother and then both die of influenza. What must she have felt as her two sons died together in such a remote place, far from help?

Mike Sheil, photographer

132

Neidpath (Pollock's) Cemetery
Saskatchewan, Canada

Donald Pollock's isolated grave can be found close to his homestead, which lies about five miles from Neidpath. He and his twin, Alexander, died on the same day of influenza and are buried side by side. Their mother died in 1921 and is buried alongside Alexander.

I'm not sure I would ever have found this grave if it hadn't been for George Carlson, the farmer on whose land the grave is now located. He found me wandering around, covered in mud and gave me a lift on the back of his quadbike.

Mike Sheil, photographer

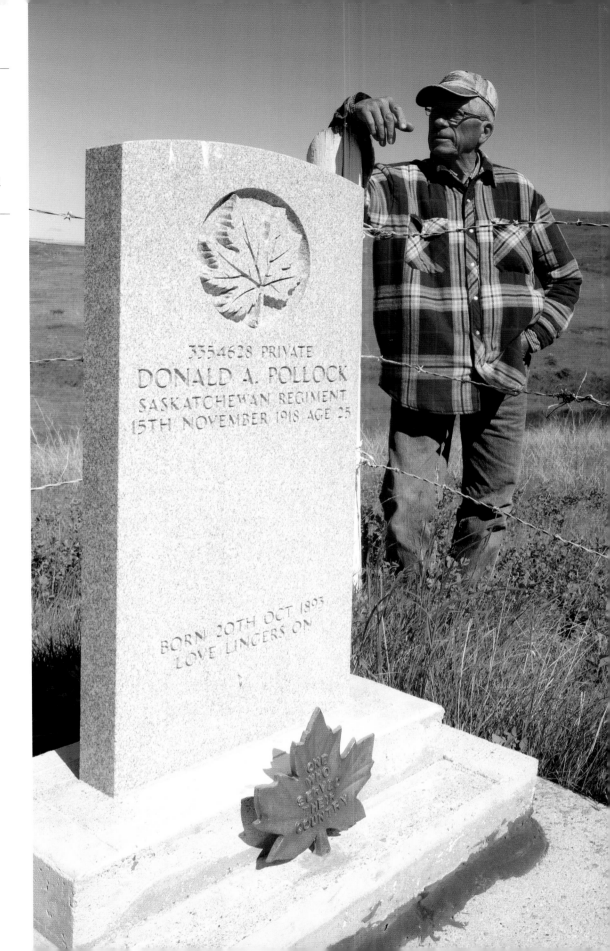

Canadian Memorial
St Julien, West-Vlaanderen, Belgium

Often called 'The Brooding Soldier', the Canadian Memorial at St Julien marks the battlefield where Canadian forces withstood the first use of a deadly new weapon – poison gas.

On 22 April 1915, the Germans, seeking to break the stalemate of trench warfare, used poison gas for the first time. Following an intensive artillery bombardment, they released 135 tonnes of chlorine gas, which drifted over the Allied trenches as thick yellow-green clouds.

Completely unprotected, the Allied soldiers, their lungs burning, either died or fled, leaving a six-kilometre gap in the Allied line. German troops pressed forward and threatened to sweep all before them, but the limited nature of the offensive, combined with the fierce defence of the Canadian and British troops, stemmed the tide.

On 24 April, the Germans attacked the Canadian line again. They held on until reinforcements arrived and gained a reputation as a formidable fighting force, but at great cost. In 48 hours over 6,000 Canadians – one man in every three – was lost. The 2,000 dead are buried in various war cemeteries in the vicinity.

The Canadians paid heavily for their sacrifice and the corner of earth on which this memorial of gratitude and piety rises has been bathed in their blood. They wrote here the first page in that Book of Glory which is the history of their participation in the war.

Marshal Ferdinand Foch, 8 July 1923
at the memorial unveiling

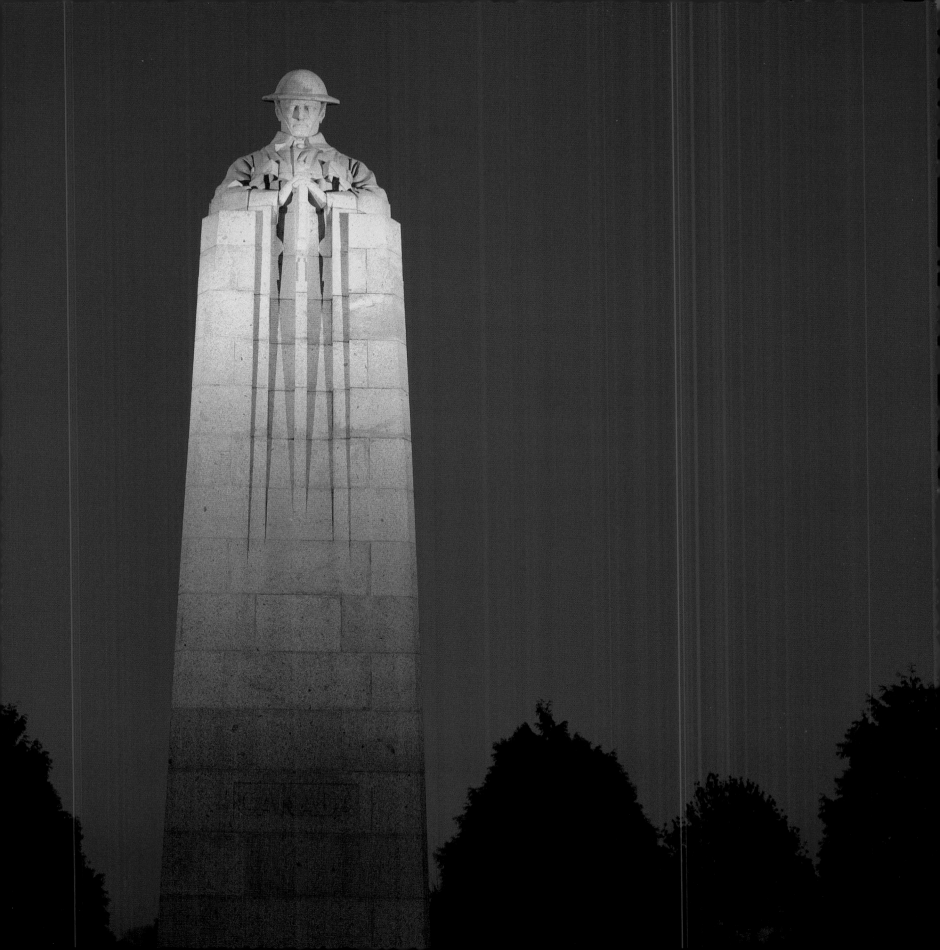

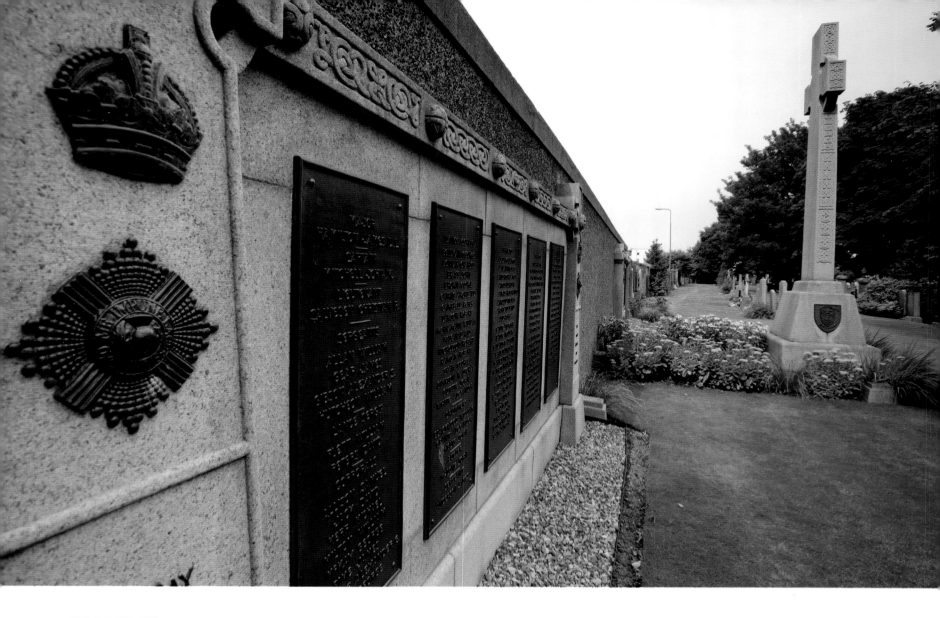

Edinburgh (Rosebank) Cemetery

Edinburgh, Scotland

On 22 May 1915 more than 200 people died in what remains Britain's worst rail crash – the Gretna rail disaster. The majority of those who died were soldiers of the 1st/7th Battalion The Royal Scots. The men, mostly from Leith, were on their way to Liverpool in order to travel to the Gallipoli front in Turkey. The handful of survivors were sent onwards the following day.

St Symphorien Military Cemetery
Mons, Hainaut, Belgium

The first major clash between the British and German forces of the Great War took place at Mons on 23 August 1914. In the aftermath, British and German dead were buried in civilian cemeteries in the city and surrounding villages.

Over a year later, the German army began exhuming soldiers who had died at Mons and re-interring them here at St Symphorien. The owner of the site, Jean Houzeau de Lehaie, agreed that it could be used as a burial ground on the condition that the British soldiers were buried and commemorated with the same dignity as their German counterparts. The landowner's wishes were respected by the Germans, who erected three monuments to the British dead in the cemetery, including a grey granite obelisk dedicated to the fallen of both sides that stands over seven metres high.

The cemetery remained in German hands until the end of the war and passed into the care of the Commission after the Armistice. St Symphorien now contains the graves of 334 Commonwealth and 280 German servicemen of the First World War, just over 100 of whom remain unidentified.

137

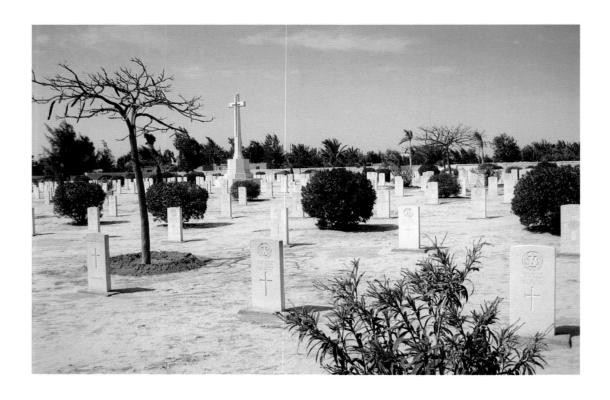

Kantara War Memorial Cemetery
Egypt

The natural desert landscape at Kantara requires a different approach to cemetery design and maintenance. Here, where water is scarce, there are no lawns and plants are chosen for their resistance to drought.

During the First World War, Kantara was an important point in the defence of the Suez Canal and marked the starting point of a new railway east towards Sinai and Palestine, begun in January 1916. It became the main supply depot for all British, Australian and New Zealand operations in the Sinai from 1916 until 1919 and a massive distribution warehouse and hospital were located in the town.

The cemetery was begun in February 1916, continuing in use until late 1920. After the Armistice, the cemetery more than doubled in size when graves were brought in from other cemeteries and desert battlefields. It now contains over 1,500 Commonwealth burials of the First World War and 110 from the Second World War. There are also a large number of graves of other nationalities in the cemetery and two memorials commemorating New Zealand and Indian servicemen.

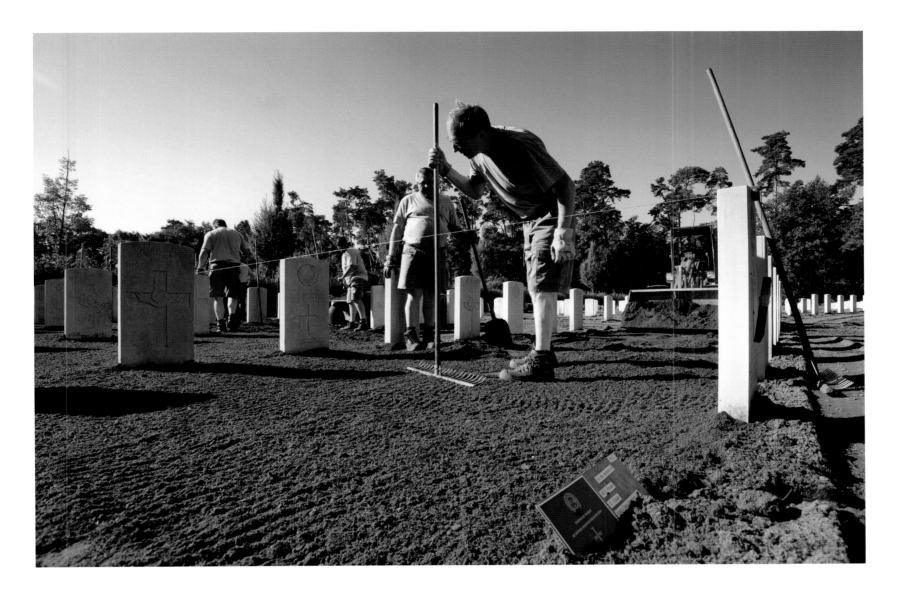

Berlin South-Western Cemetery
Berlin, Germany

Despite all the technological advances made by the Commission in recent years, a tried and tested system of adjusting levels – using string, rakes with notches in the handles, and a spirit level – is hard to beat for this team of CWGC craftsmen in Berlin.

In 1922–23 it was decided that the graves of Commonwealth servicemen who had died all over Germany should be brought together into four permanent cemeteries. Berlin South-Western was one of those chosen and graves were brought into the cemetery from 146 burial grounds in eastern Germany. There are now over 1,100 First World War servicemen buried or commemorated here.

Tyne Cot Cemetery
Zonnebeke, West-Vlaanderen, Belgium

Tyne Cot Cemetery is the largest Commonwealth war cemetery in the world in terms of burials – containing the graves of almost 12,000 men. A high proportion, over 8,300 of these, are marked 'A Soldier of the Great War. Known Unto God'.

The cemetery takes its name from a barn which stood near the level crossing on the Passchendaele–Broodseinde road. The barn, which had become the centre of five or six German blockhouses, or pill-boxes (some of which can still be seen in the cemetery today), was nicknamed 'Tyne Cot' or 'Tyne Cottage' by men of the Northumberland Fusiliers.

One of the pill-boxes was unusually large and was used as an advanced dressing station after its capture. From 6 October to the end of March 1918, 343 graves were made on two sides of it.

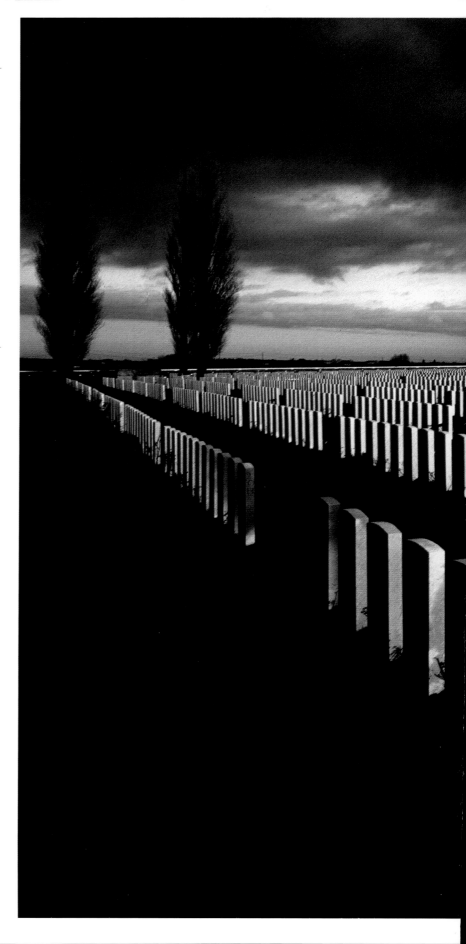

There was not a sign of life of any sort. Not a tree, save for a few dead stumps which looked strange in the moonlight. Not a bird, not even a rat or a blade of grass. Nature was as dead as those Canadians whose bodies remained where they had fallen the previous autumn. Death was written large everywhere.

Private R A Colwell, January 1918

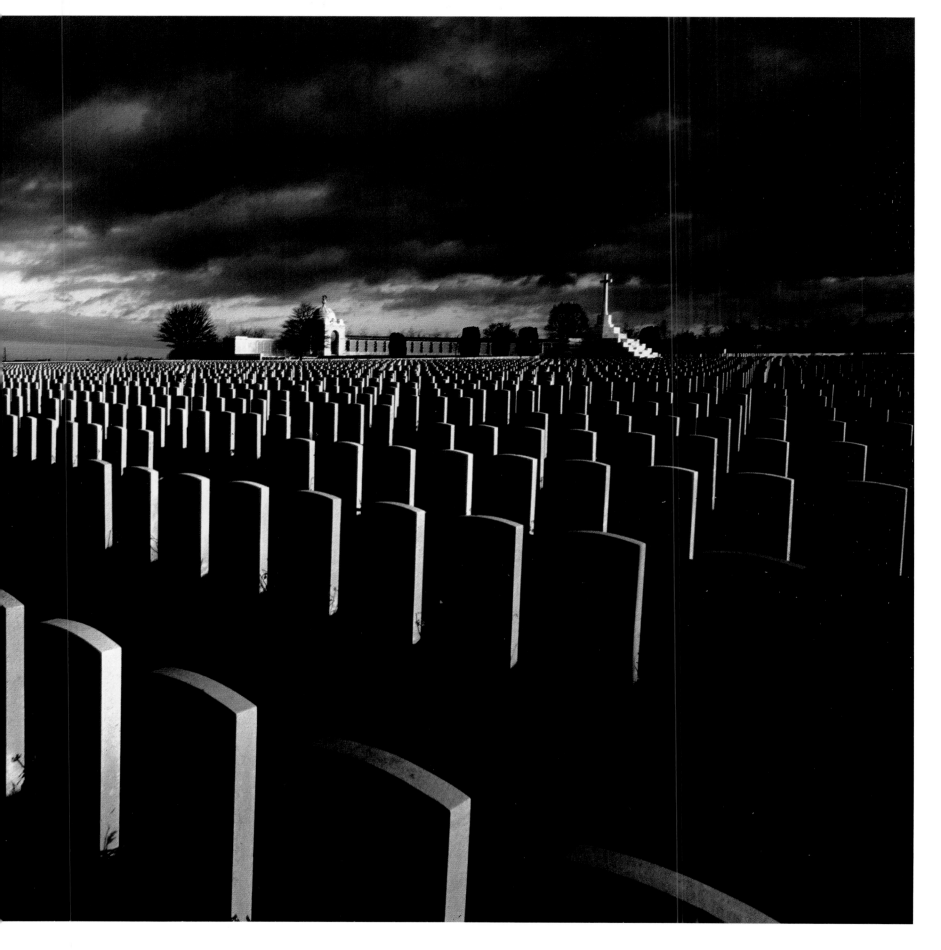

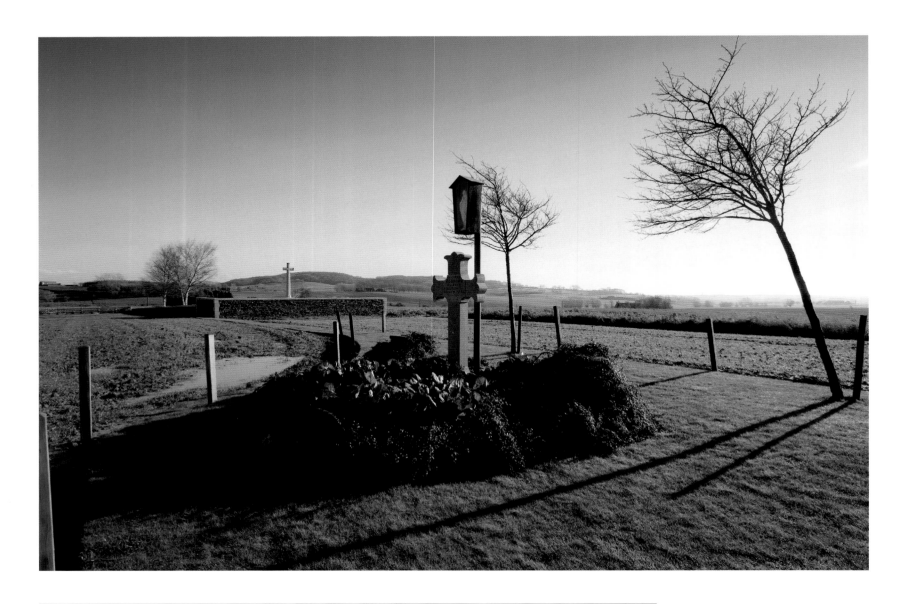

Locre Hospice Cemetery

Heuvelland, West-Vlaanderen, Belgium

While it changed hands multiple times throughout the war, the town of Loker – then known as Locre – was controlled mostly by the Allies, with field ambulances stationed at the nearby Convent of St Antoine. Locre Hospice Cemetery was begun in 1917 and today contains the graves of over 200 men.

On the northern edge of the cemetery, a Celtic cross marks the final resting place of Major William (Willie) Redmond, an Irish nationalist politician and a determined advocate of Irish Home Rule. Major Redmond, aged 53 when he enlisted, was mortally wounded at the Battle of Messines and was buried here in 1917. After the Armistice, his widow erected this memorial to mark his grave, which was maintained by a sister from the hospice until the 1950s.

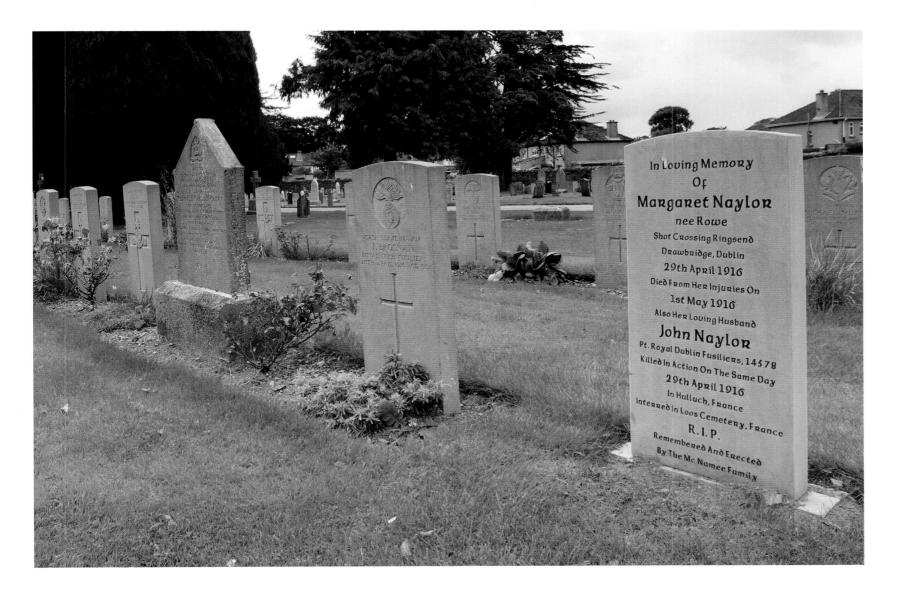

Grangegorman Military Cemetery
County Dublin, Ireland

Margaret Naylor was shot and mortally wounded in Dublin during the Easter Rising – on the very same day that her husband died serving with the Royal Dublin Fusiliers in France.

There are over 600 First World War burials in this cemetery, including a number of those who died when the RMS *Leinster* was sunk by a U-boat just outside Dublin Bay in October 1918.

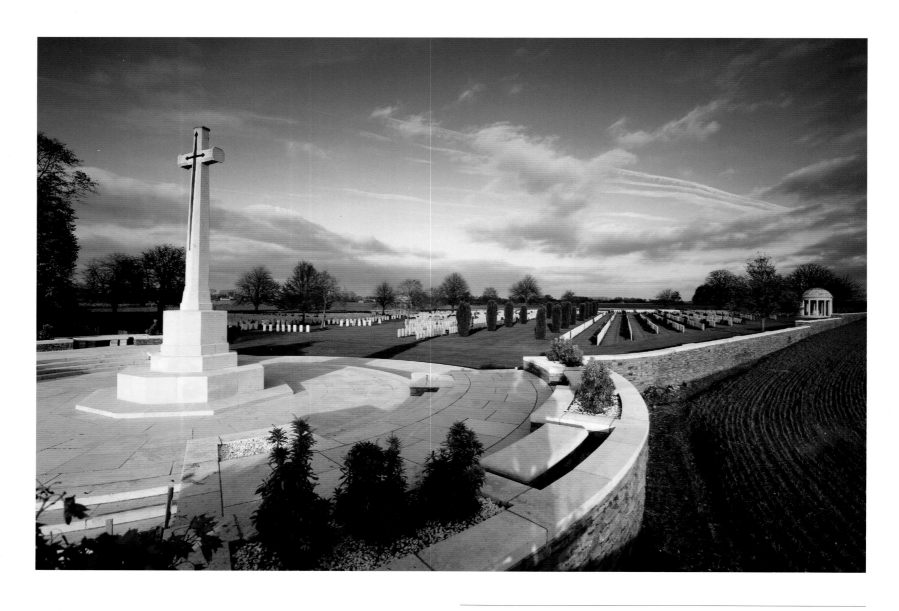

Bedford House Cemetery
Ieper, West-Vlaanderen, Belgium

Before the war the Kasteel Rozendaal, or Bedford House as it was known to the British troops, was a moated country mansion set in wooded parkland. Its ruins – some battered masonry and part of the moat – can be seen in the cemetery today. The chateau was behind Allied lines for the whole of the war but the front was never far away. Though shelled to destruction by the German artillery, its deep cellars and ruined outbuildings offered valuable refuge to a succession of billets and dressing stations for the wounded. Men lived and died here. Today, with more than 5,000 graves, Bedford House is one of the largest and most beautiful cemeteries in the Salient.

Ramparts Cemetery, Lille Gate

Ieper, West-Vlaanderen, Belgium

Ramparts Cemetery often appears on the list of the CWGC staff's favourite sites. The cemetery is quite small (almost 200 graves) and is sited between the bustling city of Ieper and the ancient defences of the Lille Gate and moat.

During the war, the fortifications provided protection against German artillery and the British Army used the location for various military units' headquarters.

The cemetery was begun in November 1914 by French soldiers who buried their dead here while using the protection of the fortified ramparts to provide shelter and living spaces near to the Lille Gate. After the Armistice the French graves were removed from the cemetery – which now contains the dead of Commonwealth forces who used the cemetery from February 1915 until April 1918.

There are almost 200 Commonwealth graves in the cemetery, which was designed by Sir Reginald Blomfield. Among them is the grave of 17-year-old Sapper William Scholz and men of the New Zealand Maori (Pioneer) Battalion. Pioneers were not front-line fighting units but a military labour force trained and organised to work on engineering projects, digging trenches, building roads, railways and any other logistical task deemed necessary. This was essential and dangerous work that was often carried out under fire.

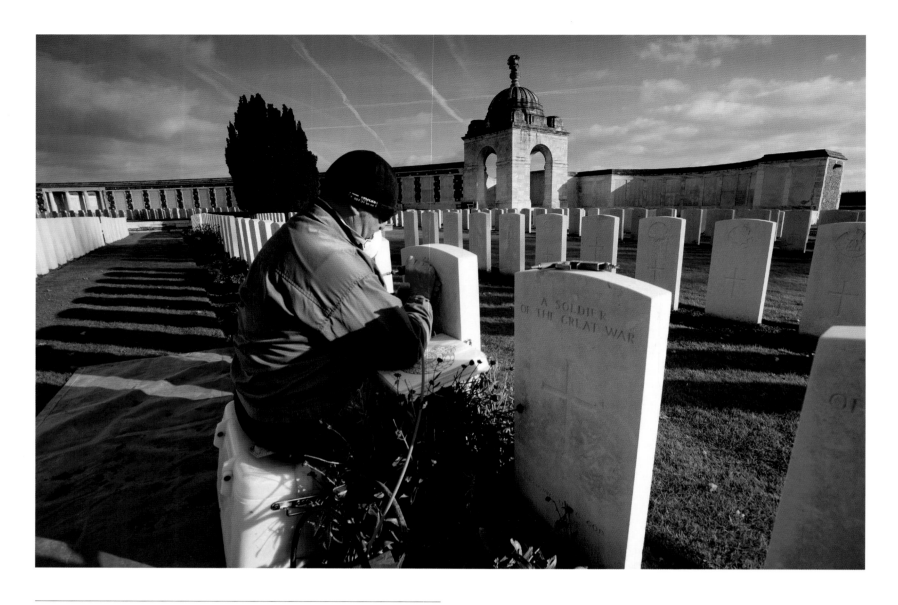

Tyne Cot Cemetery

Zonnebeke, West-Vlaanderen, Belgium

A significant part of the Commission's day-to-day work is centred on ensuring the inscriptions on headstones and memorial panels remain legible. In northern Europe, more than 19,000 headstones a year are re-engraved in situ by teams of stonemasons. Working in all weathers, their skill ensures that the names of the fallen are not forgotten.

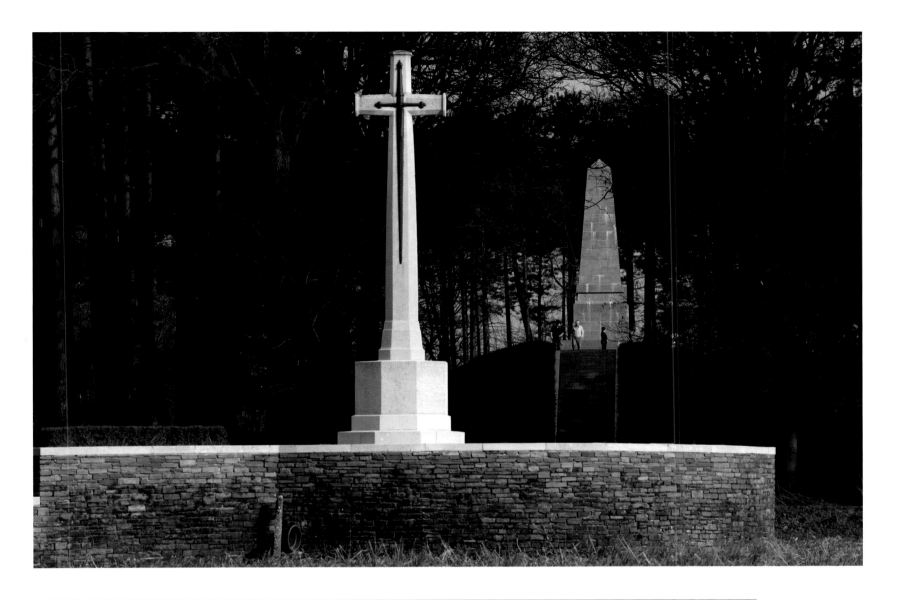

Polygon Wood Cemetery
Zonnebeke, West-Vlaanderen, Belgium

One of the smaller war cemeteries on the Western Front, Polygon Wood's irregular shape indicates it is a front-line cemetery. It was designed by Charles Holden and contains just over 100 graves.

The wood saw action during the First Battle of Ypres in 1914. On 25 October the 1st Irish Guards and 2nd Grenadier Guards were ordered to advance towards the German-held northern half. Nine Irish Guards were killed and four wounded by one single shell. The battalions were reinforced by the 3rd Coldstream Guards, and attacked again the next day. Emergency rations were given to the Irish Guards, who had been without food for 48 hours. During these actions, the 1st Irish Guards' medical officer Lieutenant Hugh Shields was killed while trying to tend the wounded. He has no known grave, and is commemorated on the Menin Gate.

Lonsdale Cemetery
Authuille, Somme, France

On 1 July 1916, the first day of the Battle of the Somme, the 32nd Division, which included the 1st Dorsets and the 11th (Lonsdale) Battalion of the Border Regiment, attacked the German line at this point and stormed the Leipzig Salient, but were compelled to retire later in the day.

In the spring of 1917, after the German withdrawal to the Hindenburg Line, V Corps cleared these battlefields and made a number of new cemeteries, including this one. The cemetery originally contained only 96 graves – all in Plot I – but now contains over 1,500.

This breathtaking aerial shot shows the landscape in which the battles of the First World War were fought.

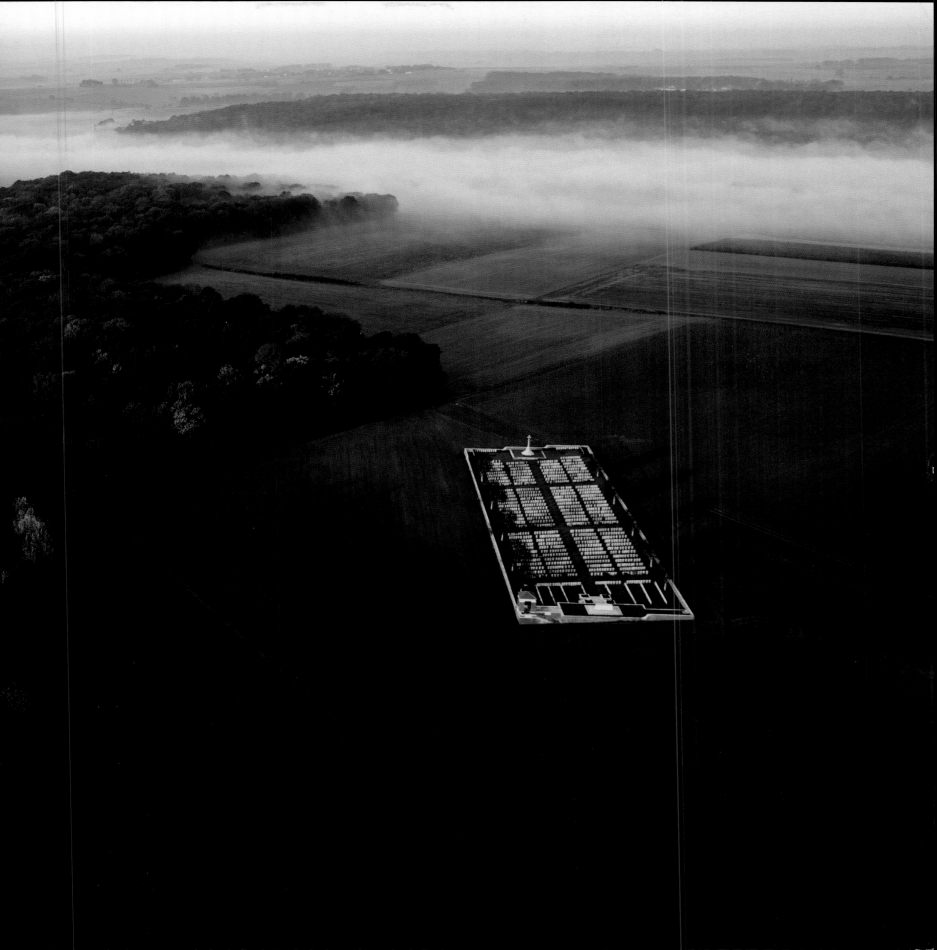

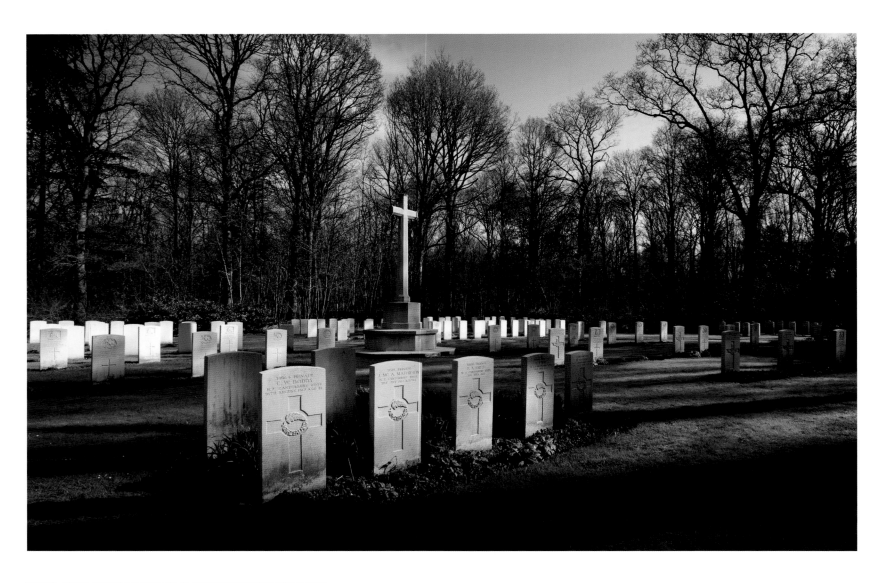

Ploegsteert Wood Military Cemetery
Comines-Warneton, Hainaut, Belgium

Ploegsteert Wood Military Cemetery was made by the enclosure of a number of small regimental cemeteries and contains just over 160 burials.

Ploegsteert Wood was where Lt Bruce Bairnsfather of the Royal Warwickshires drew his first war cartoons and where the legendary 'Old Bill' character – a pipe-smoking British Tommy with a walrus moustache – was born. Bairnsfather spent Christmas 1914 in the sector and spoke to German soldiers during that year's Christmas truce.

The … battalions … were meeting with steady gas-shelling, and on their entering Ploegsteert Wood, in whose stagnant air the gas lay densely, the difficulties increased. Long stoppages occurred, intervals of tense anxiety for all ranks. Here and there officers and men were hit direct by gas-shell … and fell out by the way, retching and collapsed.

Charles Bean, *Official History of Australia in the War of 1914–1918*

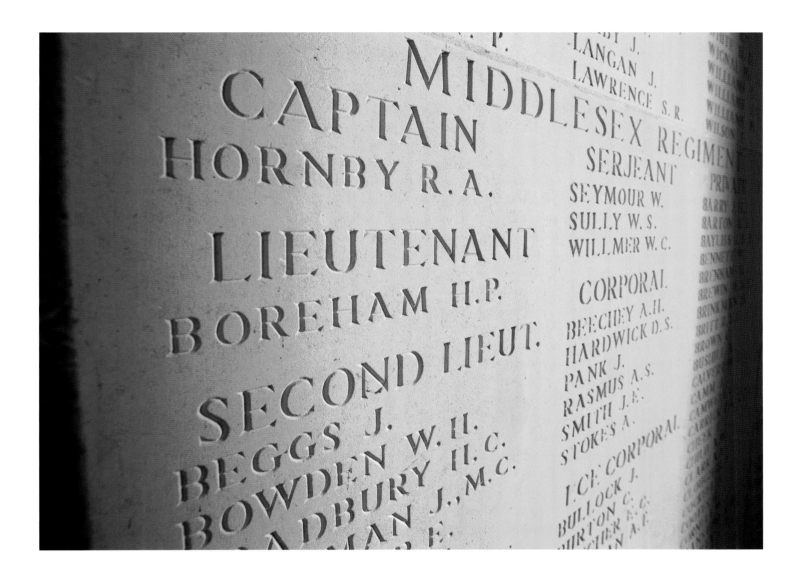

Ploegsteert Memorial
Comines-Warneton, Hainaut, Belgium

For much of the First World War the area around Ploegsteert, known as 'Plugstreet' by the troops who served here, was a relatively quiet sector of the Western Front. It was used to rest or train units before they were sent to take part in major offensives. Berks Cemetery Extension was begun in June 1916 and used continuously until September 1917. It contains over 870 First World War burials. Within the cemetery stands the Ploegsteert Memorial, commemorating more than 11,000 servicemen who died in this sector and who have no known grave. The majority did not die in major offensives but in the course of the day-to-day trench warfare which characterised this part of the line. The Memorial was unveiled on 7 June 1931 by the Crown Prince of Belgium, later King Leopold III.

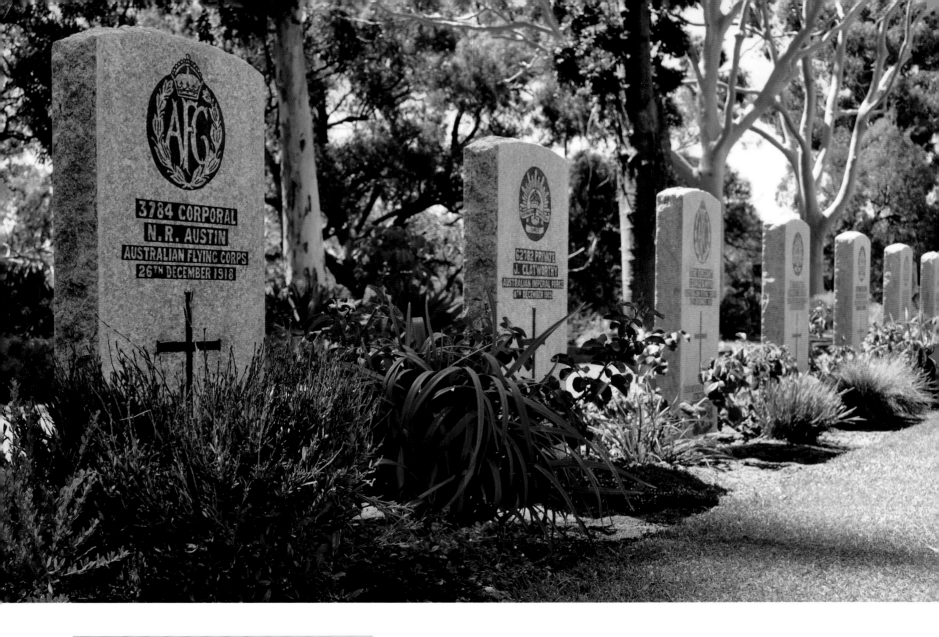

Perth War Cemetery and Annexe
Western Australia

Although predominantly a Second World War cemetery,
there are 16 First World War burials here. The majority date
from the post-war period from the influenza pandemic. The
graves are cared for by the Office of Australian War Graves,
which acts as the Commission's agent in Australia but also
commemorates Australians who died in conflicts other than
the two world wars.

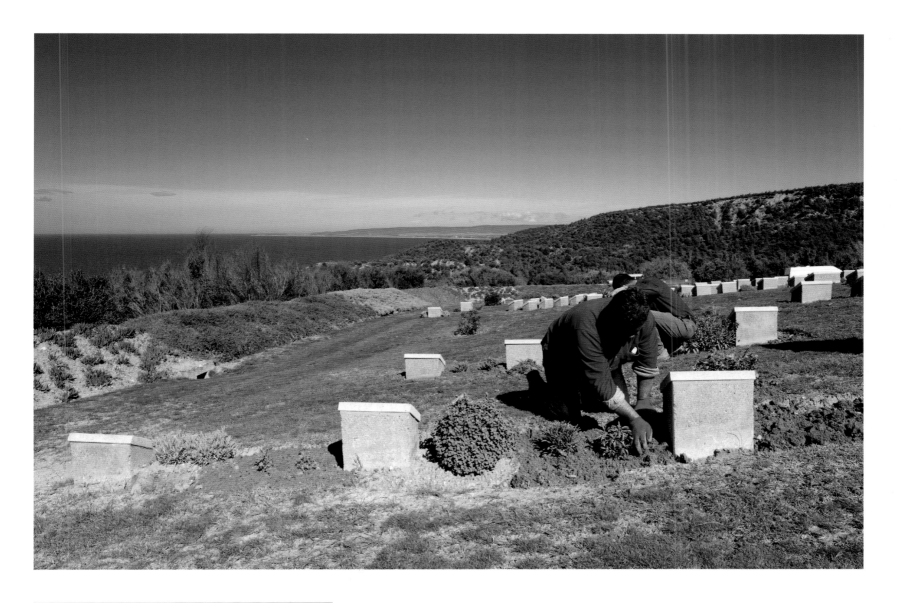

Shell Green Cemetery
Gallipoli, Turkey

Replanting headstone borders at Shell Green Cemetery.
The aim is to produce the effect of a garden; a place where
the harmonious combination of the various elements help
the visitor to achieve a sense of peace in a beautiful and
serene setting.

Buff Bay Cemetery
Jamaica

Calvin Hill, the local village stonemason, sits behind the
only Commonwealth war grave in Buff Bay Cemetery –
to Private Alexander Bennett of the Jamaica Contingent,
British West Indies Regiment, who died on 1 February 1917.
Despite the surroundings being overwhelmed by tropical
vegetation, Bennett's gravestone is immaculate.

The men of the British West Indies Regiment (BWIR)
were generally restricted to hard labour, digging trenches
and carrying supplies. Some, mainly those stationed in the
Middle East, were allowed to serve as combat troops. Every
member of the regiment was a volunteer. Of the 10,000 men
who left Jamaica, 1,000 never returned.

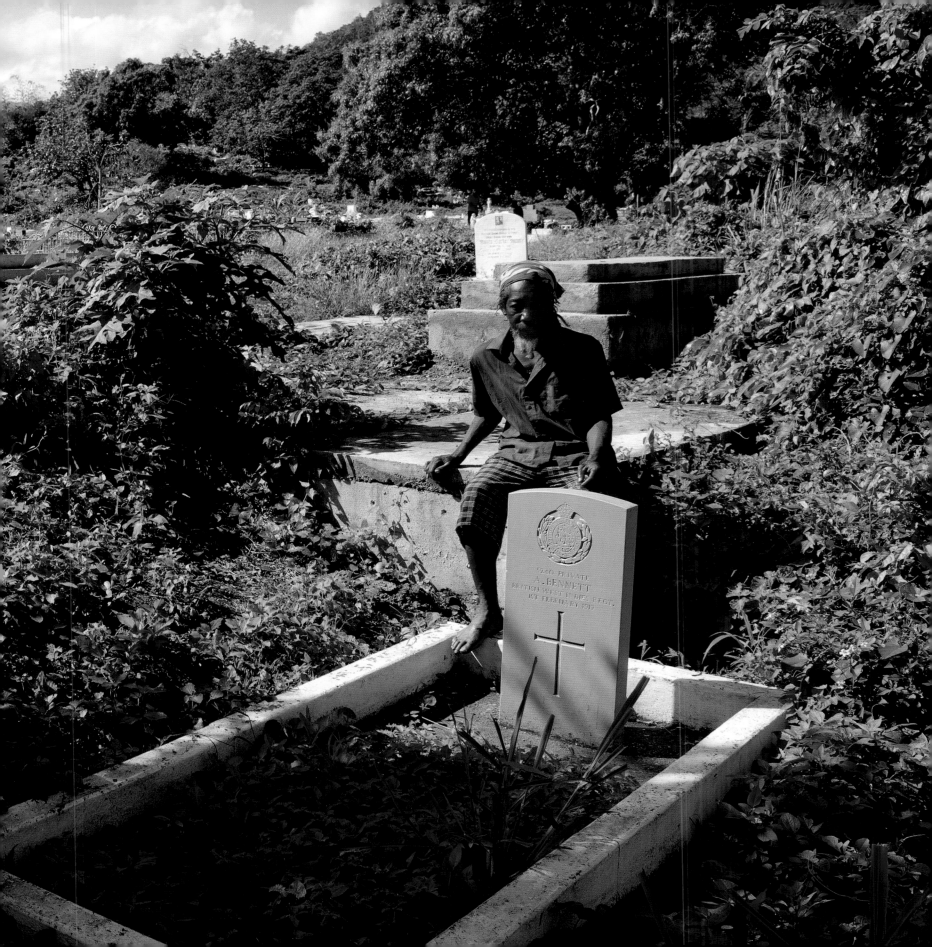

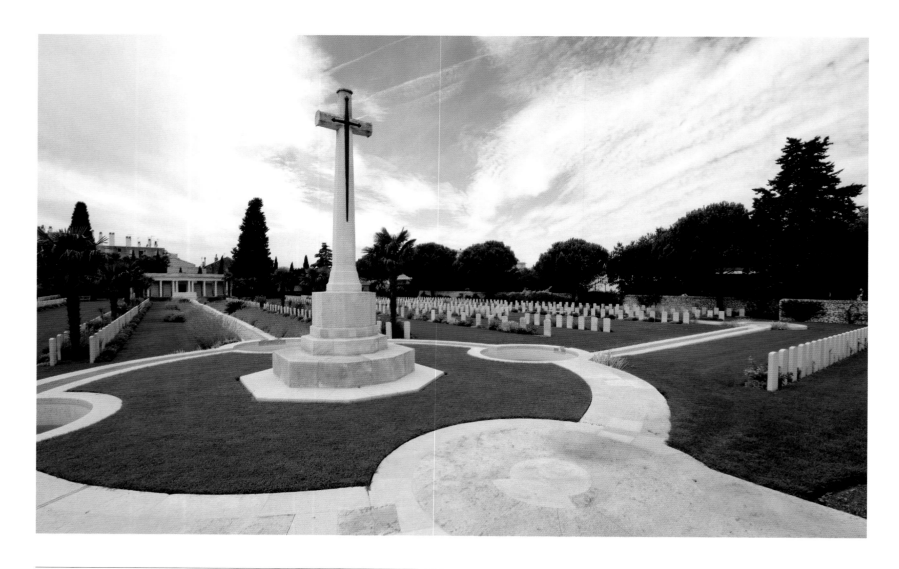

Mazargues War Cemetery
Marseilles, France

The Indian Expeditionary Force arrived in the Mediterranean port of Marseilles between the end of September and mid-October 1914. They were immediately deployed to the Ypres Salient in an attempt to stem the German advance, where they suffered heavy casualties.

Marseilles remained a base of operations throughout the war – four of the town cemeteries were originally used for the burial of Commonwealth servicemen before the graves were brought here after the Armistice. There are more than 1,500 burials in the cemetery.

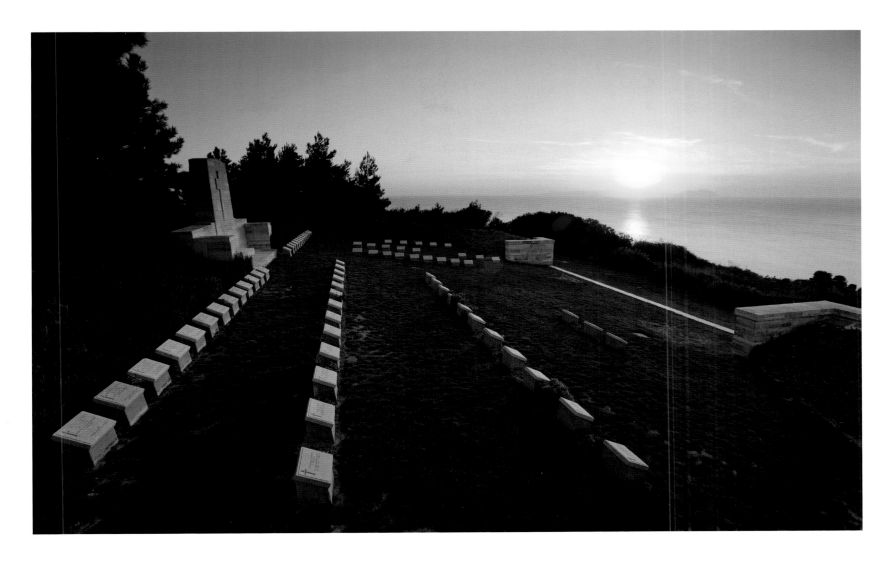

Walker's Ridge Cemetery, Anzac
Gallipoli, Turkey

The Ridge was named after Brigadier-General Harold Walker who commanded the New Zealand infantry at the landing on 25 April and established his headquarters here. The cemetery, which contains almost 100 burials, was made during the occupation and consists of two plots separated by 18 metres of ground, through which a trench ran.

James Cowen, in *The Maoris in the Great War*, gives an account of an attack on Turkish positions here by the Maori contingent:

The Turks still held this trench further on, and the Maoris could hear their voices. The advance party worked towards them, and Captain Dansey said, 'Let's charge them!' This the little party did. They yelled as they went, with bayonets at the charge,

Ka mate, ka mate!
Ka ora, ka ora!

the ancient Maori battle-song ...
Some Maoris fell, but the victory was with them.

Ka mate, ka mate!

159

Soissons Memorial
Aisne, France

Eric Kennington's understated sculpture gives the Soissons Memorial a unique and even modernistic appearance. His three blank-eyed soldiers guard a memorial that bears almost 4,000 names of men who died during the Battles of the Aisne and the Marne in 1918 and who have no known grave.

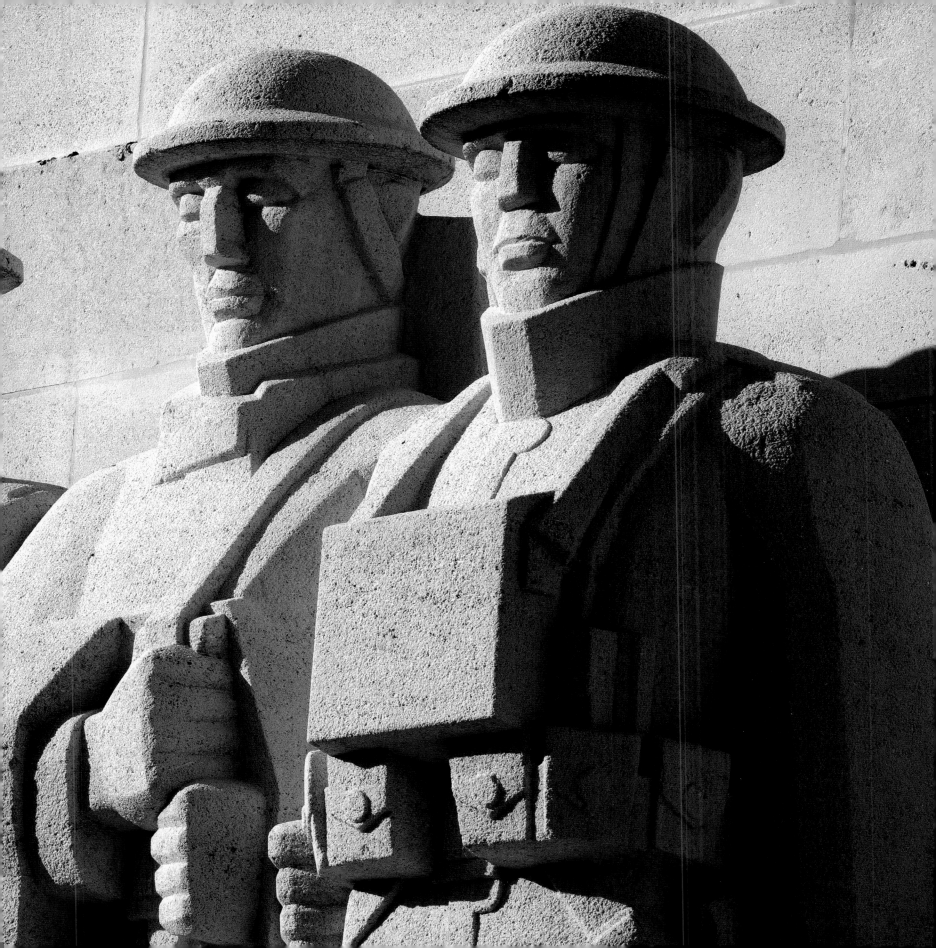

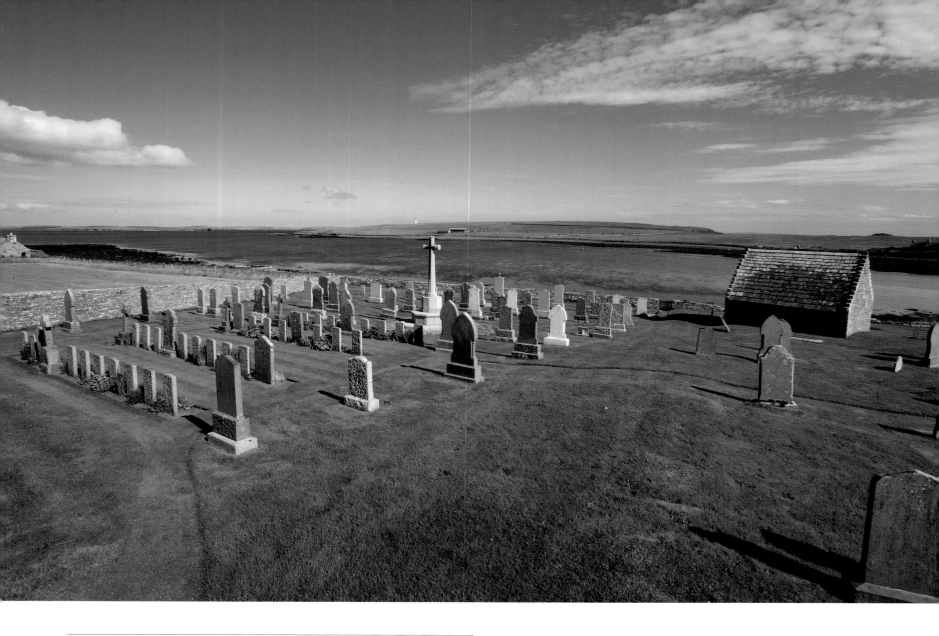

Osmondwall Cemetery

Orkney, Scotland

Despite its remote location on the edge of the Orkney Islands, the grass and graves within Osmondwall Cemetery are well-tended and demonstrate the Commission's dedication to the task of commemorating the war dead, no matter where their graves lie.

Located on the Scapa Flow – the base for the British Grand Fleet during the First World War – almost all of the graves within this cemetery are of naval casualties.

Plymouth Naval Memorial
Devon, England

After the First World War, an appropriate way had to be found of commemorating those members of the Royal Navy who had no known grave, the majority of deaths having occurred at sea where no permanent memorial could be provided.

An Admiralty committee recommended that the three manning ports in Great Britain – Chatham, Plymouth and Portsmouth – should each have an identical memorial of 'unmistakable naval form'; an obelisk, which would serve as a leading mark for shipping. The memorial commemorates more than 7,200 sailors of the First World War and almost 16,000 of the Second World War.

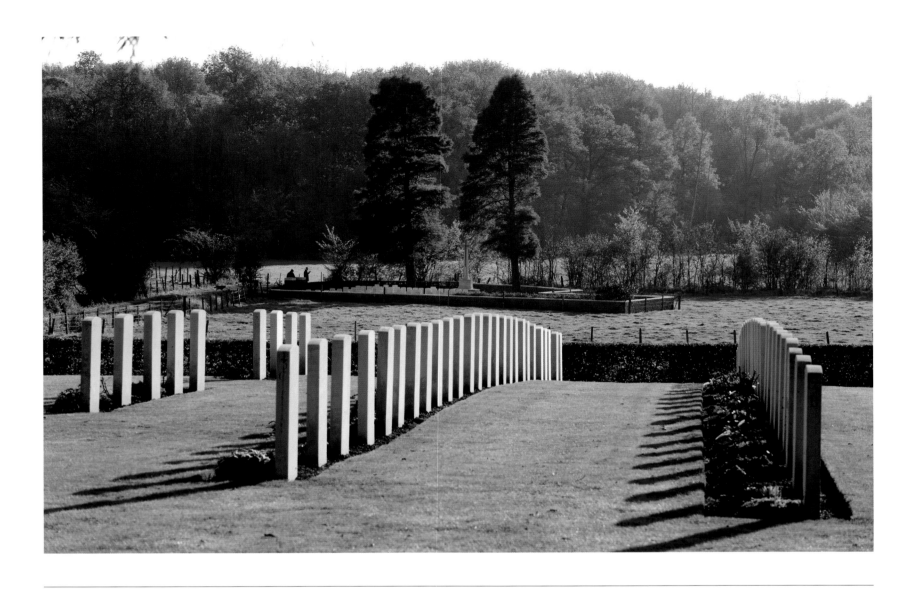

Prowse Point Military Cemetery
Comines-Warneton, Hainaut, Belgium

Prowse Point Military Cemetery is the only cemetery in the Ypres Salient to be named after an individual, Brigadier-General Charles Prowse DSO of the 1st Somerset Light Infantry who was killed on 1 July 1916 – the first day of the Battle of the Somme. It was begun by the Dublin Fusiliers and 1st Warwicks and was in use from November 1914 to April 1918. It contains 160 UK burials, 12 Australian, 12 German and one Canadian.

Private Harry Wilkinson of the 2nd Battalion Lancasters was buried here with full military honours on 31 October 2001, after his remains were identified by forensic examination. He was killed in action a mile away on the Flanders battlefield on 10 November 1914. His burial coincided with the 25,000th playing of the Last Post at the Menin Gate.

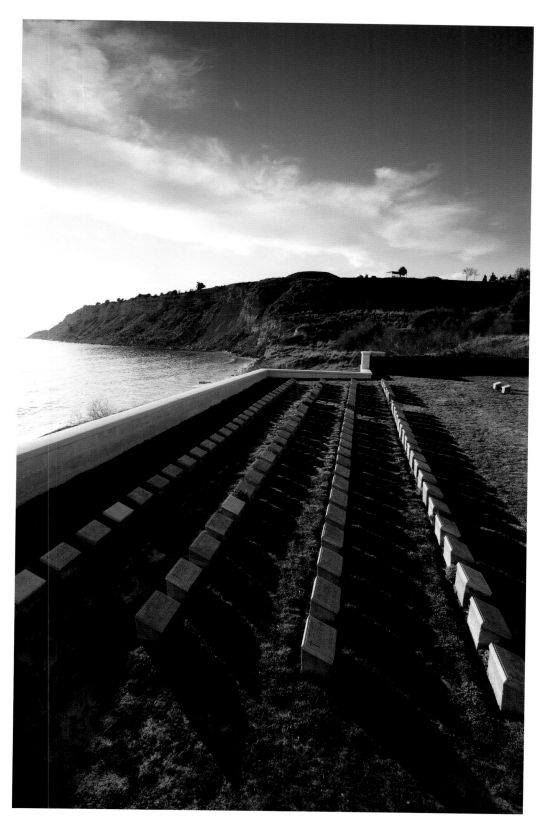

V Beach Cemetery
Gallipoli, Turkey

V Beach was one of the key landing sites for the British forces at Cape Helles, where men fought their way ashore from small boats and the converted merchant ship the SS *River Clyde*.

The beach was strongly fortified by Turkish forces who fired down at the advancing small boats. Within seconds, a devastating fire swept the shoreline – virtually every boat full of wounded or dead. Eventually some men made it to the protection of a 6ft-high bank on the shore.

V Beach Cemetery is named after one of the five beaches around the toe of the Peninsula that were used in the Helles landings on 25 April 1915. The cemetery is right on the beach and was begun the day after the invasion. It contains almost 700 burials.

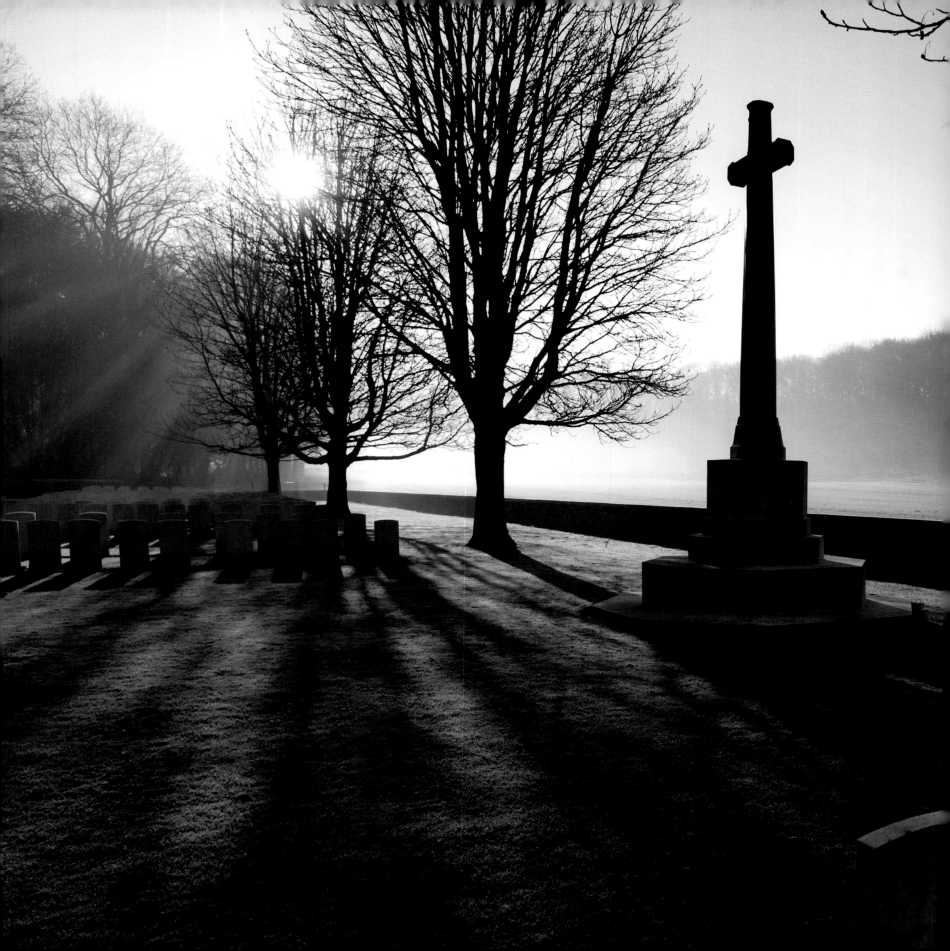

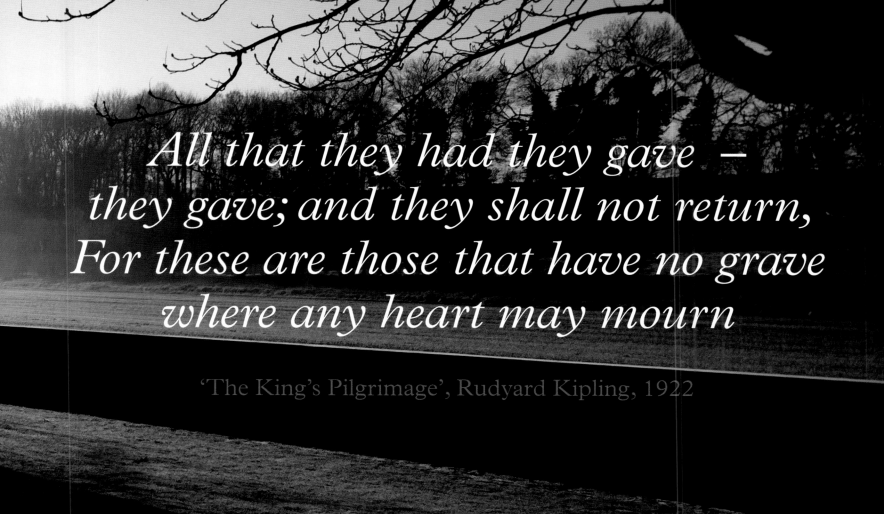

All that they had they gave –
they gave; and they shall not return,
For these are those that have no grave
where any heart may mourn

'The King's Pilgrimage', Rudyard Kipling, 1922

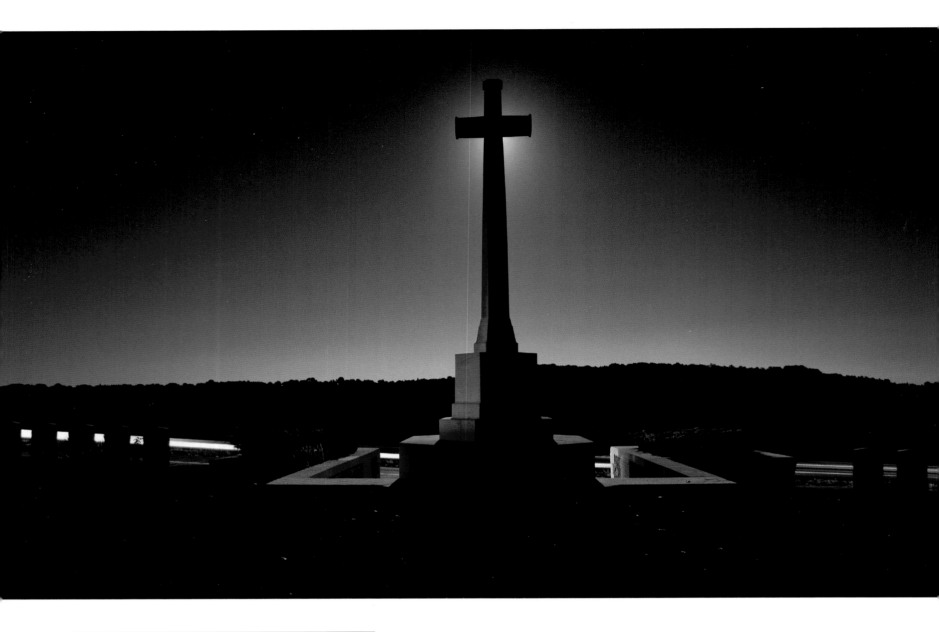

Vendresse British Cemetery
Aisne, France

The neighbourhood of Vendresse-et-Troyon was the scene of repeated and severe fighting in 1914 and 1918.

Vendresse British Cemetery was made after the Armistice by the concentration of graves from other cemeteries and from the surrounding battlefields. It now contains over 700 burials.

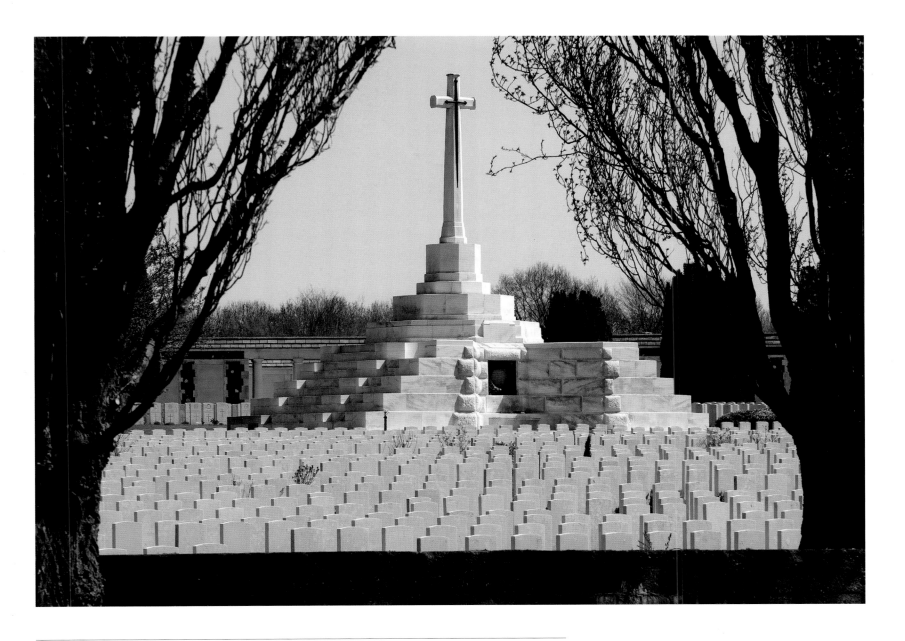

Tyne Cot Cemetery
Zonnebeke, West-Vlaanderen, Belgium

At the suggestion of King George V, who visited Tyne Cot Cemetery in 1922, the Cross of Sacrifice was placed on the original large German pill-box.

The Tyne Cot Memorial, which forms the boundary of the cemetery, bears a further 35,000 names of servicemen from the United Kingdom and New Zealand who died in the Ypres Salient after 16 August 1917 and whose graves are not known. The memorial stands close to the farthest point in Belgium reached by Commonwealth forces in the First World War until the final advance to victory.

Courcelette British Cemetery
Somme, France

The commune and village of Courcelette were the scene of heavy fighting in September 1916. The battle is notable for the first use of tanks in war – or 'land battleships' as they were known. The cemetery was begun in November 1916 and now contains almost 2,000 burials.

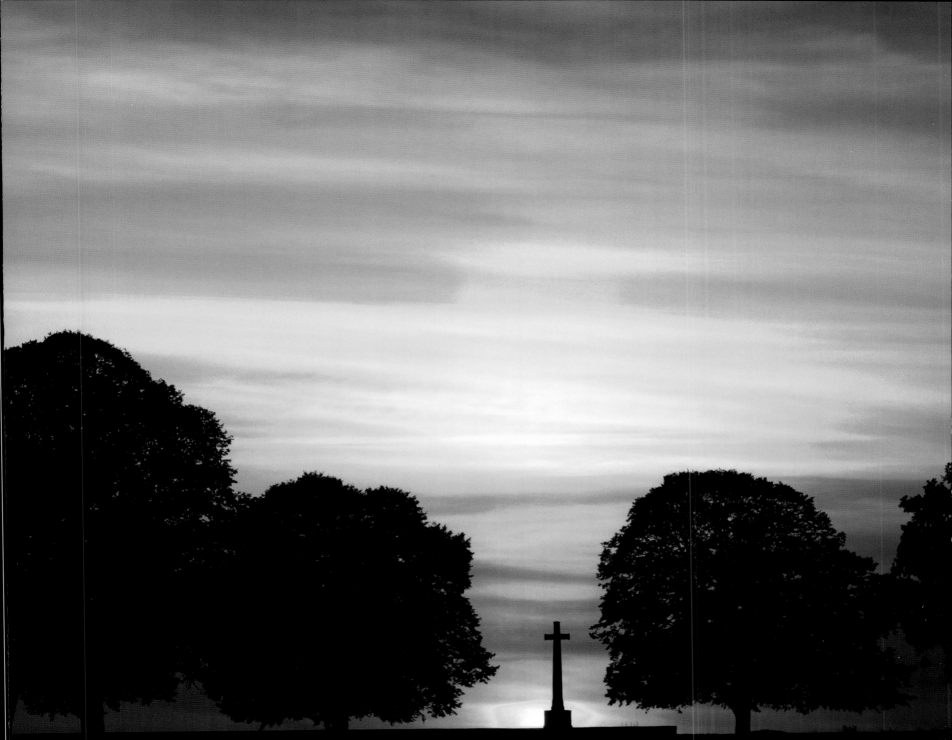

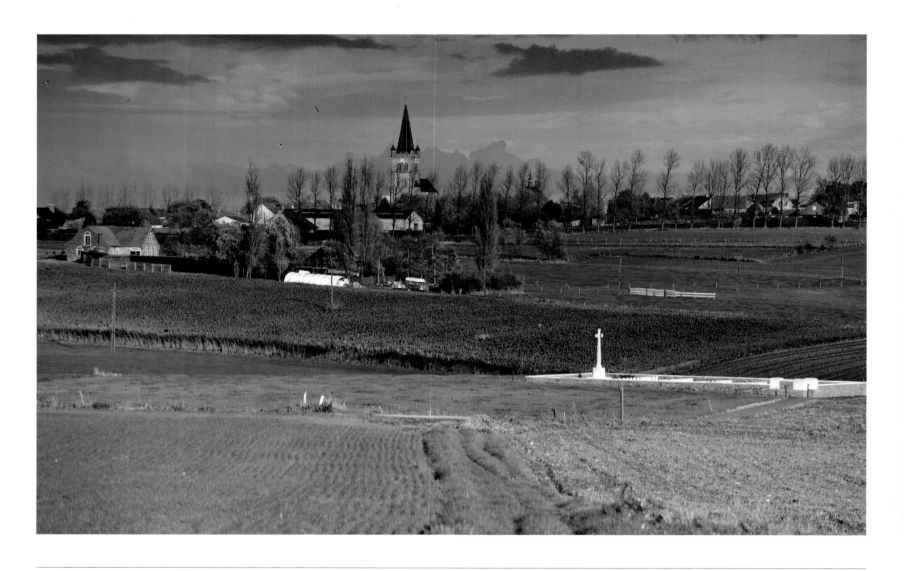

Spanbroekmolen British Cemetery
Heuvelland, West-Vlaanderen, Belgium

Almost 60 casualties of the First World War are commemorated in this cemetery named after a local windmill (*molen* is the Dutch word for mill).

Following the first Battle of Ypres in November 1914 the Germans established their front line here on the high ground of the Messines Ridge. This gave them excellent views of the British positions.

Near the cemetery is the Spanbroekmolen Mine, or the Pool of Peace as it is now called. The mine was one of 19 detonated under German positions in June 1917 to devastating effect. The cemetery contains the graves of men killed in action on the first (or in three cases the second) day of the battle. The cemetery was destroyed in subsequent operations but found again after the Armistice.

Sarigol Military Cemetery
Kriston, Greece

From April to June 1917 the 35th Casualty Clearing Station was at Sarigol. It was replaced by the 21st Stationary Hospital, which remained until December 1918. From these two hospitals, 150 burials were made in the cemetery, many of them men who had been wounded in the Allied attack on the Grand-Couronne and Pip Ridge in April–May 1917 and September 1918.

In February 1921, 560 graves were brought into Sarigol from Janes Military Cemetery, a few miles to the north. The cemetery at Janes was on low ground, and, under the normal conditions of this region, it was difficult to approach and almost impossible to maintain in good order. With a few exceptions, the burials were made from the 31st Casualty Clearing Station between August 1916 and October 1918.

The cemetery now contains almost 700 Commonwealth burials of the First World War.

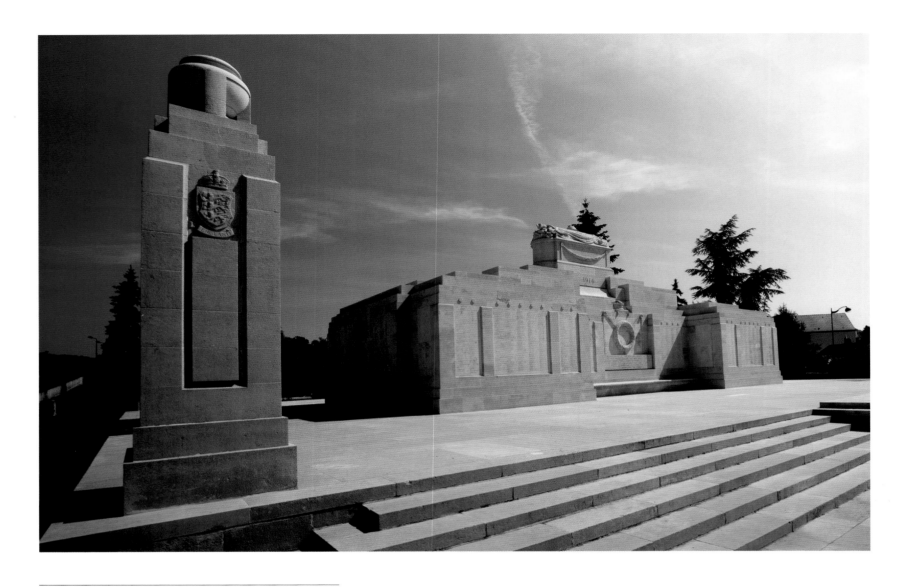

La Ferte-sous-Jouarre Memorial

Seine-et-Marne, France

The memorial commemorates more than 3,700 officers and men of the British Expeditionary Force (BEF) who fell at the battles of Mons, Le Cateau, the Marne and the Aisne between the end of August and early October 1914 and have no known grave.

It was designed by Major George H Goldsmith MC, a veteran of the Western Front who had studied under Sir Edwin Lutyens.

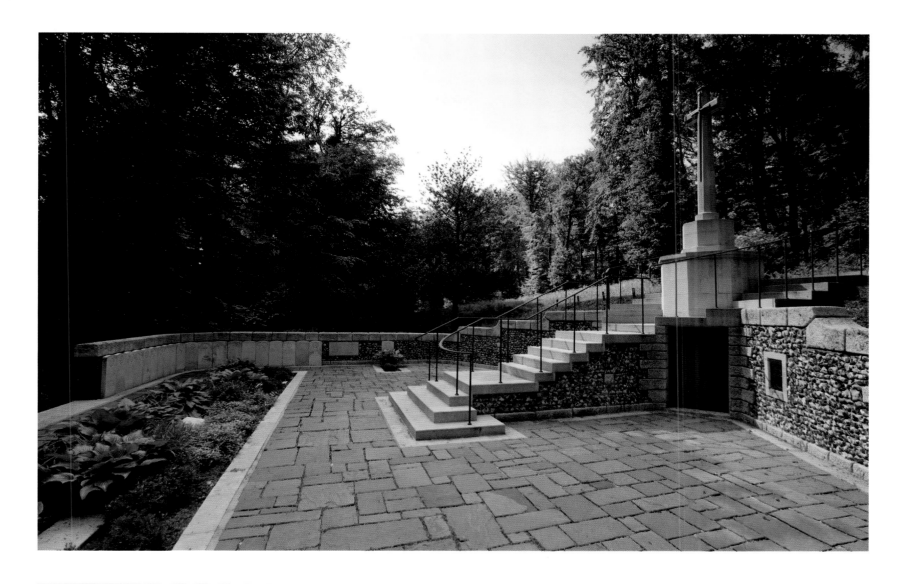

Guards Grave

Villers-Cotterets Forest, Aisne, France

The Fôret de Retz was the scene of a rearguard action
fought by the 4th (Guards) Brigade on 1 September
1914. In the aftermath of the fighting, many of the dead
Guardsmen were buried by the people of Villers-Cotterets.
The cemetery, containing almost 100 graves, was formed
by the Irish Guards when the British forces regained this
territory two months later.

Lone Tree Cemetery
Heuvelland, West-Vlaanderen, Belgium

Lone Tree Cemetery contains almost 90 graves – nearly all of them of men who
died on the first day of the Battle of Messines. The battle began when 19 mines
were detonated under German positions – their craters can still be seen to
this day.

Many of those buried in the cemetery were from the Royal Irish Rifles (36th)
Division who were killed during the mine explosions, having left their trenches
too early. The cemetery was designed by J R Truelove.

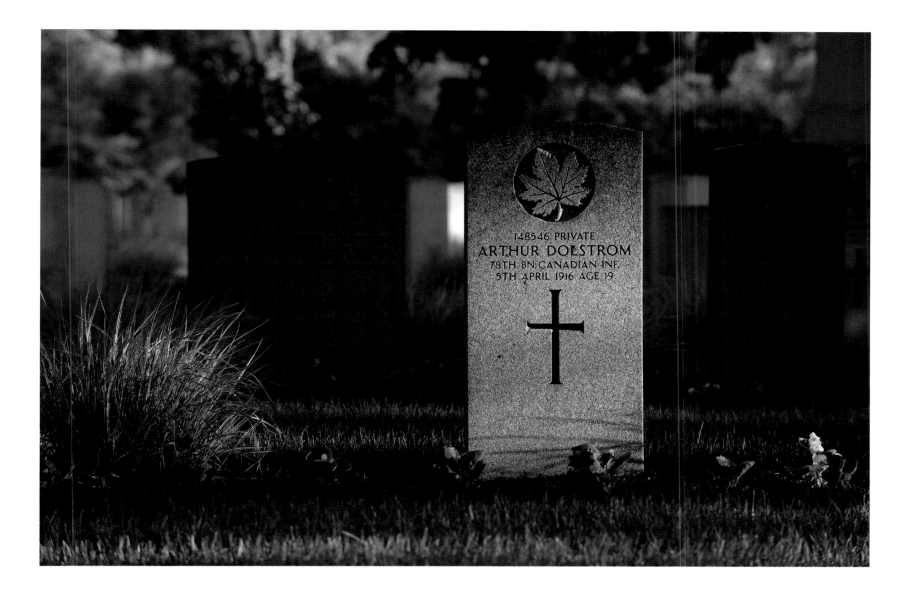

Winnipeg (Brookside) Cemetery
Manitoba, Canada

The distinctive maple leaf adorns the grave of Private Arthur Dolstrom, and the graves of Canadian war dead the world over. CWGC records show that he was the son of Peter and Mary Dolstrom from Minnesota.

During the First World War, Winnipeg was the headquarters of No. 10 Military District and contained six military hospitals with over 970 beds. The cemetery contains almost 300 burials of the First World War and 150 from the Second World War, most of them in a special military plot.

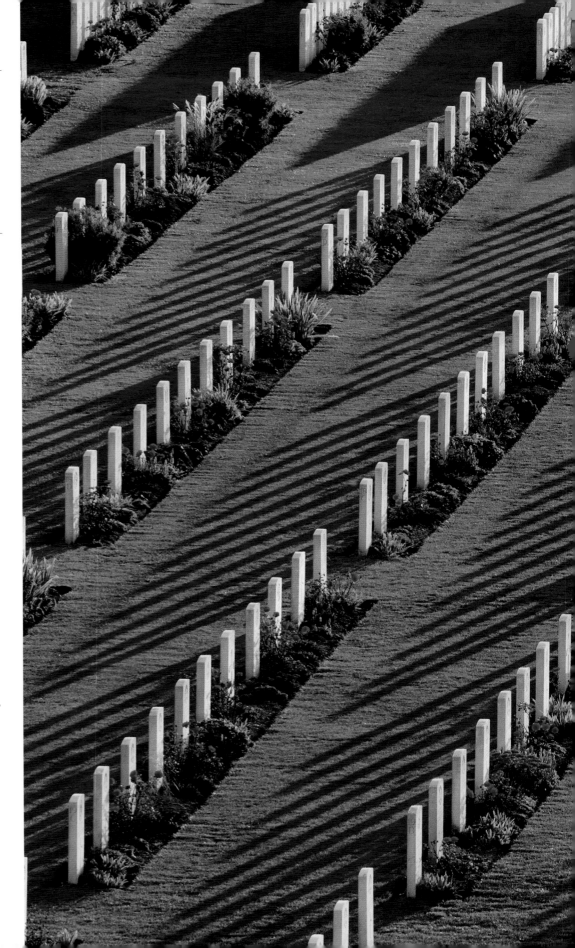

Villers-Bretonneux Military Cemetery and Memorial

Somme, France

Villers-Bretonneux Military Cemetery was created after the Armistice, when graves were brought in from other burial grounds in the area and from the battlefields. More than 2,100 Commonwealth servicemen are buried in the cemetery.

Soldiers of Australia, whose brothers lie here in French soil, be assured that your memory will always be kept alive, and that the burial places of your dead will always be respected and cared for...

Mayor of Villers-Bretonneux, 14 July 1919

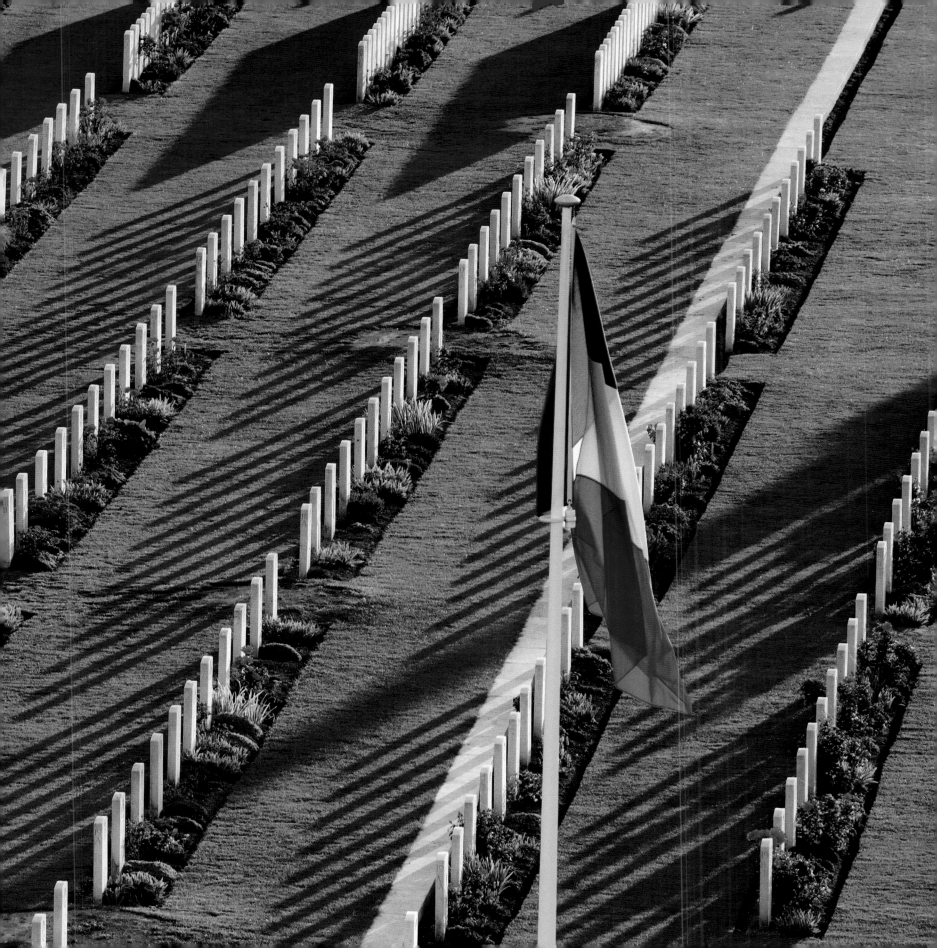

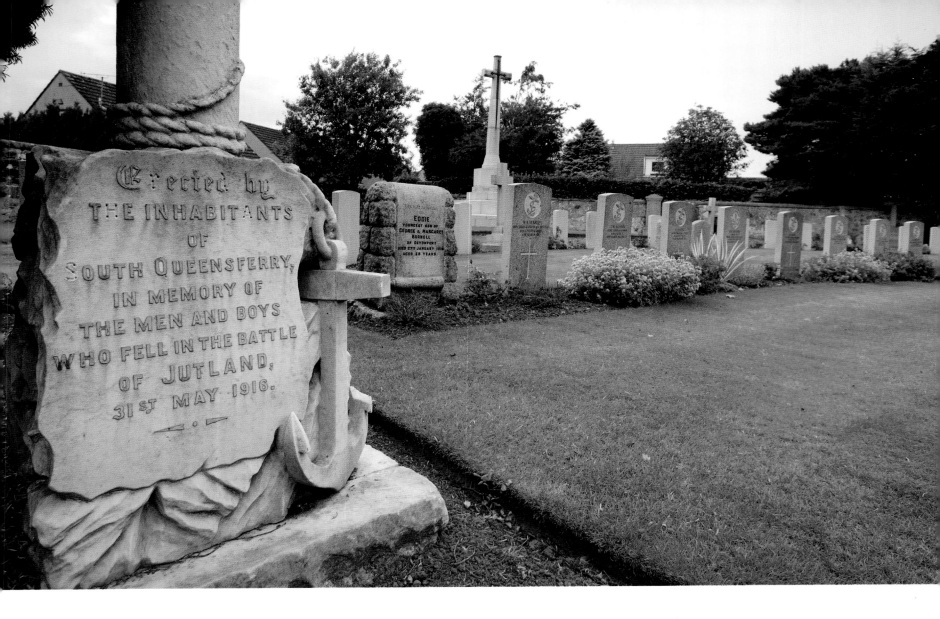

Queensferry Cemetery
West Lothian, Scotland

Queensferry Cemetery overlooks the Firth of Forth and is the final resting place for just under 200 Commonwealth war dead. Almost all are naval personnel, many of whom were killed at the Battle of Jutland in 1916 – the largest naval battle of the First World War.

The Battle of Jutland was the only time that the British and German fleets of 'dreadnought' battleships exchanged fire. The battle involved some 250 ships and 100,000 men.

The British lost 14 ships and over 6,000 men were killed – the majority have no grave but the sea. The Germans lost 11 ships and over 2,500 men, but the German fleet were forced to retreat and never again seriously challenged British control of the North Sea.

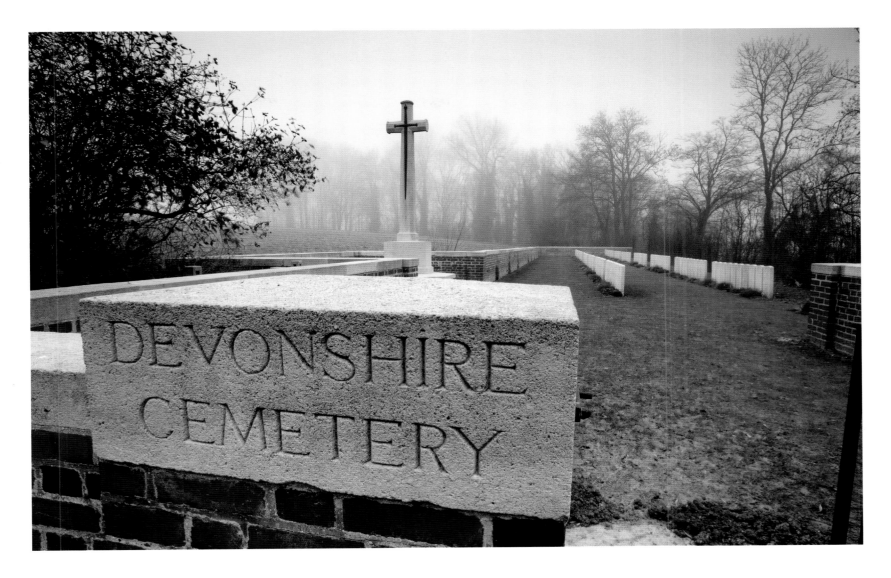

Devonshire Cemetery
Mametz, Somme, France

At the end of the first day of the Battle of the Somme over 160 men of the 9th and 8th Devonshire Regiment were retrieved from where they had fallen and buried in a section of the British front-line trench near a small wood called Mansell Copse.

Three days later a ceremony was held at the burial site and a wooden cross was erected bearing the inscription, right. The cross has since been replaced by a stone tablet but the inscription and the cemetery still honour the men buried here.

The Devonshires held this trench, the Devonshires hold it still.

Ovillers Military Cemetery
Somme, France

On the first day of the Battle of the Somme, two minutes before British troops were due to launch their attack on the villages of Ovillers and La Boisselle, a huge mine was exploded under the German strongpoint Schwaben Háhe. The sound of the blast was thought to be the loudest man-made noise in history up to that point, with reports suggesting it was heard in London.

Despite the successful blowing of the mine and the damage caused to the German strongholds, the defenders managed to get into well-placed positions to fire at the advancing British soldiers. Within half an hour of the start of the infantry attack many hundreds of men were already dead or wounded.

The cemetery was begun before the capture of Ovillers as a battle cemetery behind a dressing station. It was used until March 1917, by which time it contained 143 graves. It now contains almost 3,500 burials.

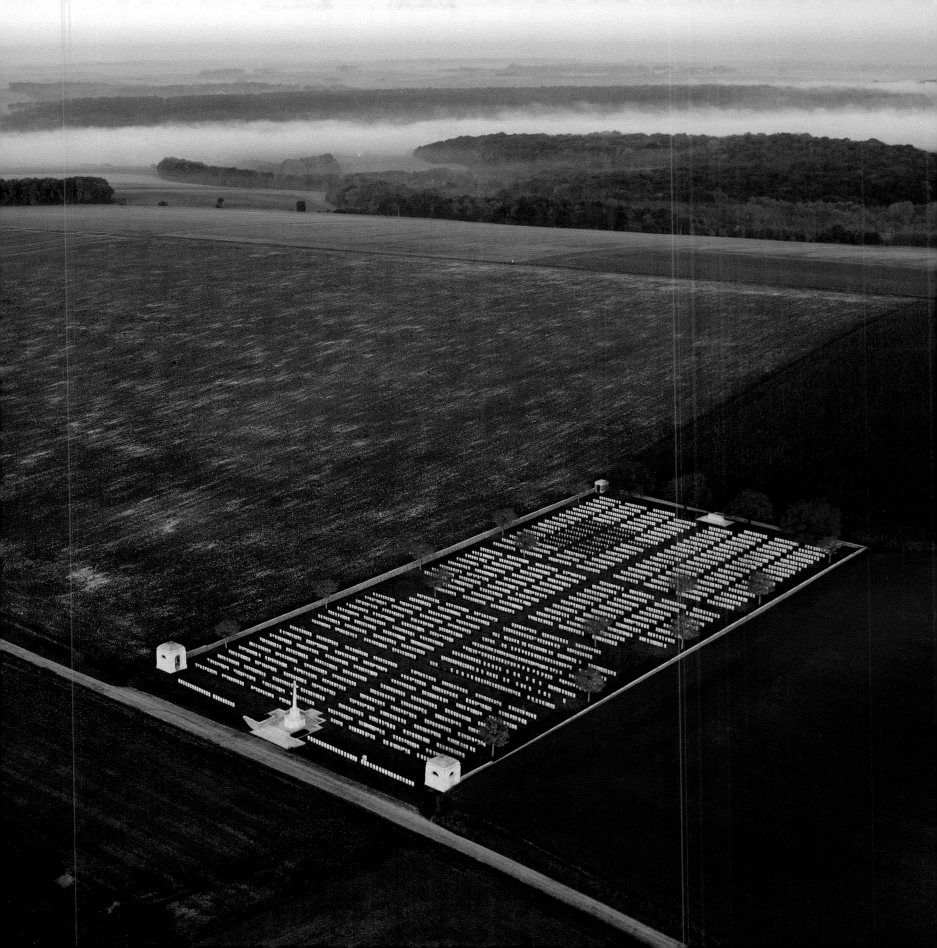

Railway Hollow Cemetery
Hebuterne, Pas de Calais, France

The cemetery is located within the Sheffield Memorial Park, a wooded area owned by Sheffield City Council where the original front-line trenches and shell-holes dating from the Somme offensive have been preserved. It contains just over 100 burials.

The Accrington Pals attacked from trenches here on 1 July 1916 and suffered huge losses. Pals battalions were units of the British Army comprising men who had enlisted together in local recruiting drives, with the promise that they would serve alongside friends, neighbours and work colleagues. Although the policy helped foster a sense of comradeship among newly formed units, when the Pals battalions suffered casualties, individual towns, villages, neighbourhoods and communities were hit hard by these losses.

Belfast (Milltown) Roman Catholic Cemetery
County Antrim, Northern Ireland

The shadow of the Cross of Sacrifice falls across the names
of men commemorated on the screen wall within Belfast
(Milltown) Roman Catholic Cemetery. The Cross was
designed by Sir Reginald Blomfield – one of three principal
architects employed by the Commission after the First
World War – and commemorates the faith of the majority of
Commonwealth war dead.

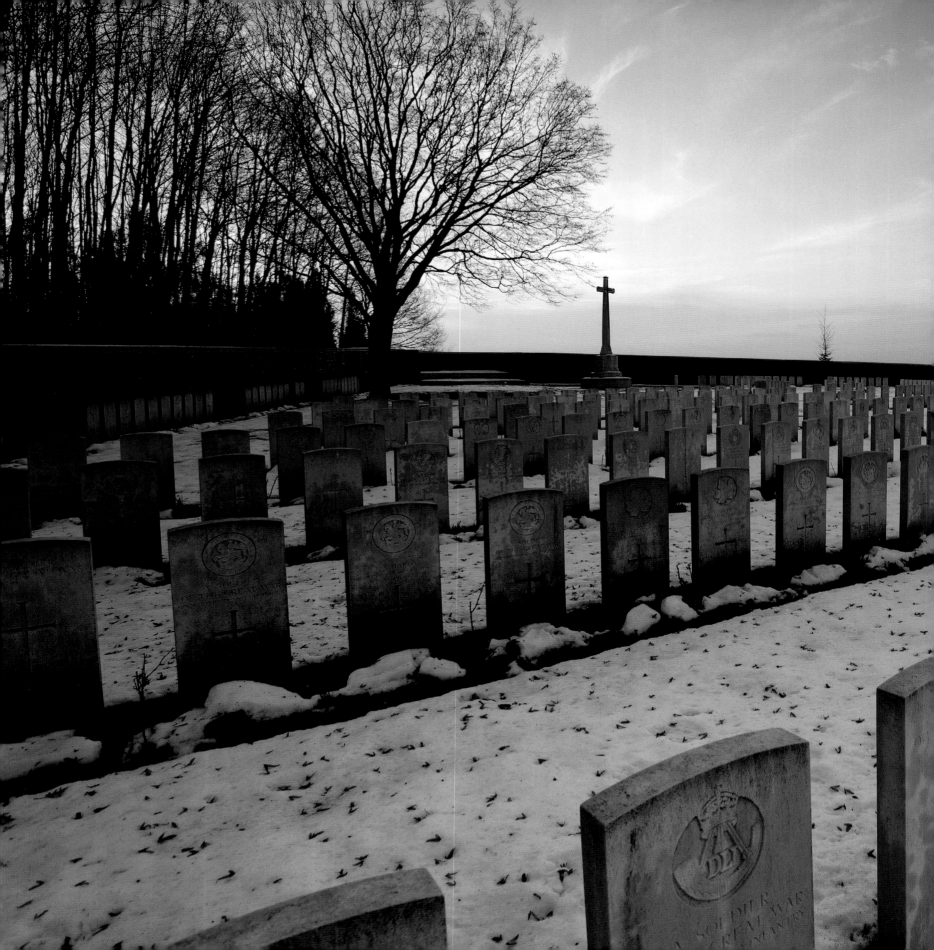

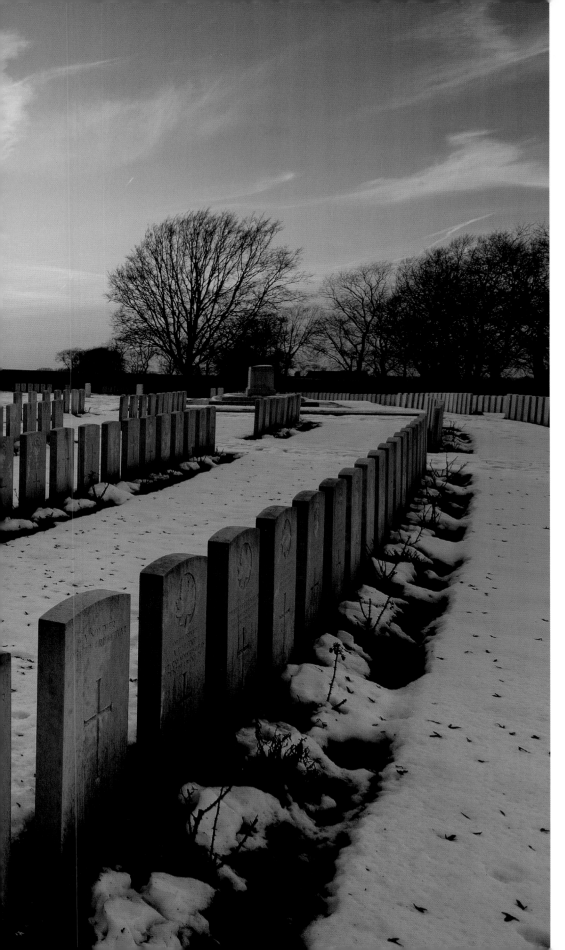

Sanctuary Wood Cemetery
Ieper, West-Vlaanderen, Belgium

Sanctuary Wood, one of the larger woods in the commune of Zillebeke, was named in November 1914, when it was used to screen troops behind the front line. It was the scene of fighting in September 1915 and June 1916.

Originally, there were three Commonwealth cemeteries at Sanctuary Wood, all made in May–August 1915. The first two were on the western end of the wood, the third in a clearing further east. All were practically obliterated in the Battle of Mount Sorrel in June 1916 – a German attack which attempted to draw British forces away from their build-up on the Somme.

Traces of the second cemetery were found and it became the nucleus of the present Sanctuary Wood Cemetery, which was greatly enlarged after the war and now contains almost 2,000 graves.

In Plot I is buried Lieutenant G W L Talbot, in whose memory Talbot House at Poperinghe was established in December 1915. The first list of the graves was made by his brother the Reverend Neville Talbot MC, later Bishop of Pretoria. The cemetery was designed by Sir Edwin Lutyens.

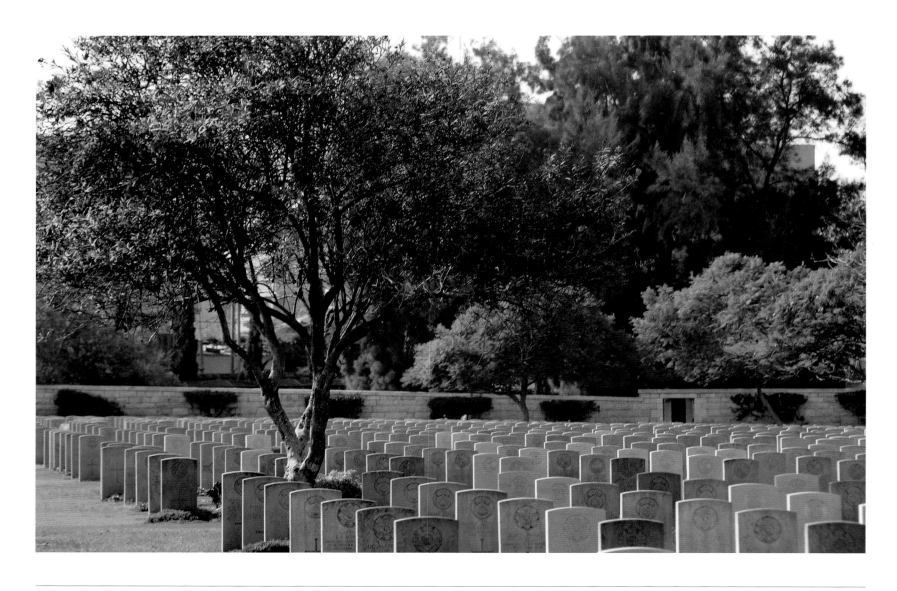

Gaza War Cemetery

Israel and Palestine (including Gaza)

The city of Gaza was captured on 7 November 1917 – following which a number of Casualty Clearing Stations and hospitals were established here. Some of the earliest burials were made by the troops that captured the city.

During the Second World War, Gaza was an Australian hospital base, and the AIF Headquarters were there along with a large number of military hospitals. There was also a Royal Air Force aerodrome at Gaza, which was considerably developed from 1941 onwards.

Gaza War Cemetery contains over 3,200 burials from the First World War, over 200 from the Second World War and more than 260 other graves. The seven members of the CWGC's Gaza Mobile Group maintain the war graves in this most challenging of locations with unwavering commitment and physical and moral courage. Their ingenuity and dedication ensure that the graves are maintained to a standard of excellence.

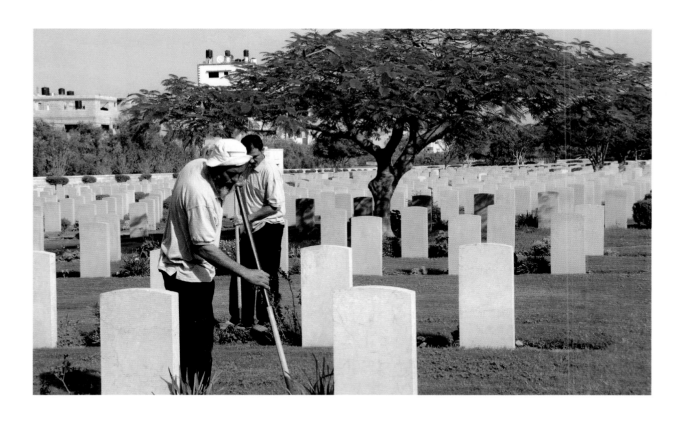

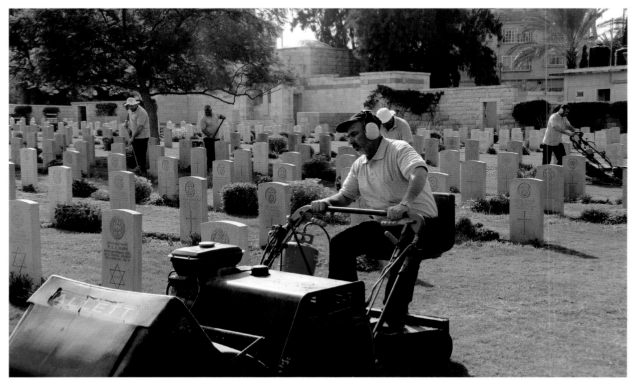

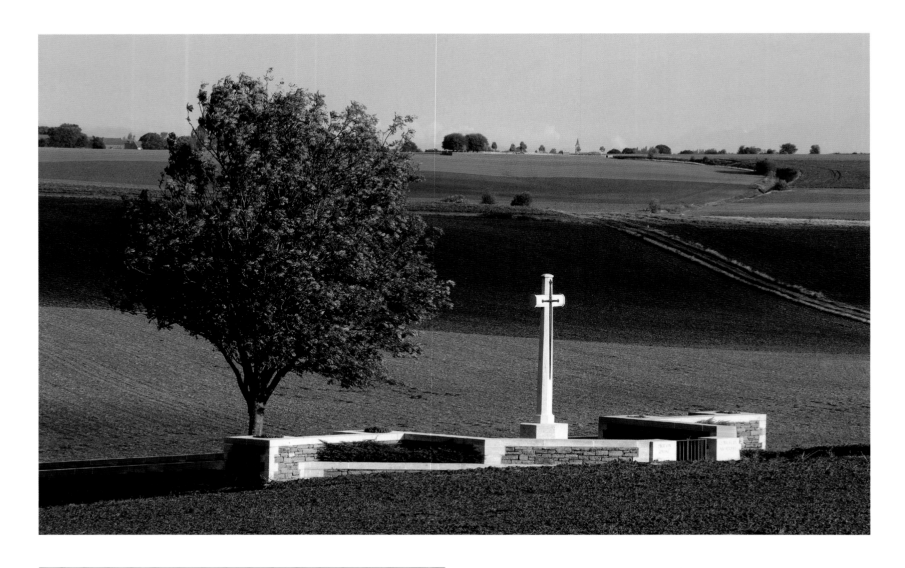

Pigeon Ravine Cemetery
Epehy, Somme, France

The Battle of Epehy was fought on 18 September 1918 with the aim of clearing
German positions on the high ground before the Hindenburg Line. The battle
resulted in the capture of Epehy and although a limited success, large numbers
of prisoners and guns were captured – particularly by the Australian forces under
the command of General Monash.

The cemetery contains over 100 burials and is on the south side of a shallow
valley running east and west, which was the scene of a mounted charge by the
2nd Lancers on 1 December 1917. The cemetery was made by the 33rd Division
Burial Officer at the beginning of October 1918.

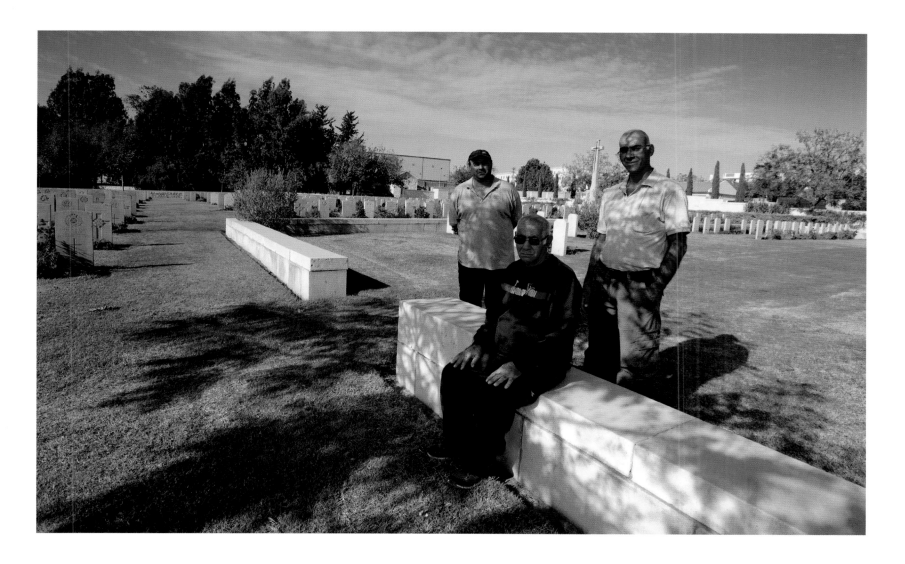

Ramleh War Cemetery
Israel and Palestine (including Gaza)

Ibrahim Khoury and his sons Issa and Johny have clocked up a remarkable 100 years of experience working for the CWGC between them.

The cemetery dates from when Ramleh (now Ramla) was occupied by the 1st Australian Light Horse Brigade on 1 November 1917. Field Ambulances, and later Casualty Clearing Stations, were posted here and the cemetery was begun by the medical units. During the Second World War, this cemetery was used by the Ramla Royal Air Force Station and by various Commonwealth hospitals posted to the area.

The cemetery contains 3,300 Commonwealth burials of the First World War, and over 1,100 of the Second World War.

St Symphorien Military Cemetery
Mons, Hainaut, Belgium

The design of St Symphorien is not the only thing that makes it unique among CWGC cemeteries.

Among those buried at St Symphorien is Private John Parr of the Middlesex Regiment, who was killed on 21 August 1914, two days before the Battle of Mons, thus becoming the first British soldier to be killed in action on the Western Front. The cemetery is also the resting place of Commonwealth and German soldiers who were killed in the final days and hours of the conflict, including George Ellison of the Royal Irish Lancers and George Price of the Canadian Infantry. Ellison and Price were killed not long before 11am on 11 November 1918 and are believed to be the last Commonwealth combat casualties of the First World War.

The graves of Lieutenant Maurice James Dease VC and Musketeer Oskar Niemeyer are also noteworthy. Dease was one of the first British officer battle casualties of the war and the first posthumous recipient of the Victoria Cross. During the battle for the Mons bridges, Niemeyer swam the canal in order to operate the machinery which would swing the bridge back across for his company to follow. Though successful he was killed in the process. It is believed that Niemeyer may be one of the first recipients of the Iron Cross of the war.

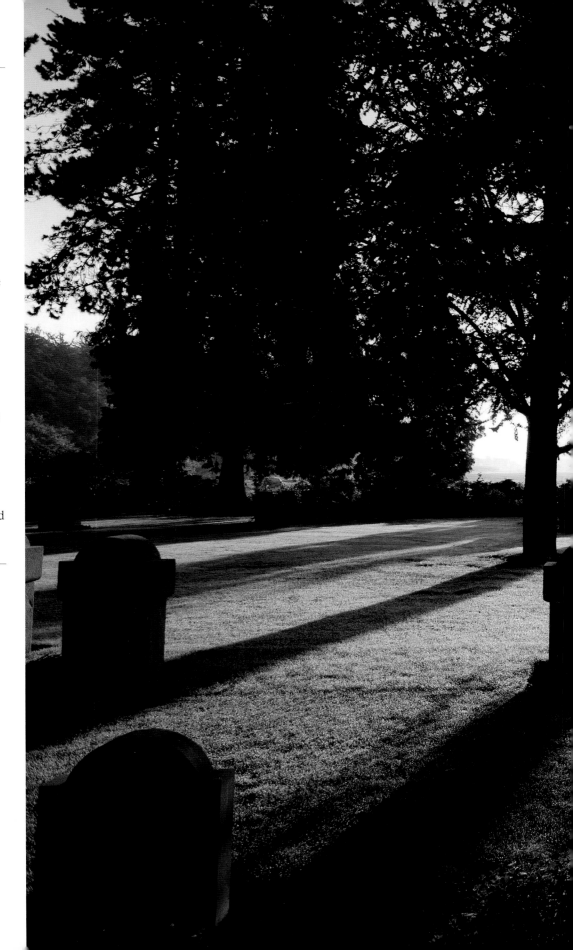

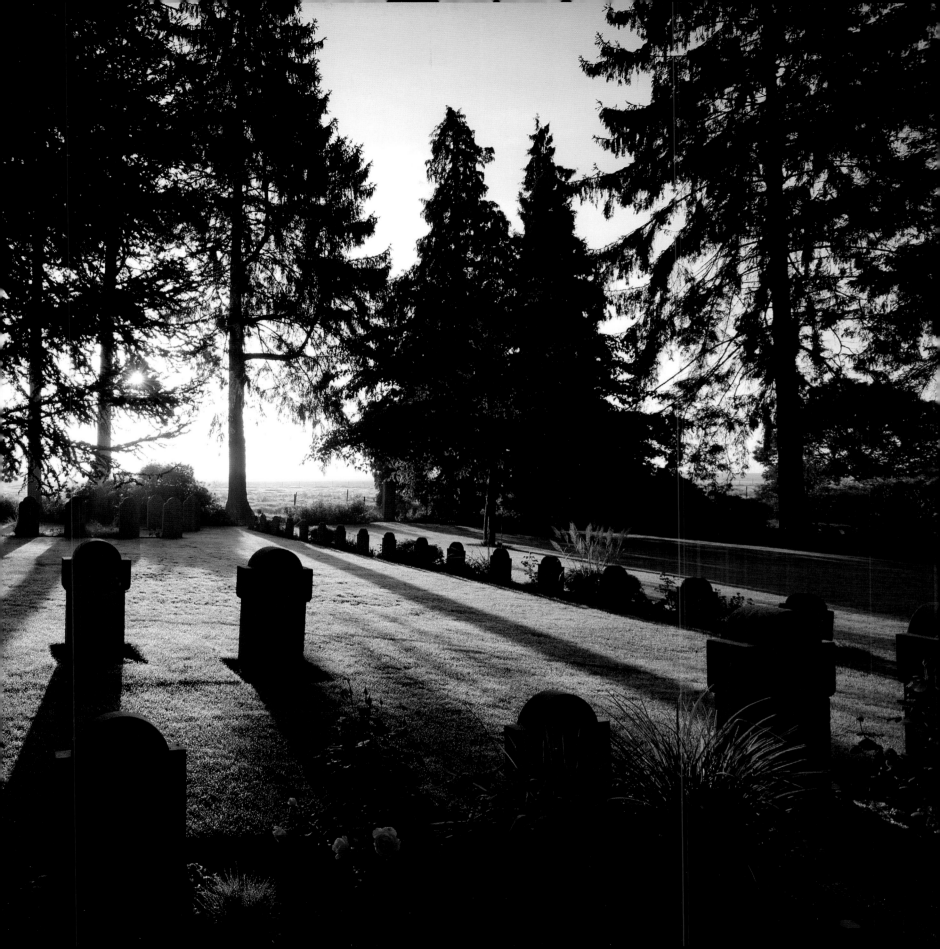

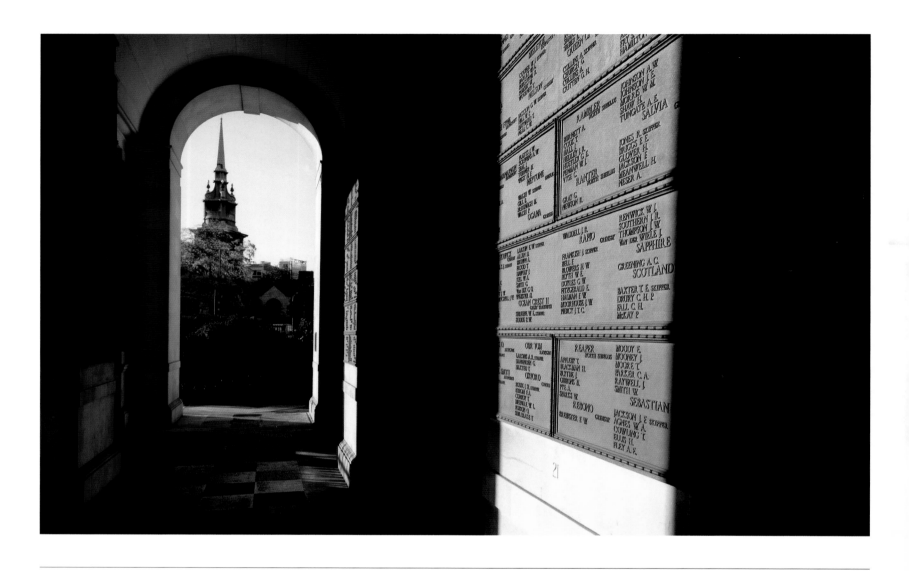

Tower Hill Memorial
London, England

Located in the heart of London is the CWGC's memorial to the sacrifice of the Merchant Navy.

Britain's merchant fleet was the largest in the world at the start of the First World War. The ships were crewed by men from the British Isles and all parts of the Empire. Wartime Britain depended on them to import food and raw materials, as well as transport soldiers overseas, and keep them supplied.

Germany, of course, knew this and operated a policy of sinking merchant vessels on sight. Losses were high from the outset and sometimes averaged more than 13 ships sunk each day. By the end of the war, more than 3,000 British flagged merchant and fishing vessels had been sunk and nearly 15,000 merchant seamen had died.

After the First World War King George V granted the title 'Merchant Navy' in recognition of the contribution made by merchant sailors. The First World War section of the Tower Hill Memorial commemorates almost 12,000 Mercantile Marine casualties who have no grave but the sea. The memorial was designed by Sir Edwin Lutyens with sculpture by Sir William Reid-Dick. It was unveiled by Queen Mary on 12 December 1928.

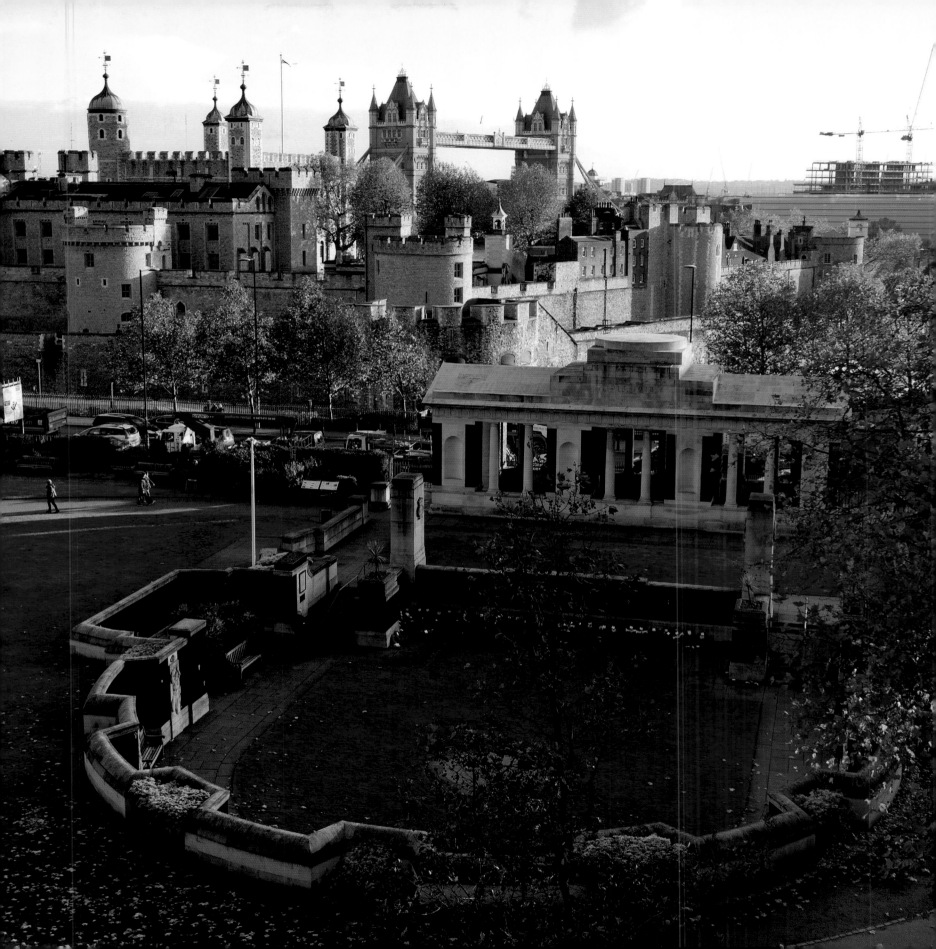

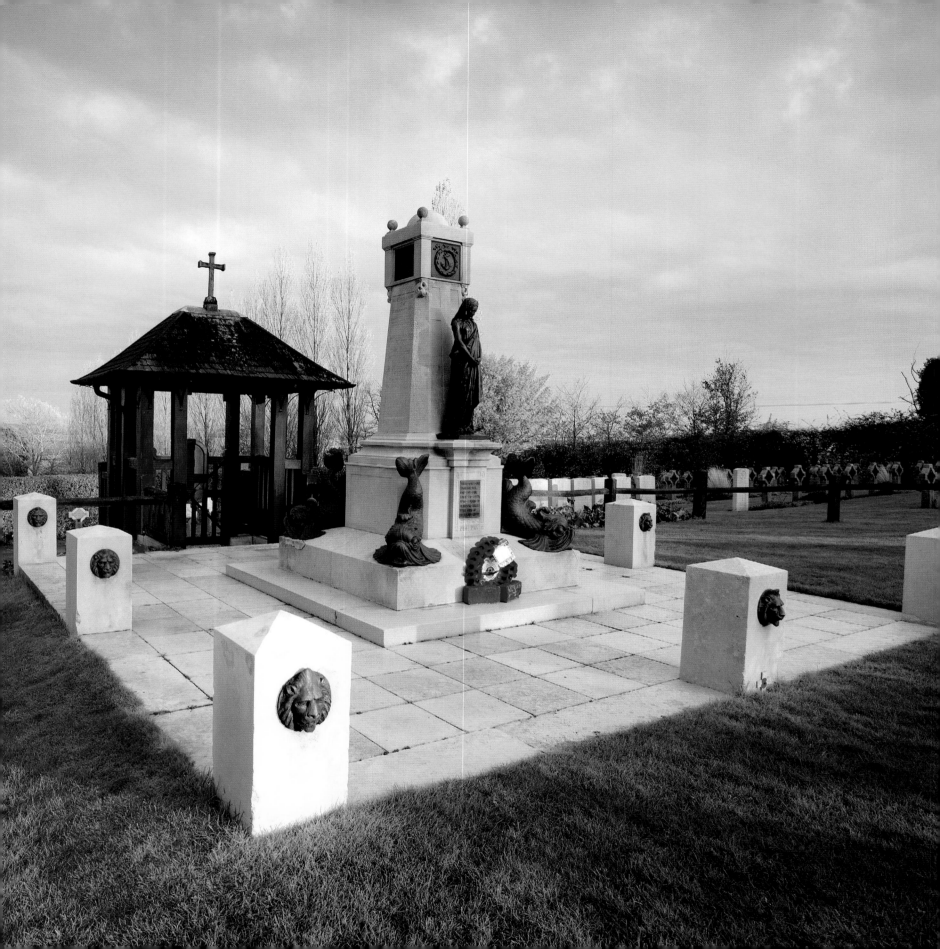

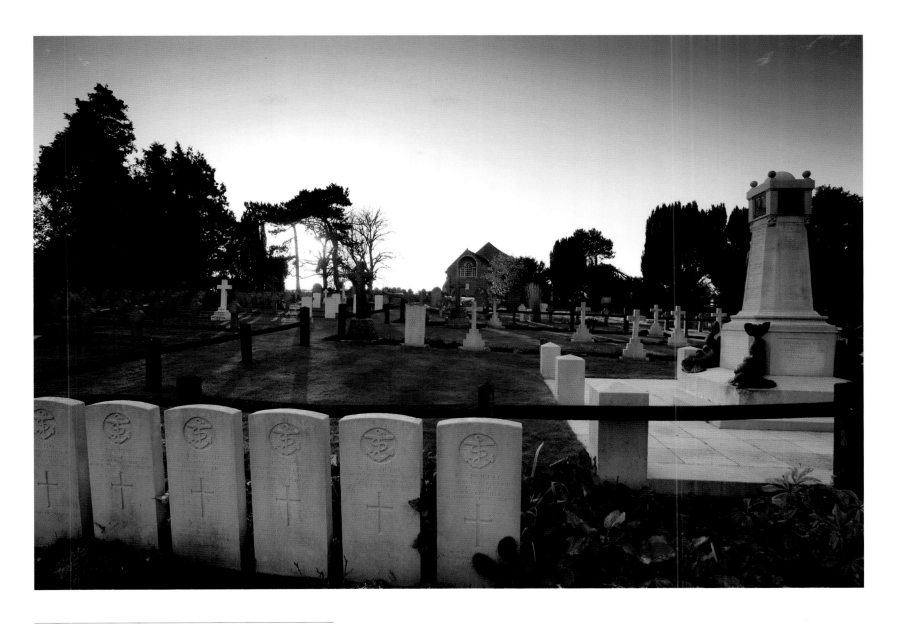

Shotley (St Mary) Churchyard
Suffolk, England

St Mary's Churchyard, Shotley contains more than 200
war graves from the First World War. They are marked with
a combination of the familiar CWGC white headstones
and crosses known as 'Admiralty Markers'. Also within
the cemetery is a memorial to the men of the 8th and 9th
submarine flotillas who lost their lives in the war.

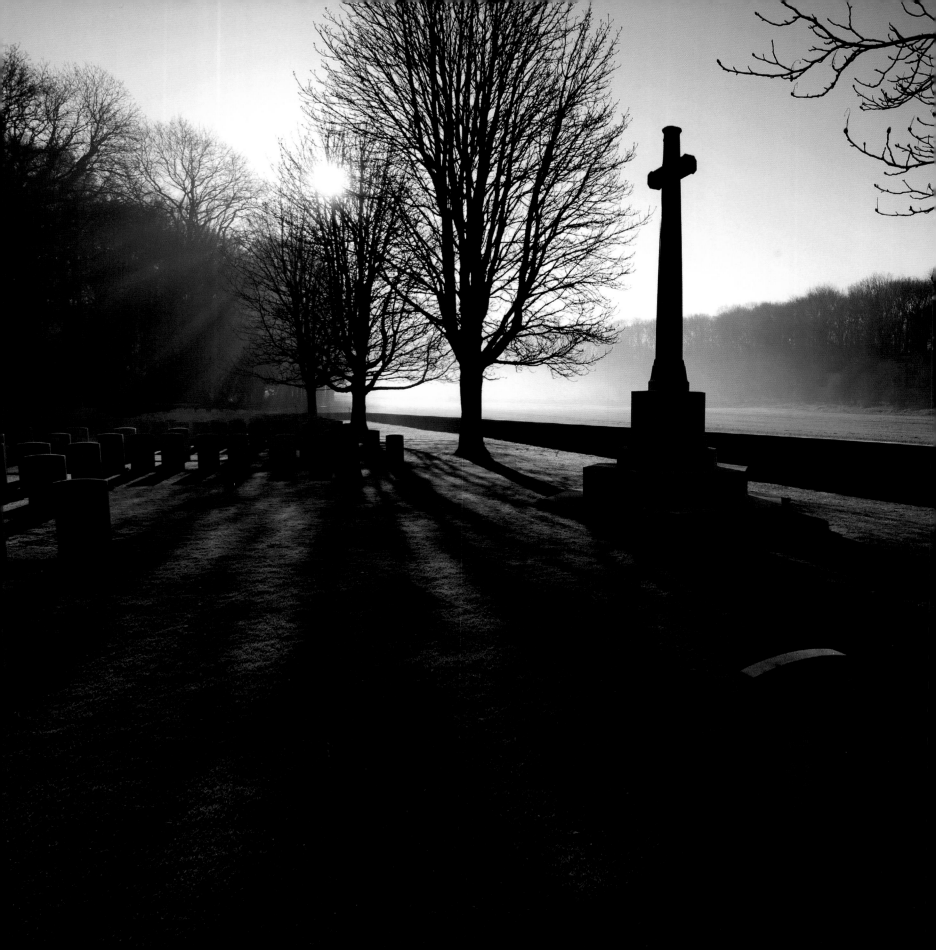

Blighty Valley Cemetery
Authuile Wood, Somme, France

Blighty Valley was the name given by British troops to the lower part of a deep valley running southwestward through Authuile Wood to join the river between Authuile and Aveluy.

'Blighty' – a slang term for Britain – was often used in the context of a 'Blighty wound' – an injury serious enough to require a return home, but not so serious as to kill or maim the individual.

The cemetery was begun early in July 1916, at the beginning of the Battle of the Somme, and used until the following November. It was greatly enlarged after the war and now contains over 1,000 burials.

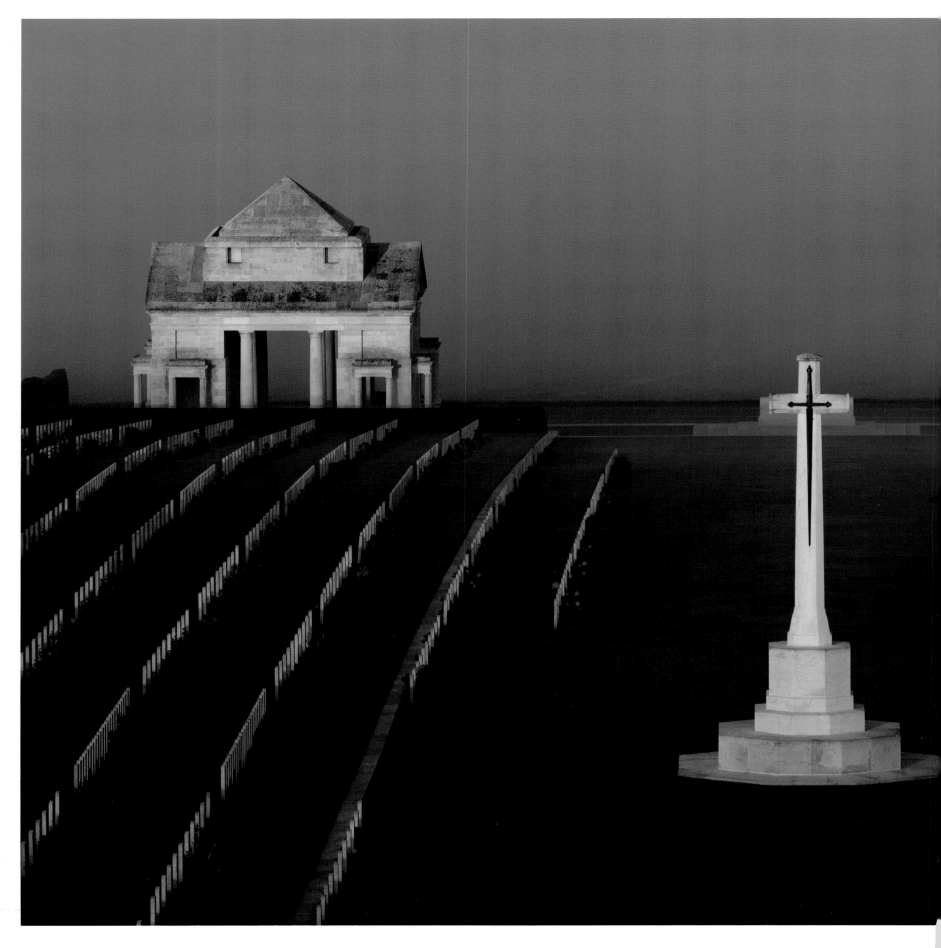

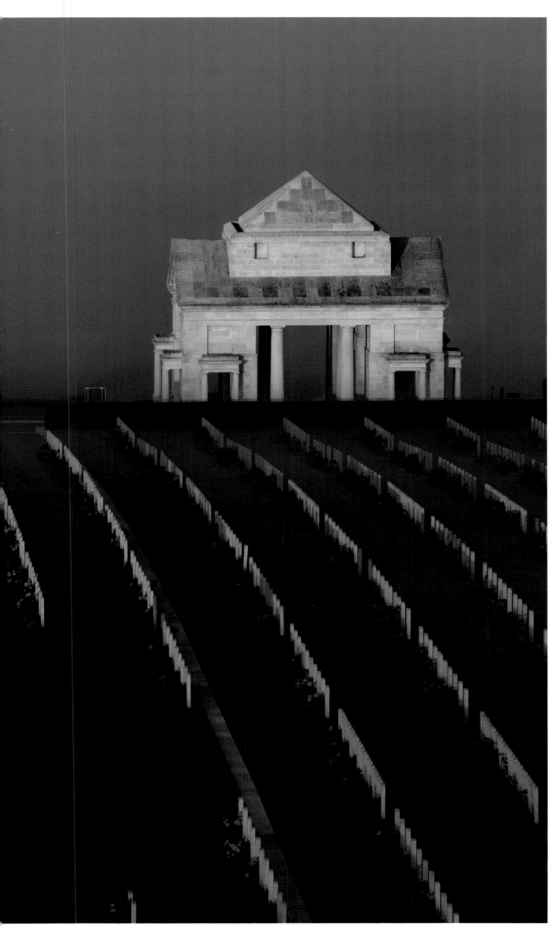

Villers-Bretonneux Military Cemetery and Memorial
Somme, France

The memorial at Villers-Bretonneux was the last to be completed by the Commission – unveiled by King George VI on 22 July 1938. It commemorates all Australians who died in France and Belgium during the First World War and bears the names of over 10,700 Australian servicemen with no known grave.

Villers-Bretonneux was captured during the German advance on Amiens on 23 April 1918. On the following day, the 4th and 5th Australian Divisions, with units of the 8th and 18th Divisions, recaptured the village. The battle was the first occasion when two tank forces clashed – three British Mark IVs against three German A7Vs.

Le Touret Military Cemetery and Memorial
Richebourg-L'avoue, Pas de Calais, France

The men of the Indian Corps began burying their fallen comrades at this site in November 1914 and the cemetery was used continually by field ambulances and fighting units until the German spring offensive began in March 1918. It now contains over 900 burials.

The site was also selected for a memorial to commemorate over 13,400 British soldiers who were killed in this sector of the Western Front from the beginning of October 1914 to the eve of the Battle of Loos in late September 1915 and who have no known grave. This part of the Western Front was the scene of some of the heaviest fighting of the first year of the war. The memorial was designed by John Reginald Truelove, who had served as an officer with the London Regiment.

The cemetery and memorial stand on the Rue du Bois – not far from where a Roman Catholic chaplain, Francis Gleeson, administered absolution to the 2nd Battalion Royal Munster Fusiliers on the eve of the Battle of Aubers Ridge in May 1915. The battalion suffered heavy casualties in the attack. The scene was captured in a famous painting by Fortunino Matania – the original of which was sadly destroyed.

Gleeson returned to Ireland in 1915 stating: 'I am sorry to be leaving the dear old Munster lads, but I really can't stand it any longer. I do not like the life, though I love the poor men ever so much.'

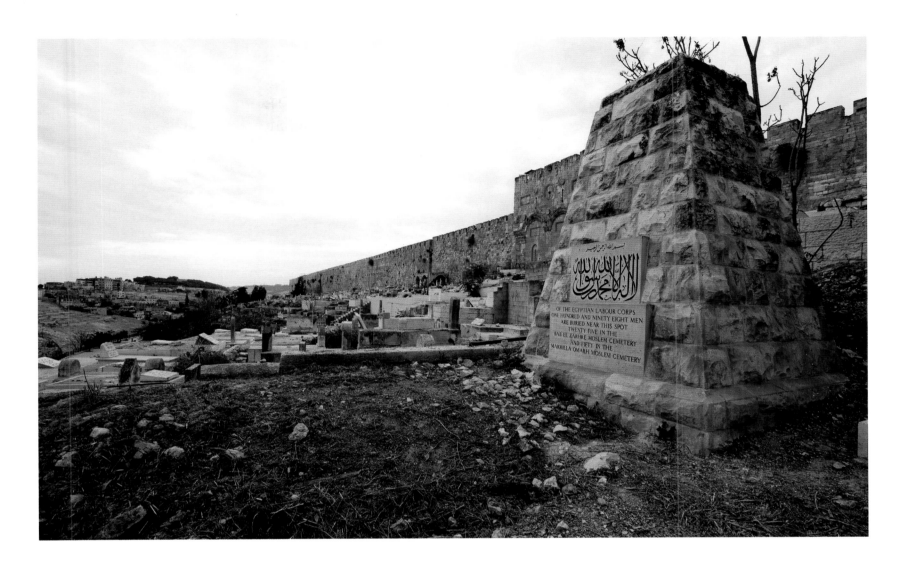

Jerusalem (Bab Sitna Mariam)
Muhammedan Cemetery

Israel and Palestine (including Gaza)

Standing outside the walls of Jerusalem, this civil cemetery contains the graves of almost 200 unidentified men of the Egyptian Labour Corps who died during the First World War. The memorial commemorates these men and 75 others buried in cemeteries west and north of the city respectively.

The huge demands placed on manpower by the war resulted in the recruitment of labour units on all fronts. They came from many countries and fulfilled vital, often dangerous, but non-combattant roles. By November 1918 some 1,000,000 British and Dominion soldiers and around 2,000,000 civilian labourers had been used to support the army.

Malta (Capuccini) Naval Cemetery
Malta

Malta (Capuccini) Naval Cemetery, which once belonged to the Admiralty, is divided into two sections, Protestant and Roman Catholic. Most of the 350 Commonwealth burials of the First World War form a triangular plot in the Protestant section, the rest are scattered elsewhere in the cemetery.

From the spring of 1915, the hospitals and convalescent depots on Malta and Gozo dealt with over 135,000 sick and wounded, chiefly from the campaigns in Gallipoli and Salonika.

Chief Petty Officer Henry Ernest Wild AM was a member of the Ross Sea party, in support of Sir Ernest Shackleton's Imperial Trans-Antarctic Expedition, 1914–17. He was part of a group of 10 men who were stranded ashore when their ship was blown from its moorings in a gale. In 1917 Wild returned to naval duty. He died on 10 March 1918 after contracting typhoid. In 1923 he was posthumously awarded the Albert Medal (the forerunner of the George Cross) for his efforts to save the lives of two comrades during his Antarctic expedition.

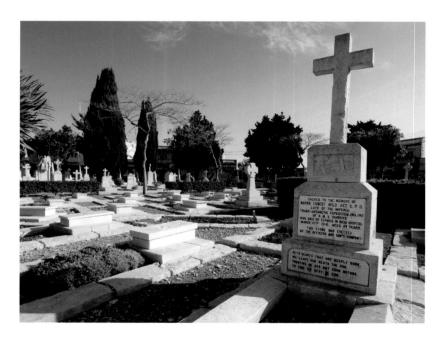

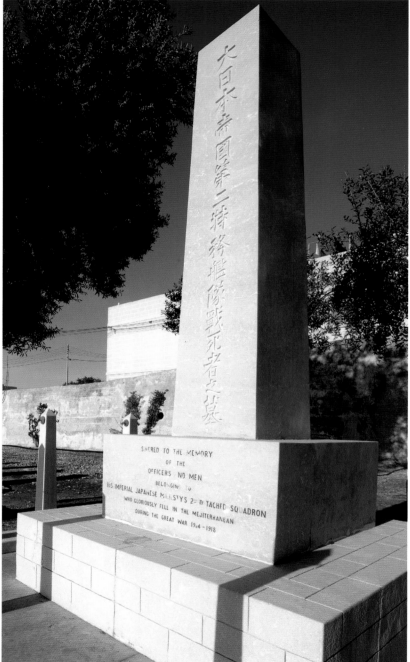

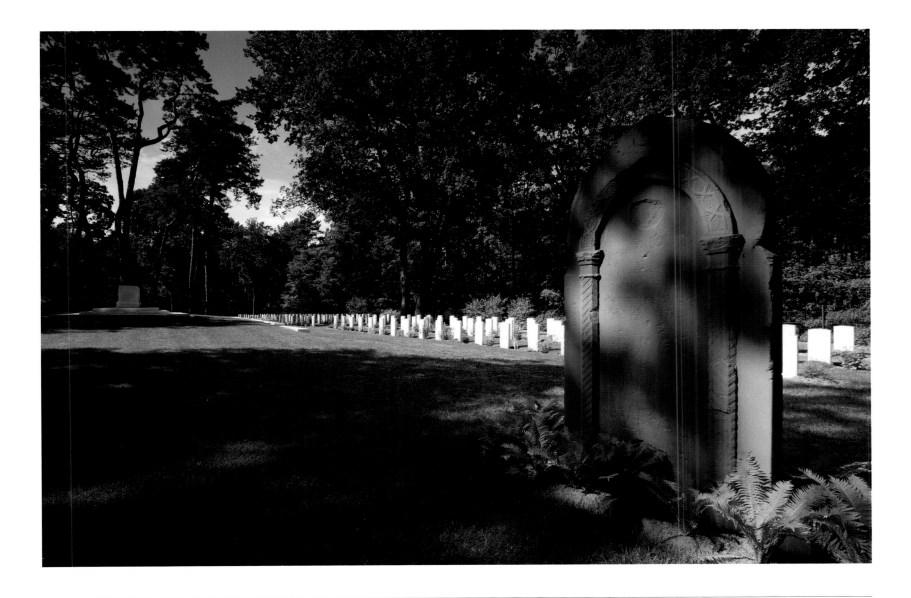

Zehrensdorf Indian Cemetery
Berlin, Brandenburg, Germany

Zehrensdorf Indian Cemetery contains the graves of over 200 soldiers and sailors of the forces of 'Undivided India' who died during the First World War at a prisoner-of-war camp three miles away at Zossen.

Until the re-unification of Germany in 1990 the cemetery was inaccessible – the land having been used as a tank training ground by Russian forces following their capture of Berlin at the end of the Second World War.

The cemetery was badly damaged, but after a three-year renovation programme, which included clearing the site of unexploded shells and the manufacture of a new Stone of Remembrance, it was completely restored and re-dedicated in 2005.

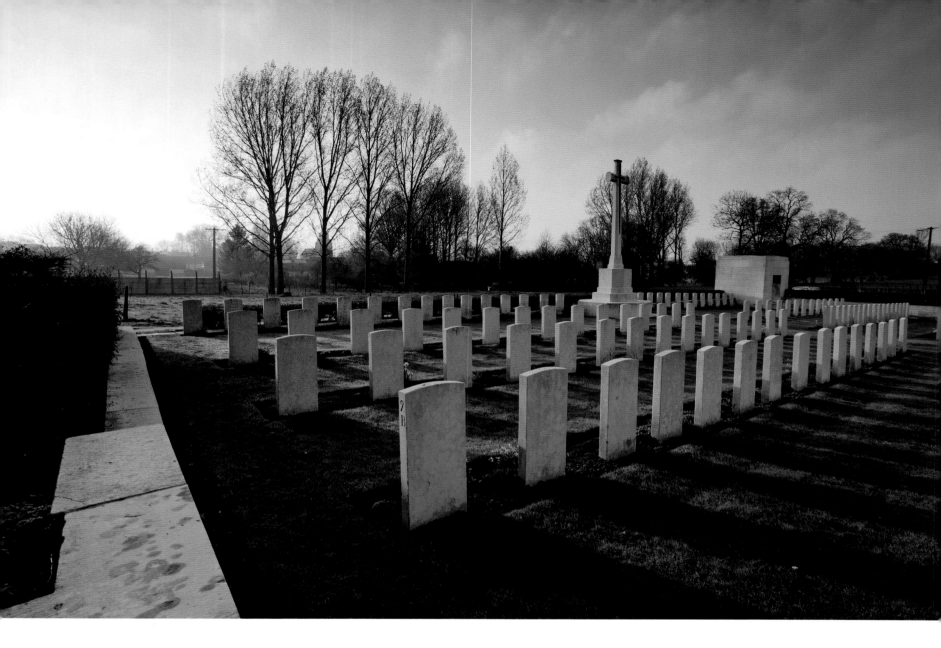

Forceville Communal Cemetery and Extension
Somme, France

Containing almost 450 burials, Forceville was one of the first three cemeteries
to be built after the First World War and was considered the most successful
test of the Commission's principles. All three 'experimental' cemeteries were
designed by Sir Reginald Blomfield – one of three principal architects employed
by the CWGC. The work completed here was closely monitored for its effects,
construction time and cost and informed the construction programme for all the
war cemeteries to come.

*The most perfect, the noblest, the most
classically beautiful memorial that
any loving heart or any proud nation
could desire to their heroes fallen in a
foreign land.*

The Times, 1920

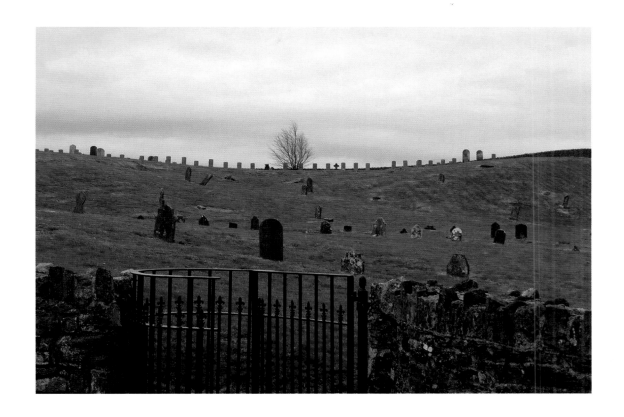

Curragh Military Cemetery
County Kildare, Republic of Ireland

The cemetery was last used in 1922 when the British Army handed over the Curragh Military Camp – the largest in Ireland – to the Irish Free State Army. There are over 100 Commonwealth burials scattered throughout the cemetery of soldiers who died in the camp.

The camp remains an army base, military college, and the main training centre for the Irish Army.

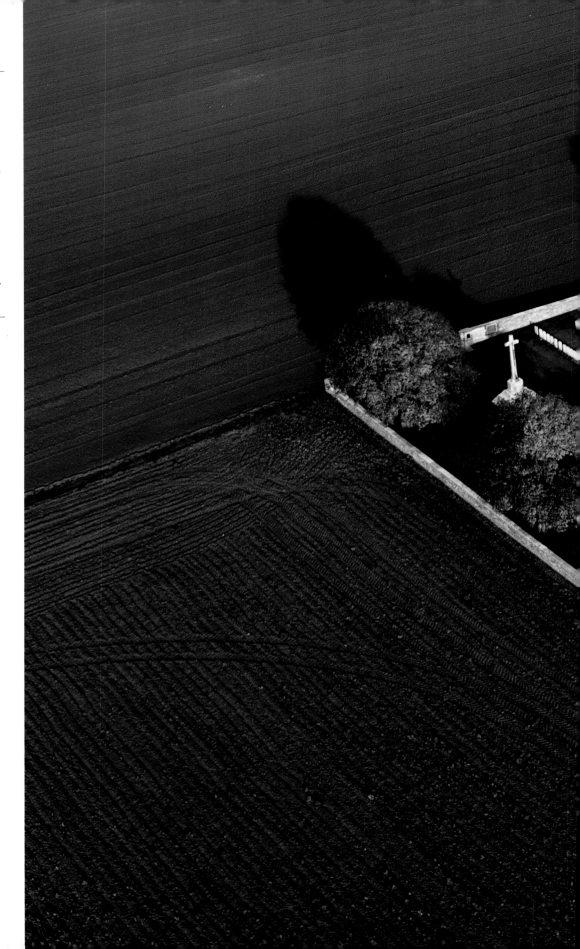

Knightsbridge Cemetery
Mesnil-Martinsart, Somme, France

The cemetery, which is named after a communication trench, was begun at the outset of the Battle of the Somme in July 1916. It was used by units fighting on that front until the German withdrawal in February 1917, and was used again by fighting units from the end of March to July 1918, when the German advance brought the front line back to the Ancre.

There are nearly 550 burials in the cemetery. Among them are brothers A and T Holman – aged 22 and 18 respectively – who died within a week of one another in July 1916.

It is desirable that the cemeteries should be fenced in by some boundary which will keep out the farmer's plough and his cattle – and wherever possible, enclosed by a wall; not a high wall, which suggests rather a kitchen-garden than a cemetery, and which conceals the nature of the enclosure from the passer-by, but by a low wall such as is usually found round a country churchyard, which leaves the ground within open to view, but effectually protects it from violation.

Sir Frederic Kenyon, *How the Cemeteries Abroad will be Designed*, 1918

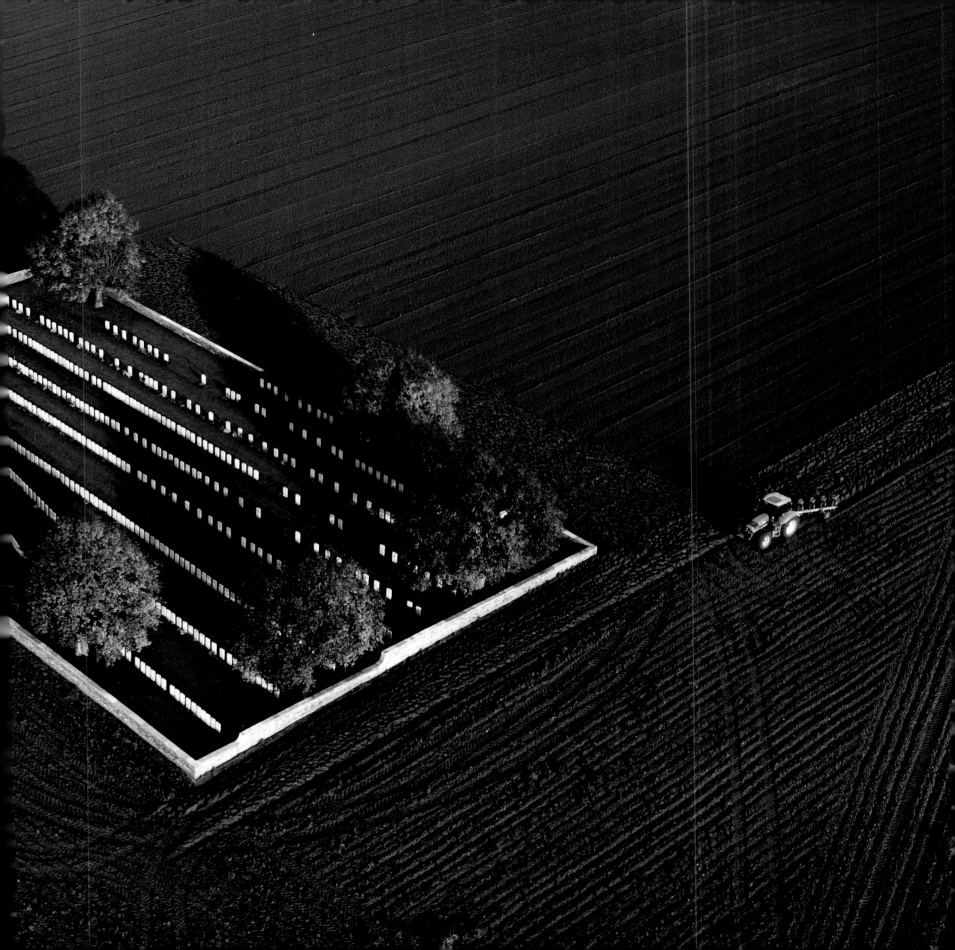

The Nek Cemetery, Anzac
Gallipoli, Turkey

'The Nek' was a narrow stretch of ridge in the Anzac battlefield area perfectly suited to defence. On 7 August 1915 two regiments of the Australian 3rd Light Horse Brigade mounted a costly attack on Turkish trenches there. In a mere 45 minutes, more than 230 men from Victoria and Western Australia were killed.

The Australian historian Charles Bean wrote: 'At first here and there a man raised his arm to the sky, or tried to drink from his water bottle; but, as the sun of that burning day climbed higher, such movements ceased: over the whole summit the figures lay still in the quivering heat.'

The cemetery was made after the Armistice in what had been No Man's Land and now contains over 320 burials.

**Serre Road Cemetery No. 3 (foreground), Queen's Cemetery
and Luke Copse British Cemetery, Puisieux**
Somme, France

In the spring of 1917, the battlefields of the Ancre were cleared by V Corps and a number of cemeteries were made. These small, neat, battlefield cemeteries mark the front line and the fierce fighting which took place here in 1916. Originally all named 'V Corps' with a number, the cemeteries later took names from local features or actions.

Serre Road Cemetery No. 3 was created in the spring of 1917 and contains over 80 burials of men who fell here in July and November 1916.

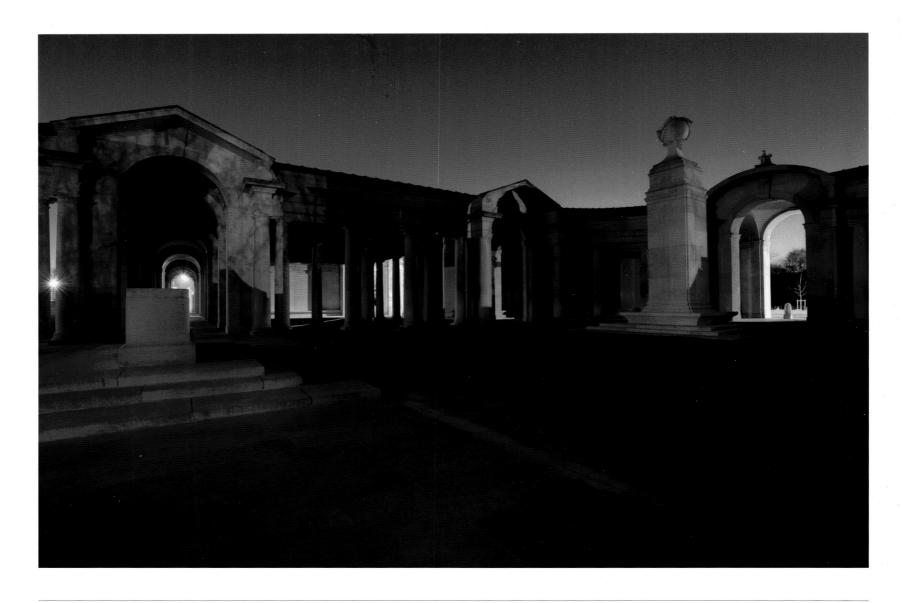

The Arras Flying Services Memorial
and Arras Memorial

Pas de Calais, France

The Great War was the first in which aircraft were deployed on a large scale. This new form of warfare attracted the public's attention – the deeds of pilots often featured in newspaper reports and were promoted at home. The reality was that the young men of the Royal Flying Corps, the Royal Naval Air Service and the Royal Air Force often had a short life expectancy at the front.

The memorial commemorates almost 1,000 airmen who were killed on the Western Front. It is sited within the much larger Arras Memorial, which commemorates almost 35,000 servicemen from the United Kingdom, South Africa and New Zealand who died in the Arras sector between the spring of 1916 and 7 August 1918, the eve of the 'Advance to Victory', and have no known grave.

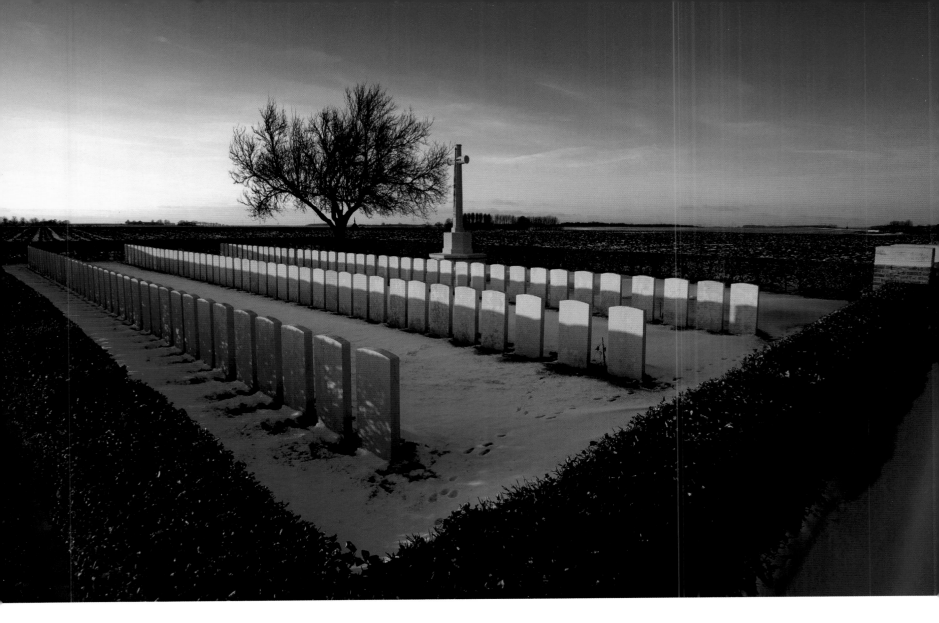

Munich Trench British Cemetery

Beaumont-Hamel, Somme, France

Munich Trench British Cemetery (originally V Corps
Cemetery No. 8) was named after a German trench
captured by the 7th Division on 11 January 1917.
The cemetery contains over 120 burials.

Tyne Cot Cemetery

Zonnebeke, West-Vlaanderen, Belgium

Officially known as the Third Battle of Ypres (31 July–10 November 1917), Passchendaele has become inextricably linked to the public's view of the First World War. Heavy rains, combined with the effects of shelling, made the battlefield a quagmire in which men and animals drowned. Historians still debate the numbers of casualties and the merits of the battle. It is estimated that there were 325,000 Allied and 260,000 German casualties. When the battle drew to a close, the Allies had advanced five miles.

I have many times asked myself whether there can be more potent advocates of peace upon earth through the years to come than this massed multitude of silent witnesses to the desolation of war.

King George V, 1922

Helles Memorial
Gallipoli, Turkey

The eight-month campaign in Gallipoli was fought by Commonwealth and French forces in an attempt to force Turkey out of the war, to relieve the deadlock of the Western Front in France and Belgium, and to open a supply route to Russia through the Dardanelles and the Black Sea.

The Allies landed on the peninsula on 25-26 April 1915; the 29th Division at Cape Helles in the south and the Australian and New Zealand Corps north of Gaba Tepe on the west coast, an area soon known as Anzac. On 6 August, further landings were made at Suvla, just north of Anzac, and the climax of the campaign came in early August when simultaneous assaults were launched on all three fronts. However, the difficult terrain and stiff Turkish resistance soon led to the stalemate of trench warfare. From the end of August, no further serious action was fought and the lines remained unchanged. The peninsula was successfully evacuated in December and early January 1916.

Sutton Veny (St John) Churchyard
Wiltshire, England

The village of Sutton Veny lies nestled among the chalk downs of the Wiltshire countryside. During the First World War, both the 26th Division and the No. 1 Australian Command were based in this typical English village. Today, the graves of more than 150 men – mostly those of Australian servicemen headquartered here – are found in Sutton Veny (St John) Churchyard. Every Anzac Day, 25 April, children from the local primary school hold a commemorative service in the churchyard to honour the men.

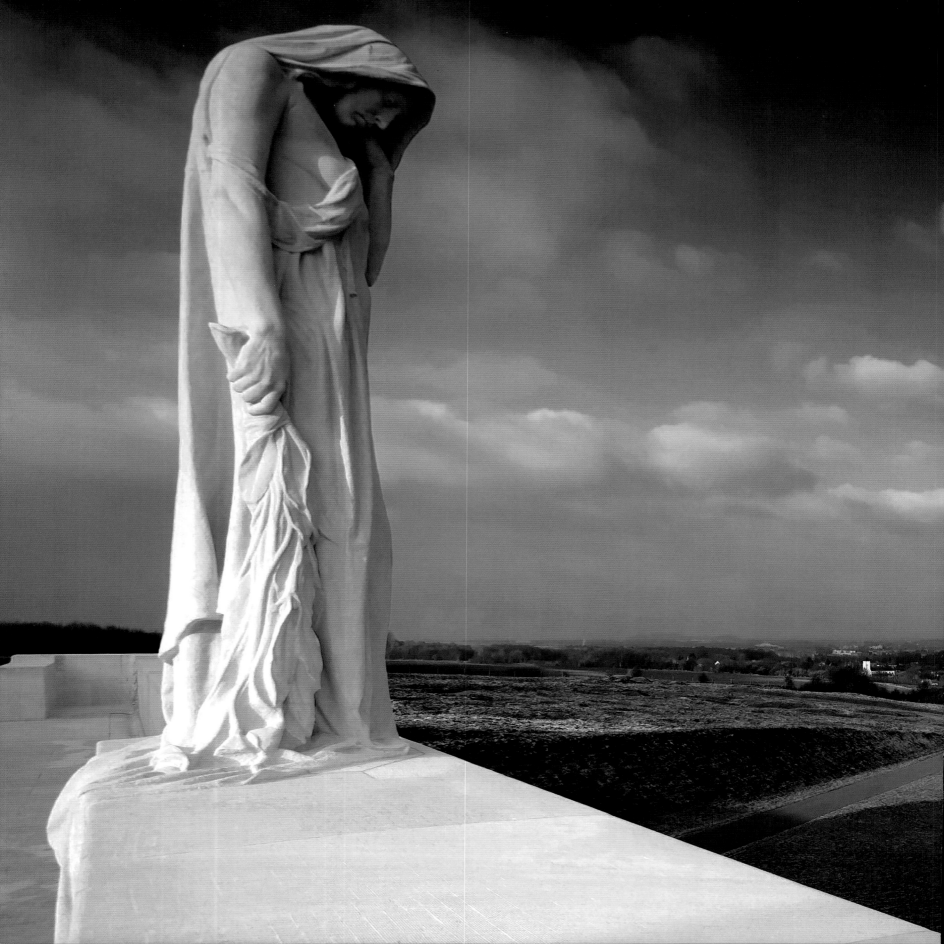

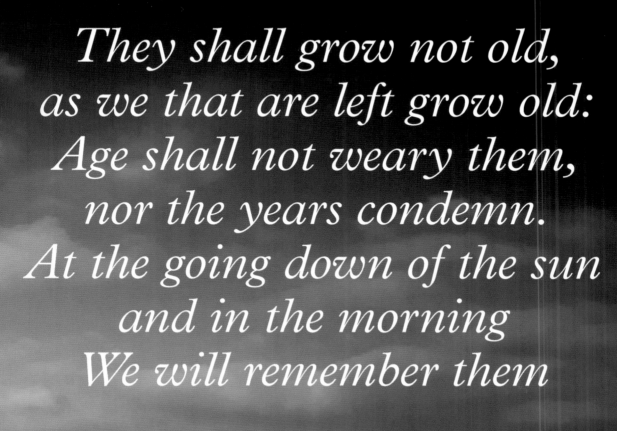

They shall grow not old,
as we that are left grow old:
Age shall not weary them,
nor the years condemn.
At the going down of the sun
and in the morning
We will remember them

'For the Fallen', Laurence Binyon, 21 September 1914

Index

Index

Index

Postscript from the photographer

I wanted these pictures to reflect the way in which the Commission has fulfilled its unique function and maintained a global presence for a century. Their original aim – to ensure that all are remembered with dignity and equality in a setting of beauty and peace – has been summarily met in all their various locations. However, merely concentrating on the cemeteries and the headstones is perhaps not enough: the idea is to also illustrate how that universal headstone fits into the very different landscapes around the world and how the Commission functions in an international setting. Thus some photos show the landscape wherein these cemeteries lie, illustrating their wider context, and wherever possible the photographs were shot to reflect the extraordinary range and diversity of the countries and cemeteries where the Commission operates.

The setting itself often creates a very powerful atmosphere. For example, it is the vast emptiness of the desert in Trekkopje surrounding the cemetery, which gives it its extraordinary nature. But sometimes an image of massed gravestones is all that is needed to show the mass sacrifice the war brought.

All the photographs for this book were taken digitally using either a Kodak 14N or a Nikon D700 camera equipped with a variety of Nikkor lenses from 17mm to 300mm. All the pictures have been adjusted using Photoshop but at no stage has there been any manipulation or alteration of major elements within the photograph other than that required to remove rubbish and suchlike to produce an image fit for reproduction.

I invariably use a graduated filter to enable me to control the sky: it is easier than having to use digital correction in Photoshop. I am also a firm believer in using a tripod, otherwise it is amazing how headstones move around when you try and shoot them with a long lens! Practically speaking, the best tripods I know for working in muddy conditions are the Benbo range, as when collapsing the legs the muddy bottom section encloses the upper sections and thus mud is not transferred into the legs. The extraordinary design – apparently based on the legs of a First World War machine gun tripod – means they can be levelled on any surface, however uneven, in seconds, using just one handle to lock the entire tripod.

Working in conditions varying from -15C through desert and tropical rain forests is hard on gear and the fact that my equipment has stayed working for so long is down to the amazing team at 'Fixation' who have even fixed a lens over the phone.

But when I consider the problems I have had, I stand in awe of the photographers of 1914–18 who, with their bulky plate cameras and attendant apparatus, waded through all that mud to document the lives of so many of the men who sadly were to become the subject of this book. My respect and admiration to them all.

Michael St Maur Sheil
Photographer

Michael St Maur Sheil was born in 1946. After leaving Oxford, where he read geography, he began his career in photo-journalism and a career-long association with the New York picture agency Black Star, working in Northern Ireland in the early 1970s. He has worked in over 60 countries around the world and in 2001 he received a World Press Photo Award for his work on child trafficking in West Africa.

Since 2006 he has been documenting the battlefields of the First World War as they are today and is a Fellow of the Royal Geographical Society and a member of the British Commission for Military History. He lives in Oxfordshire with his long-suffering wife Janet and a very chilled greyhound called Gonzo.

His photographic odyssey through the lands of the First World War *Fields of Battle, Lands of Peace 14–18* will be exhibiting internationally during the centenary period of 2014–18.

www.fieldsofbattle1418.org

Acknowledgements

The Commonwealth War Graves Commission and AA Media are grateful to the following individuals and organisations for their assistance with this publication or for permission to publish photographs. Our thanks also to CWGC staff all over the world for their help in realising this work and to the staff of the Office of Australian War Graves and Manatū Taonga | Ministry for Culture and Heritage New Zealand for their generous assistance.

Page 31: Tomb of the Unknown Soldier © Australian War Memorial

Pages 96 and 97: Featherstone Cemetery © Andy Palmer, www.acpalmer.co.nz

Page 154: Perth War Cemetery and Annexe © Office of Australian War Graves

Pages 188 and 189: Gaza War Cemetery © Basel El Maqosui

All other images © CWGC/Mike Sheil